COMPOSITION
PHOTO WORKSHOP

Blue Fier

BICENTENNIAL
1807
WILEY
2007
BICENTENNIAL

Wiley Publishing, Inc.

Composition Photo Workshop

Published by
Wiley Publishing, Inc.
111 River Street
Hoboken, N.J. 07030
www.wiley.com

Copyright © 2007 by Blue Fier

All photographs © Blue Fier 2007

Published simultaneously in Canada

ISBN: 978-0-470-11436-0

Manufactured in the United States of America

10 9 8 7 6 5 4 3 2 1

For general information on our other products and services or to obtain technical support, please contact our Customer Care Department within the U.S. at (800) 762-2974, outside the U.S. at (317) 572-3993 or fax (317) 572-4002.

Wiley also publishes its books in a variety of electronic formats. Some content that appears in print may not be available in electronic books.

Library of Congress Control Number: 2007925983

About the Author

Blue Fier studied art extensively while in college, receiving a Bachelors of Arts degree in Art from Occidental College; a Masters of Art degree in Art from California State University, Northridge; and a Masters of Fine Art degree in Art from the University of California, Los Angeles. Before committing himself to photography on a full-time basis more than 20 years ago, working with clients in the travel, real-estate, sports, and environmental industries, Fier was an exhibiting artist for nearly two decades. In addition to working as a professional photographer, Fier has taught photography for 15 years.

© Photo by David Paul Bayles, 2007

Credits

Acquisitions Editor
Kim Spilker

Senior Project Editor
Cricket Krengel

Project Editor
Kelly Maish

Development Editor
Kelly Dobbs Henthorne

Technical Editor
Larry D. Sweazy

Editorial Manager
Robyn Siesky

Vice President & Group Executive Publisher
Richard Swadley

Vice President & Publisher
Barry Pruett

Business Manager
Amy Knies

Book Designers
LeAndra Hosier
Tina Hovanessian

Project Coordinator
Adrienne Martinez

Graphics and Production Specialists
Joni Burns
Brooke Graczyk
Jennifer Mayberry
Barbara Moore
Shelley Norris
Amanda Spagnuolo

Quality Control Technician
Todd Lothery

Cover Design
Larry Vigon
Daniela Richardson

Proofreading and Indexing
Broccoli Information Management
Sossity R. Smith

Wiley Bicentennial Logo
Richard J. Pacifico

Acknowledgments

Many extremely talented people collaborated on this book. My utmost gratitude and appreciation goes to Kate Shoup Welsh, my personal editor, who clarified my thoughts, organized my ideas, and researched topics above and beyond my expectations. I'd also like to acknowledge all the editors and staff at Wiley for allowing me the opportunity to work with them. Next up, thanks to the many students I have taught at Santa Monica College, who have been the testing ground and inspiration for my ideas; also, thanks to my clients, who have trusted me to bring back images of beauty out of seeming chaos. My wife, Kim, and sons, Zack and Easton, have enthusiastically supported me in undertaking this lengthy project in lieu of other events. I am grateful for the ideas and suggestions offered by my close friend, David Paul Bayles, in addition to his excellent portrait of me. Special thanks go to Robert Farber for suggesting I get involved in this series. I would like to thank Christian Erhardt of Leica USA for loaning me the latest Leica digital cameras and the Lifepixel Company for converting my Canon digital camera to an infrared one. In creating this book, it helped immeasurably to be a part of Ian Summers' Heartstorming group, which encouraged me to pursue my vision.

To all those who follow their hearts.

Foreword

After 10 years of helping photographers hone their skills on photoworkshop.com, I'm thrilled to present this new line of books in partnership with Wiley Publishing.

I believe that photography is for everyone, and books are a new extension of the site's commitment to providing an education in photography, where the quest for knowledge is fueled by inspiration. To take great images is a matter of learning some basic techniques and "finding your eye." I hope this book teaches you the basic skills you need to explore the kind of photography that excites you.

© Photo by Jay Maisel

You may notice another unique approach we've taken with the Photo Workshop series: The learning experience does not stop with the books. I hope you complete the assignments at the end of each chapter and upload your best photos to pwsbooks.com to share with others and receive feedback. By participating, you can help build a new community of beginning photographers who inspire each other, share techniques, and foster innovation and creativity.

Robert Farber

Contents

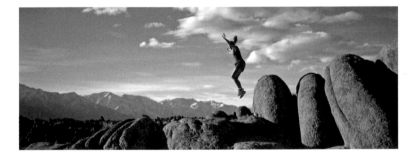

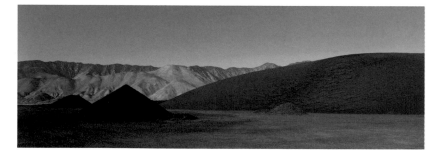

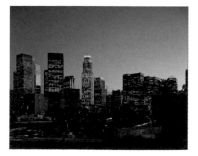

CHAPTER 5 Capturing Light **79**

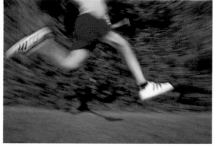

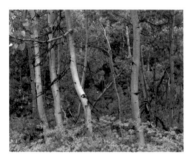

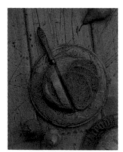

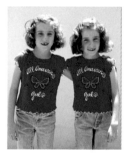

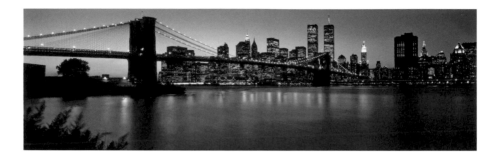

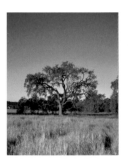

Introduction

Every waking moment of every single day, you face choices. Toast or bagel? Decaf or regular? Paper or plastic? The list is endless. Some of these choices, like those listed here, are of little importance. That is, choosing one or another option might improve your day, but probably won't change your life. Other choices, however, can have a tremendous impact: where to live, whom (if anyone) to live with, and what type of work to do.

Like life, photography — indeed, any art form — is about choices. What type of camera should you use? Should you orient the image vertically or horizontally? Should the image be in color or in black and white? What settings — ISO, aperture, and shutter speed — would work best? How should your subject be arranged? How should the scene be lit? Should you use a tripod, filters, or special lenses? Where should you position yourself relative to your subject when clicking the shutter button?

Each of these choices factors into your photograph's *composition* — that is, how your picture looks or, more precisely, the information or idea that your photograph conveys. A well-composed picture communicates its message clearly and effectively, inviting the viewer both to further examine the work and to appreciate it.

Just how do you create a well-composed picture? That's where this book comes in. In its pages, you can discover the tools necessary to compose photographs that urge the viewer to look more closely. Specifically, you explore the following:

- The elements of design that represent the building blocks of any photograph

- How depth of field can factor into your composition

- The compositional effects of using different shutter speeds

- The various ways you can use light in your images

- How shooting in color versus black and white (or vice versa) can articulate your photograph's message

Armed with this information, you then investigate how best to compose images of various kinds, including portraits, landscapes, and other scenic shots, still-life pictures, and macro photographs. You then survey how to use image-editing software to enhance your photograph's composition. Along the way, you complete assignments designed to illustrate the principles of composition explored in each chapter and apply what you've learned.

However, this book is intended to do more than teach you a bunch of compositional rules. Its true goal is to help you develop your own unique compositional style. Using what you learn in this book, you can discover the ways in which to make your photographs, well, yours. If you're ready to change the way you take pictures, to choose between creating images that viewers pass by with barely a glance to ones that stop them in their tracks, then read on.

For comments and up-to-date information regarding this book, as well as future workshops, podcasts, or to purchase prints by Blue Fier, please visit compositionphotoworkshop.com and bluefier.com, or e-mail me at blue@bluefier.com. Many images in this book are available through www.gettyimages.com or www.panoramicimages.com.

May good light follow you wherever you go.

~Blue Fier

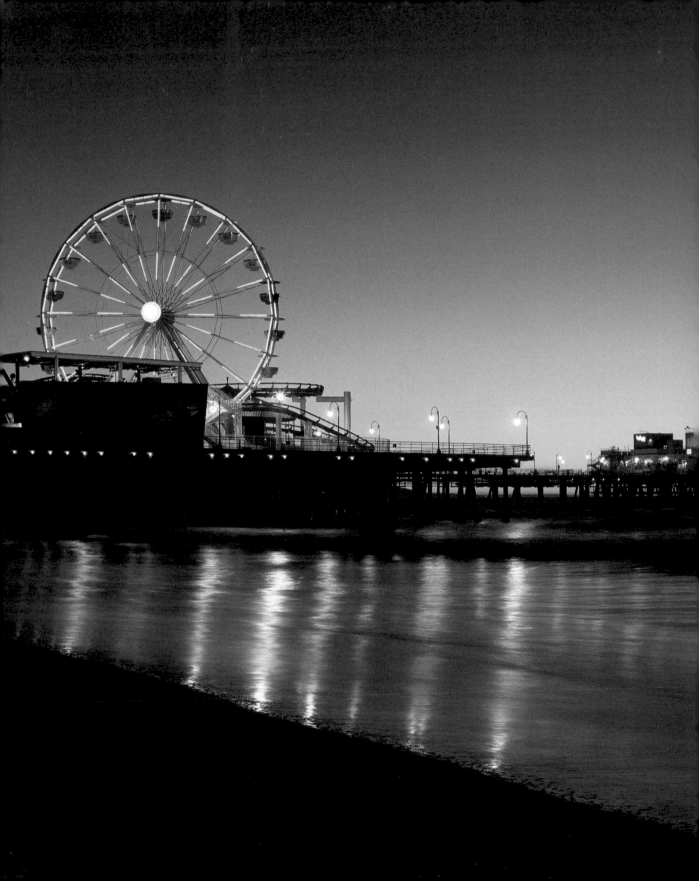

UNDERSTANDING COMPOSITION

Have you ever studied a snapshot and wondered why it looked amateurish compared to a photograph taken by a more experienced photographer? Even when the subject matter is the same — say, for example, that both photographs depict a shoreline — the difference between them is clear. The master's image is more captivating, more vital, more powerful than the snapshot. But why? What is it about the more skilled photographer's image that makes it so compelling? What is it about the skilled photographer's photograph that promotes it from a snapshot to a work of art?

Many factors can affect a photographic image. Lighting, for one, can greatly influence the outcome of a photographic shoot. So, too, can the camera's settings — the f-stop, shutter speed, and ISO. The quality of the camera's lenses can be a factor, as can the use of additional equipment such as a tripod and filters. But more than these is the photo's *composition*, that is, the arrangement of the elements within the image. Indeed, composition is the unifying element behind all visual art, from painting to photography and beyond.

Taking a snapshot is a simple matter of picking up a camera and photographing whatever is in front of you. Little, if any, thought process is involved. In contrast, when you compose a photograph, you consciously choose what visual elements to leave in and what to omit from your photos (see 1-1). When a picture is well-composed, the message the image is meant to convey is clearly and effectively communicated, inviting the viewer to appreciate and examine the work.

APPROACHES TO COMPOSITION

Although it's true that composition is about choosing which elements your photograph contains, that's not to say that everyone makes those choices in the same way. Some people carefully position themselves for just the right shot;

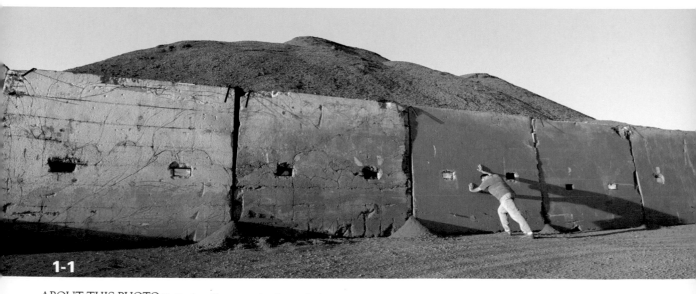

1-1

ABOUT THIS PHOTO *Notice how the person leaning against the wall adds scale to the image (105mm, 100 ISO, center-weighted neutral-density filter, f/32.5 at 1/4 second).*

4

others painstakingly arrange their subjects, creating their compositions just so. Still others wing it — waiting for the elements of a photograph to naturally coalesce. For example, nineteenth-century photographer Carleton Watkins, famous for his photographs of the American West (particularly Yosemite), didn't bother setting up his camera until after he had walked around a site, waiting for all the elements in the scene to align in a way that pleased him (see 1-2). Watkins understood how a slight shift in position could change how the components in an image came together, yielding what he called "the best view."

Similarly, Edward Weston, known for his beautiful close-up images of fruits, vegetables, and nudes, carefully arranged his subjects before photographing them, whether they were in the studio or outdoors (see 1-3). In contrast, Henri Cartier-Bresson, renowned for his superb images of people and places (see 1-4), relied more on intuition than planning. He developed a knack for recognizing in a split second, even as the world swirled around him, when a photograph was perfectly composed — what he called "the decisive moment."

ABOUT THIS PHOTO
Best General View, Mariposa Trail, ca. 1860's. Photograph by Carleton Watkins. Courtesy Center for Creative Photography, University of Arizona

1-2

5

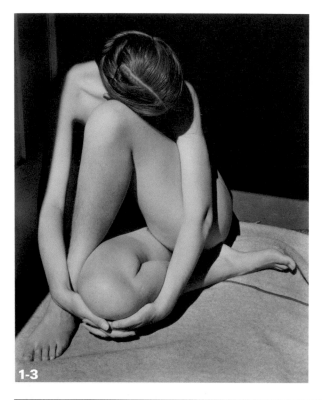

1-3

HOW YOU SEE

Why does the way in which a photograph — or other piece of visual art — is composed affect how effectively that piece communicates its meaning? Why do some compositions provoke the viewer to linger on an image, and others barely garner a glance? One answer relates to how you see.

THE PHYSIOLOGY OF THE EYE

When you perceive something visually, it's because that object is either emitting or reflecting light, which enters the eye in the form of waves. These waves pass through the eye's pupil, lens, and cornea to the retina to stimulate visual receptors called *rods* and *cones* (see 1-5). Rods enable you to see the general outlines of objects, even in dim light — although without color. In contrast, cones detect color and enable you to discern an object's details. Cones are concentrated in the

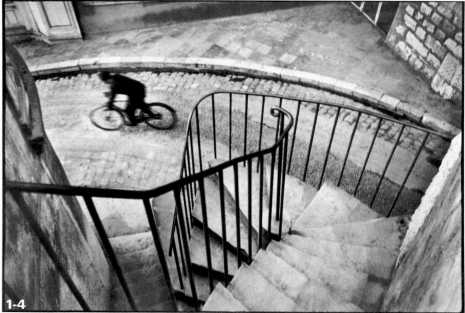

1-4

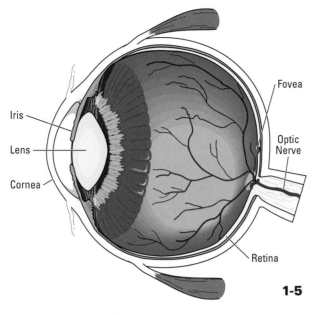

1-5

ABOUT THIS FIGURE *An eye in cross-section.*

fovea centralis — a depressed area in the center of the retina. In contrast, rods are spread around the outer portion of the retina. Rods and cones, when activated by light, transmit nerve impulses to the optic nerve behind the retina, which ushers these impulses to the brain's visual cortex for processing. To visualize this effect, imagine walking into a dark movie theater when you just came from a brightly lit room. Your eyes can barely make out the seats or what's in front of you...that is your rods working first, then as more light is gathered, you begin to see more details...that is your cones working.

note Light that strikes the depressed area at the center of the retina (called the *fovea centralis*) is perceived more sharply than light that falls outside the depression. The result is an image that appears focused at the center but blurred around the edges. A camera, however, can generate a photograph that is sharp from foreground to background and edge to edge. This explains why a photograph of a scene can be evenly focused throughout, even though your eye didn't perceive the scene that way.

Because humans have two eyes, with pupils roughly 2.5 inches apart, people view the world *stereoscopically*. That is, each eye sees an object slightly differently. To form a single, 3-D image that conveys depth, dimension, distance, height, and width, the brain merges the image registered by one eye with the image registered by the other. (Note that this applies primarily when the object is fewer than 18 feet away. For objects that are farther out, the brain uses relative size and motion to determine its depth.) The brain also flips the image as in figure 1-6, which is originally upside down due to the way light is refracted through the lenses of the eyes, right side up.

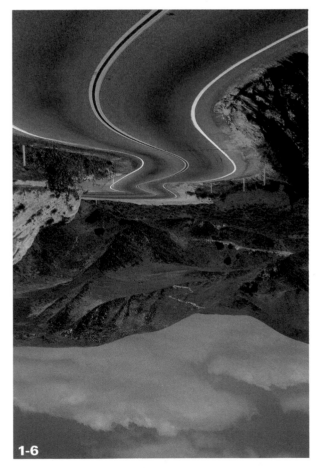

1-6

ABOUT THIS PHOTO *This is how your brain actually sees the image, upside down, and then flips it right side up (105mm, 50 ISO, f/16 at 1/40 second).*

7

SELECTIVE VISION

Although roughly one-third of the brain busies itself with various aspects of seeing, the brain cannot respond to each and every signal sent to it via the optic nerve. The volume of information is simply too great and would quickly overwhelm the brain's resources. For this reason, your vision is selective. So, rather than processing each bit of data it receives from the optic nerve, the brain processes differences in this data — a slight movement, an alteration in color, a shift in light or shadow. To facilitate this, the eye continually scans the scene before it. Even if your environment is static, you continue to unconsciously scan for changes. The eye also moves to bring different portions of the scene into focus.

Just as you continuously scan your environment, so, too, do your eyes move about when you examine a photograph or other still image. The difference is, a still image is, by definition, static. There

are no changes to detect. Even so, as a photographer, you can take advantage of the eye's impulse to scan by carefully placing the objects in your scene — composing the photograph (see 1-7). When a photograph is well-composed, the eye is naturally drawn to the center of interest, typically comprised of contrasting objects that stand out from their surroundings, before scanning the rest of the photograph (see 1-8).

SELECTIVE VISION AND NATURAL SELECTION To stay alive, early humans had to quickly detect danger and determine how to react. Selective vision enabled them to do just that. By restricting the volume of information processed by the brain, selective vision prevented over-stimulation — a condition that rendered the brain less able to swiftly and correctly evaluate one's surroundings. Although these early humans certainly used all five of their senses — touch, taste, smell, hearing, and sight — to assess their environment, vision was the most active and dynamic and, as such, particularly critical to their survival. Indeed, vision is so central to the human experience that people often think and even reason using visual images and their brains create full-color images even when they are asleep or sensory deprived. Put another way, the sense of sight is so powerful, so much a component of the human experience, it can function even without stimulation.

ABOUT THESE PHOTOS *Even rectangles can be organized in such a way that your eye moves about the picture, as shown in figure 1-7 (30mm, ISO 100, f/5.6 at 1 second, with FL-D filter to compensate for the fluorescent lighting). In figure 1-8, you see dinosaurs that are located off of California's Highway 10. Notice how the smaller dinosaur counterbalances the larger one, keeping your attention anchored in the picture (24mm, ISO 50, f/16 at 1/60 second).*

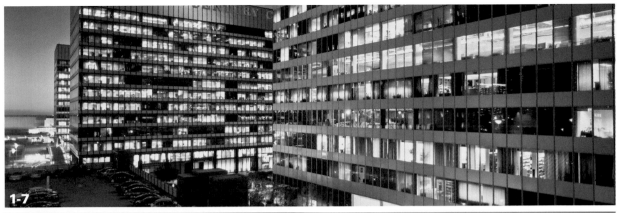

1-7

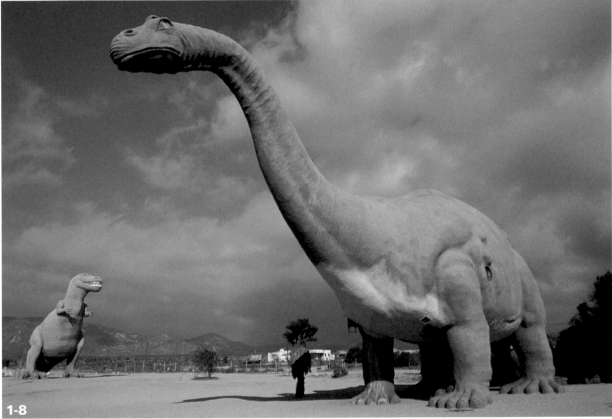

1-8

THE ORIGINS OF COMPOSITION

The origins of the compositional tricks that enable a photographer to generate interest in a photo lie in the very beginning of art itself. After all, even the arrangement of picture elements on a cave wall were concerned with communicating a message as effectively as possible. Over time, the more effective arrangements evolved into simple compositional rules that were passed down from each generation of artists to the next.

That said, compositional rules do vary by culture — primarily because of the way people in various cultures are trained to read and write.

People in Western cultures read and write from left to right, starting at the top of the page and working downward line by line. In contrast, although most Arabic languages are similarly line-oriented, each line is read from right to left; and many Asian languages, such as Chinese and Japanese, are column-oriented rather than line-oriented, meaning they're read from top to bottom, starting on the left side of the page and working rightward. As a result, most Westerners naturally look first at the top-left area of an image, scan to the right, and then move downward as in 1-9. In contrast, Arabic people tend to look first at the top-right area of an image and scan to the left before moving downward;

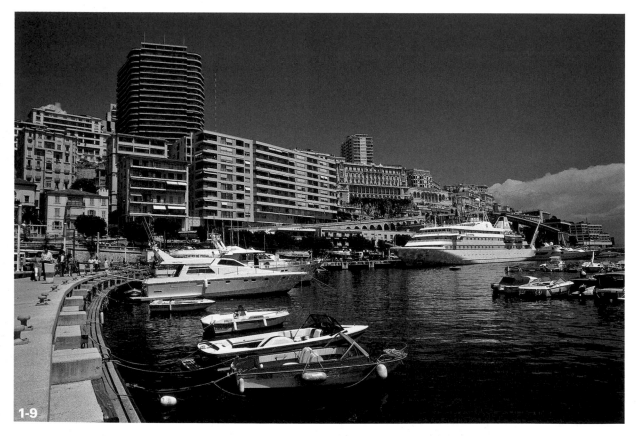

1-9

ABOUT THIS PHOTO *A typical Western composition in which the viewer starts looking on the left and moves to the right as if he or she is reading (24mm, ISO 100, f/16 at 1/125 second).*

note Two of the most common methods for learning compositional rules were — and remain — copying the works of the Old Masters, such as Da Vinci, Michelangelo, Raphael, Caravaggio, Albrecht Dürer, Rubens, and Rembrandt, and discussing famous works of art in student forums.

Asian people generally begin at the top-left area but scan downward before looking to the right. These ingrained tendencies greatly affect the way in which you see and how you organize your compositions. This book focuses on the rules of design and composition as they apply to Westerners; however, the beauty of knowing how to compose your photographs lies in being able to guide the viewer to look exactly where you want them to go in your image, regardless of cultural background.

UNDERSTANDING LINEAR PERSPECTIVE

Although early painters often attempted to compose images that depicted reality, their efforts were hampered by the fact that *linear perspective* — that is, the technique used to create the illusion of three dimensionality, distance, and depth on a two-dimensional surface, be it a cave, a wall, or a canvas — was not yet understood. Indeed, the only way these artists knew to denote distance in their compositions was by simply overlapping the characters and objects on the picture plane. Compounding the problem was that artists often sized the subjects of their paintings according to their importance, spiritual or otherwise, further skewing their attempts at representational compositions.

THE CAMERA OBSCURA One tool artists used to create images that mirrored reality was the *camera obscura*. Early versions of the camera obscura consisted of a small, dark room with a single, tiny aperture in one wall through which light was admitted, casting an inverted image of the outside scene on the wall opposite the hole (a convex lens would later be used to correct the inverted image).

Mentions of the camera obscura, which is Latin for "dark room," appear in literature at least as early as the tenth century A.D., by Arabian scholar Hassan ibn Hassan, although Aristotle is known to have observed and understood the science behind the camera obscura more than a millennium earlier. Subsequent mentions of the device occur in works by Francis Bacon and Leonardo Da Vinci — but it's believed that Venetian nobleman Daniel Barbaro (1528–1569) first suggested using the camera obscura as a drawing aid.

In time, artisans crafted portable models of the camera obscura — first in the form of a tent and later a wooden box with a lens to focus the image. The image was then projected onto a slab of ground glass over which a piece of transparent paper could be laid, enabling the artist to trace the scene in front of the lens. Although amateur artists comprised the majority of camera obscura enthusiasts, the device was sometimes used by even the most skilled artists, possibly including Jan Vermeer (1632–75), Canaletto (1697–1768), Joshua Reynolds (1723–1792), and Paul Sandby (1725–1809), and served as the basis for the cameras used by Louis Daguerre, Nicéphore Niépce, and William Fox Talbot to create the first photographs between 1826 and 1839.

All that changed when the Italian painter Giotto painted a fresco cycle in the Cappella degli Scrovegni in Padua between 1303 and 1305. Giotto used a mathematical method to determine the composition of characters and objects within their setting, resulting in a sense of depth and dimensionality that, though imperfect to modern eyes, was entirely new. In the early 1400s,

ABOUT THESE PHOTOS *There is nothing manmade in the Death Valley landscape of Zabrenski Point shown in figure 1-10 where no parallel lines exist (105mm, ISO 100, center-weighted neutral-density filter, f/22.5 at 1/8 second). The interior courtyard shown in figure 1-11 shows the one point perspective of the camera, parallel lines, and orthogonal rays used in perspective drawings (105mm, ISO 50, center-weighted neutral-density filter, f/32 at 1/4 second).*

Filippo Brunelleschi perfected Giotto's attempts at perspective, demonstrating the linear perspective still practiced today.

Key to linear perspective are foreshortening, the horizon line, and vanishing points (see figures 1-10 and 1-11). *Foreshortening* involves enlarging the parts of an object or character nearest the viewer such that the rest of the object or character appears to recede. The horizon line runs across the image plane directly opposite the viewer's eye and represents (either explicitly or implicitly) the line where the sky in the image meets the ground. *Vanishing points* are points in an image,

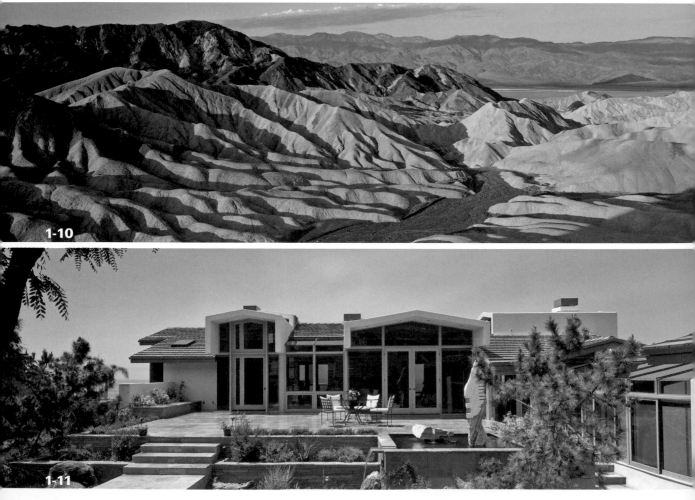

1-10

1-11

often on the horizon line, where parallel lines appear to converge. An image can contain any number of vanishing points, depending on how many sets of parallel lines are featured (or none at all, as is the case in some natural scenes such as those depicting mountain ranges in which no parallel lines exist). *Orthogonal lines* visually connect points around the edges of the image to each vanishing point; the artist uses these to correctly position objects in three-dimensional space, such as tiles on the floor or chairs and tables in a room.

Ultimately, artists' further understanding and use of linear perspective enabled them to align rendered characters and objects on a two-dimensional plane in such a way to suggest space, overlap, and scale, making objects look more like how you see with your eyes — or like a photograph. Not only that, artists developed an understanding of *atmospheric perspective* (that is, how objects appear fainter and fuzzier the farther away they are), resulting in scenes that resembled reality even more. To exploit these new techniques, artists began composing paintings that depicted a single, unified scene (think Jan Vermeer's *The Art of Painting*), rather than a combination of several (think Hieronymous Bosch's *Garden of Earthly Delight*).

COMPOSITION AND PHOTOGRAPHY

When composing a photograph, the photographer must keep a few key considerations in mind — considerations that are unique to photography:

■ **Detail.** Have you ever shot a portrait outdoors and noticed upon examination of the finished photo that your subject appears to have electrical wires, tree limbs, and street lamps projecting from his head? That's because the camera processes an incredible amount of detail — much more than you, with your selective vision, can manage. Because the camera is so precise, because it misses nothing, you, as a photographer, must train yourself to pay close attention to every detail in a scene and to create order out of chaos. One way is to try to simplify your surroundings, which explains why so many photographers work in a studio setting. Another way is to simply organize your picture around the chaos, as shown in 1-12. Notice that even though it depicts a disorderly environment, the light from the single skylight above points your eye toward the tools near the top of the picture.

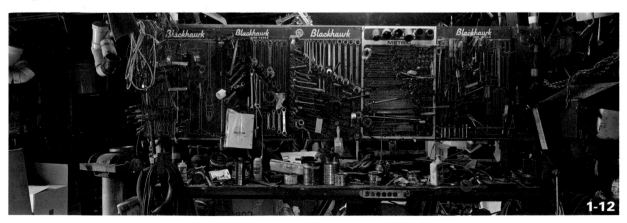

1-12

ABOUT THIS PHOTO *Notice all the details. A photograph enables you to slow down and relish all the details and objects, which you might not observe as closely in person (105mm, ISO 400, f/22 at 30 seconds).*

■ **Time.** Although a painting can attempt to depict a moment in time, it cannot serve strictly documentary purposes. By necessity, it is limited in its portrayal by what details the artist perceived (or failed to perceive). In contrast, a photograph can serve as a historical document. In a fraction of a second, the camera accurately captures a moment that will never happen again, stopping time to preserve the present for the future. In addition to stopping time as shown in 1-13 and 1-14, the camera can also appear to manipulate it. That is, the shutter can be used to show the effects of motion in ways your eyes cannot record. Your composition might freeze a falling drop of water mid-air or create a slow-motion record of a river flowing over rocks over the course of several minutes. By choosing how you want to capture time — slicing it up into thousandths of a second or capturing events over the course of several hours — your composition can make the invisible visible.

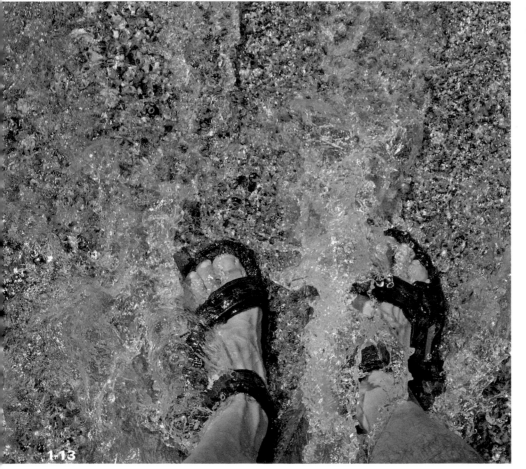

ABOUT THIS PHOTO
The water is frozen in time, something your eye cannot see, but the camera can record (50mm, 100 ISO, f/4 at 1/2000 second).

1-13

■ **Monocular vision.** As mentioned previously, you see stereoscopically, which enables you to perceive the world in three dimensions. In contrast, the camera has *monocular vision.* That is, it sees with one eye only and from one point of view. Part of composition is learning to see as the camera sees so you can predict in your mind's eye how the finished image will look. This is called *previsualization,* and it takes time and practice to perfect.

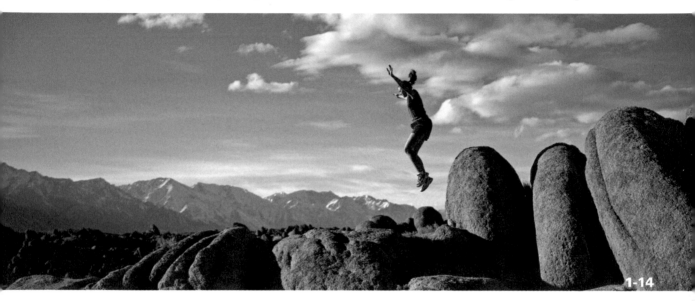

1-14

ABOUT THIS PHOTO *This photo's composition draws your eye to the woman, around to the clouds, the boulders, and the mountains, and back to the woman (30mm, 100 ISO, center-weighted neutral-density filter, f/5.6 at 1/250 second).*

Assignment

360 Degrees

This assignment is a great beginning exercise meant to loosen up your shooting techniques. Choose an object at least as large as a car. You should be able to walk around the entire object. Now shoot a minimum of 30 images of this object. Get down low, hold your camera up high, move in close, back up, change lenses, and play with investigating this object in as many different ways possible, including shooting it at different times of the day. The purpose of this assignment is to get you moving in directions you would not normally seek out.

Work on making each image different and unique. Push yourself to really look for different views. Don't forget to change the orientation of the camera from vertical to horizontal and in between. Shoot in a way you've never shot before. Have fun and surprise yourself!

When you choose your image to upload to the Web site, think about your composition. One way of testing it is to turn your image 90 degrees and upside down, looking at it by turning it 360 degrees. If the composition works in all directions, you've got a definite winner!

To complete this assignment, I chose the Italian city of Portofino, adjacent to the French Riviera. I was overwhelmed by the sheer beauty of the little harbor and colored buildings. Although it is a large object, it is confined to a relatively small area. I walked the area first and shot from ground level looking down along the buildings and from across the harbor with boats in the foreground... your classic postcard shots. I shot with every lens I had, wide angle, telephoto, and different aspect ratios: 35mm and panorama. I made verticals and horizontals. I couldn't shoot enough. Finally, I realized I needed to get a different view and noticed an observation area up on a hill overlooking the scene. It was quite a trek to get up there. As a little fog started to come down the hills, the view from up top told a different story, one you could not get from down below.

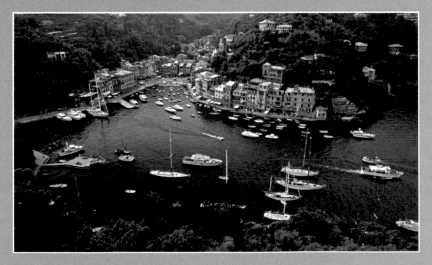

Don't forget to go to www.pwsbooks.com when you complete this assignment so you can share your best photo and see what other readers have come up with for this assignment. You can also post and read comments, encouraging suggestions, and feedback.

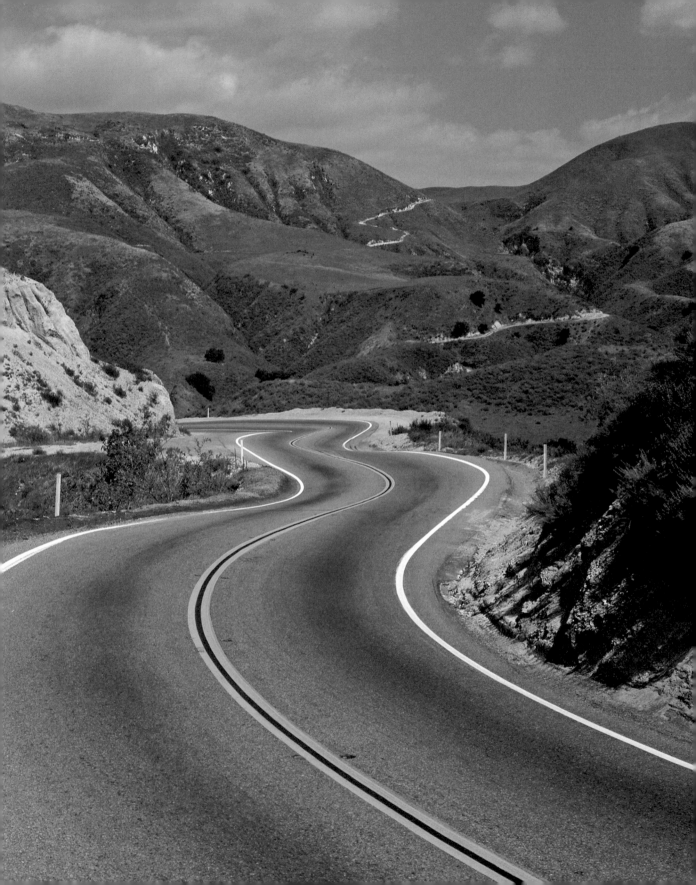

THE ELEMENTS OF DESIGN

Whether or not you've ever attempted to learn a new language, you know that in order to become fluent, you must understand both the language's grammatical structure and its vocabulary. Becoming a fluent photographer is no different. In order to master the language of photography, to effectively convey a thought visually, you must understand the grammar and vocabulary of the craft. The *elements of design* — points, lines, planes, and solids — represent photography's primary building blocks. They are the words of the photographic language. The ways in which the elements of design are arranged within the picture represent composition, photography's grammar. In this chapter, you learn how to arrange the elements of design in the picture for maximum impact.

tip Notice in figure 2-1 how the large expanse of wet sand acts as a mirror, providing reflections to further enhance the composition. To obtain the largest expanse of wet sand and great reflections, coordinate your shot with low tide at dusk. Check the tide tables to find out when low tide will occur.

UNDERSTANDING THE ELEMENTS OF DESIGN

Although the elements of design can yield an infinite variety of compositions, not all of those compositions prove effective. Precisely which elements you use, and how you arrange those elements, greatly affects your ability to tell the story of what is happening in front of your camera in a captivating way. A thoughtfully composed photograph communicates its message quickly, easily, effectively — and beautifully.

POINTS

The *point*, or dot, is the foundation of all information in the two-dimensional graphic world. In digital photography, each individual *pixel* on your camera's LCD screen is a point. (Short for picture element, a pixel is simply the smallest unit of an image that can be displayed.) When multiple points are exposed in concert, they form shades of gray or colors, which together form images.

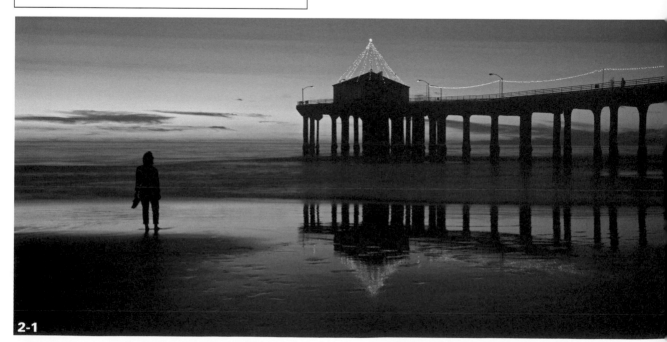

2-1

Points also represent the beginning and end of a line.

Although points often serve to define other design elements, they can also factor into a composition as design elements in their own right. For example, in the photograph shown in 2-1, the hanging lights on the pier are, in fact, points. These points both attract the eye's attention and lead it to the end of the pier, which itself represents the *terminal point* — that is, the spot at the end of a line where your vision naturally stops. When you travel, you do so from point to point, launching at a starting point and touching down at your destination; your vision also moves from dot to dot in order to travel from one area of the picture to another.

LINES

A succession of points comprises a *line*, which represents the next vital compositional ingredient. Lines lead the viewer into and around the scene, acting as signposts to direct the viewer's eye. *Leading lines* are any lines that direct the viewer towards a focal point in the picture. In addition, lines can evoke a psychological response or serve a symbolic purpose, depending on their orientation and direction. To create a successful composition, you need a basic understanding of how lines can be used to achieve a certain mood or feeling.

■ **Vertical lines.** The vertical line is like a tree: tall and balanced, solid, and firm (see 2-2). It presses against the sky, even as gravity pulls it downward. As such, the vertical line symbolizes strength, power, and stability.

■ **Horizontal lines.** Peaceful and static, the horizontal line suggests stability, permanence, and tranquility. This may explain why gazing at the horizon, at the horizontal line that occurs where the Earth meets the sky, is inherently soothing (see 2-3).

> ⓟ *note* How objects are placed relative to the horizon line greatly influences the viewer's perception of space. Generally, objects closer to the horizon line appear to the viewer to be more distant, and objects that are farther away from the horizon line appear to the viewer to be closer. The placement of the horizon line itself also affects the viewer's response. When the horizon line is low in the frame, the emphasis is on the upper portion of the image, yielding a more expansive look. In contrast, when the horizon line is high in the frame, what is below it takes on more meaning.

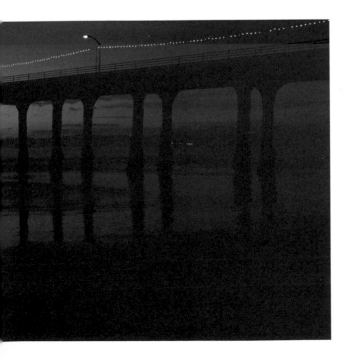

ABOUT THIS PHOTO *The points of light lead the eye to the end of the pier (105mm, ISO 64, center-weighted neutral-density filter, f/22.3 at 2 seconds).*

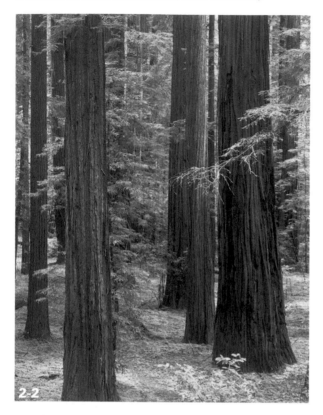

2-2

- **Diagonal lines.** Diagonal lines are active and dynamic, creating tension and bringing to mind action and motion. Because of the placement of diagonal lines, there is no doubt where the viewer will look in the photograph shown in 2-4. Diagonal lines, when receding toward a vanishing point, create a sense of perspective in a scene.

- **Zigzag lines.** Like a lightning bolt, a zigzag line starts, stops, and changes direction in a jerky fashion. Erratic, active, and imbued with tension and energy, zigzag lines evoke a sense of anxiety (see 2-5).

- **Curved lines.** Like diagonal lines, curved lines suggest motion — but slower motion. These lines are the graceful, gentle curves of a wispy branch, of a young tree's trunk, or of a reed bending in the wind. A gentle tension results from the arc in the line, with more dramatic arcs yielding more dramatic tension (see 2-6).

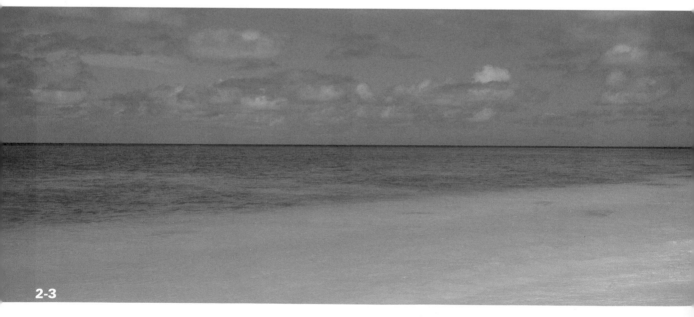

2-3

ABOUT THIS PHOTO *I used a low point of view and positioned the elevated train tracks to the left to create movement in this picture of the Chicago El (30mm, ISO 100, center-weighted neutral-density filter, f/8 at 1/125 second).*

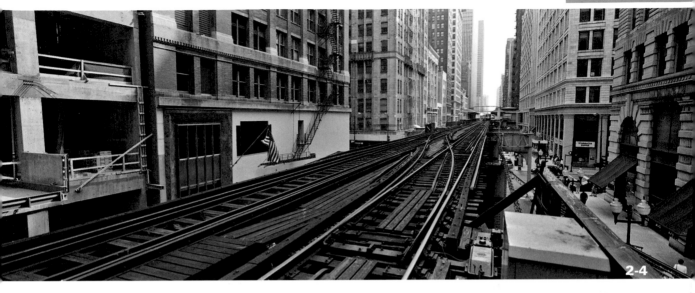

2-4

ABOUT THIS PHOTO
Zigzag lines are often man-made, typically not found in nature — although an earthquake did cause this train to derail in Northridge, California (55mm, ISO 50, f/16 at 1/60 second).

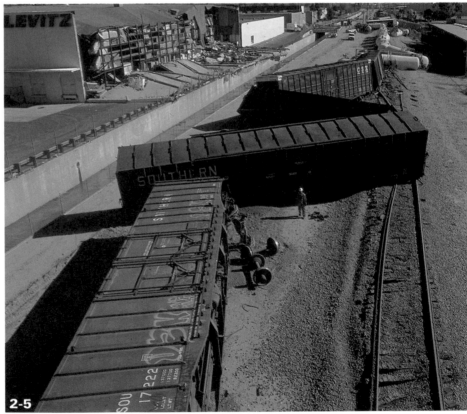

2-5

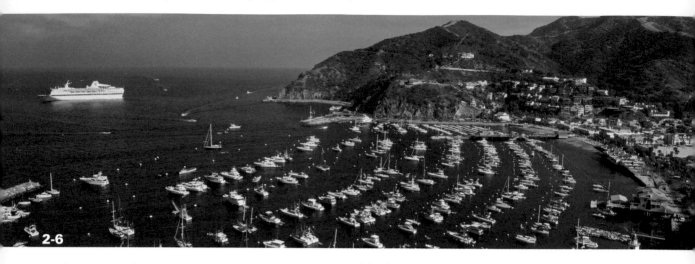

2-6

■ **S-curves.** The S-curved line shows repetitive motion that is gentle and moves with a sense of distance. An S-curve might be present in a seascape, where the surf rushes up to meet the sand. S-curves are also often found in the placid, rolling curves of a road abutting foothills or in a slow, meandering river, winding its way through a canyon (see 2-7).

The lines in your photograph can be real or imagined. The most obvious examples of real lines are, well, lines, such as the ones on the road shown in 2-8. Real lines might also result from the intersection of two planes, such as the long, linear edges of a building or the edge of a box; or they might separate two color tones in an image. In contrast, imaginary lines are the lines your brain draws when you view a photograph containing

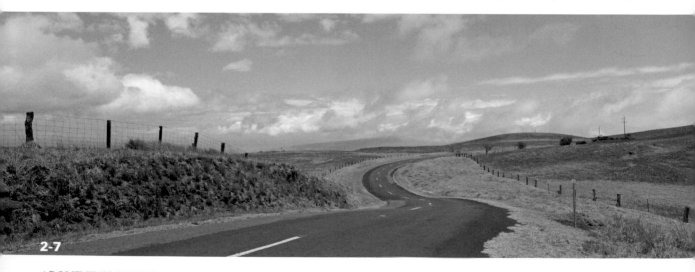

2-7

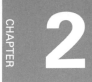

multiple points. For example, look at 2-8 and notice how your brain connects the wheelchair racers to form an imaginary line. Imaginary lines such as these operate in much the same way as actual lines, leading the viewer's eye into and around a scene.

Part of getting unusual shots is simply being at the right place at the right time and looking carefully at the environment. When I shot the photograph shown in 2-8, I was at the start of the Los Angeles Marathon and planning to shoot photos of the runners, but the wheelchair racers took off first. The graphics on the pavement coupled with the incredible energy of these racers made the shot. Given that I was shooting into a lot of shadows, I imagined this in black and white instead of color, which would have looked very muddy.

> **note** Remember that if a line continues off the edge of the picture, so, too, will the eye of your viewer. Normally, I advise against using lines to lead the viewer's eye off the edge of the photograph. Sometimes, however, you need to break the rules if your subject matter warrants it.

PLANES

A *plane* is defined by three points not in a straight line, a straight line and a point outside the line, two intersecting lines, or two parallel lines. An example of a plane, which is typically two-dimensional in nature, might be the side of a building, the top of a table, the cover of a book, or the face of a cliff. Planes in a photograph can be distinct, with clear boundaries, or can be infinite, extending beyond the picture. Like lines, planes direct your vision, guiding your eye into and around the photograph. Planes generally appear more solid as several planes will make up a solid. In addition, overlapping planes, and the way in which light falls upon them, create the illusion of depth as shown in 2-9. Planes can also be used to isolate a subject by being the background against which a subject is placed.

SOLIDS

Planes grouped together create a *solid*, which is three-dimensional in nature. An example of a solid, sometimes referred to as a shape, might be a ball, a banana, or a box. Solids can be infinite,

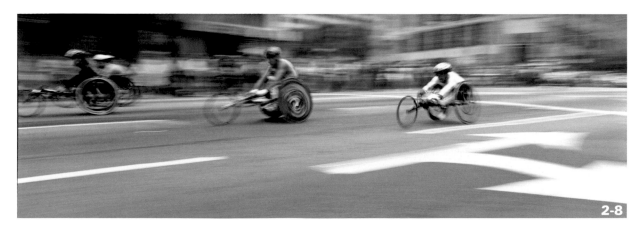

2-8

ABOUT THIS PHOTO *Even though the arrows painted on the pavement move you off the image, the power of the subject matter brings you back (105mm, ISO 400, center-weighted neutral-density filter, f/22 at 1/8 second).*

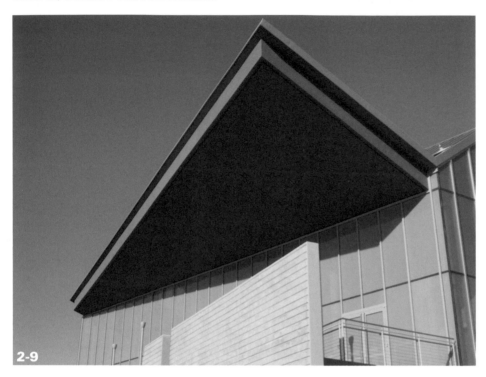

2-9

extending beyond the picture; alternatively, if the planes comprising a solid contain boundaries, the result is a solid with a recognizable form such as a sphere, cube, prism, and so on. Solids provide visual clues about size, scale, and mass of the subjects through the interplay of light and shadows on them. In addition, the texture of a solid's surface yields information about the materials that comprise the solid (see 2-10).

For the purpose of survival, humans have evolved to quickly recognize solids. Moreover, our ability to recognize certain solids improves due to cultural conditioning and our memory. In fact, you are so conditioned to recognize solids that you often don't need to see an object in its entirety to understand what it is. If it is familiar to you, your brain will fill in the rest of the shape. For example, even though the photograph in 2-11

shows only part of the motorcycle's front tire, the rest of the tire is filled in by your brain. When photographing a solid, you need not show it in its entirety for the viewer to comprehend what it is. You do, however, need to show enough of it for the viewer's brain to connect the dots.

Despite your uncanny ability to recognize solids, however, you might have more difficulty recognizing a shape in one environment than in another. For example, as shown in 2-12, a red leaf is much easier to identify than trying to pick out a brown leaf among this pile. Your eye constantly scans for differences in texture, color, and light. Your compositions will benefit if you take care to ensure that the shapes you photograph are separated from the background either by color or by texture. This helps your viewer pinpoint the photograph's message more quickly.

ABOUT THESE PHOTOS *Lighting the ball in figure 2-10 from the side both brings out its texture and creates a beautiful shadow that helps reinforce the spherical shape (150mm, ISO 50, f/64 at 1/125 second). Because you're familiar with motorcycles, your eye completes the circle representing the front tire in figure 2-11 (210mm, ISO 50, f/64 at 1/125 second). The difference in color makes your eye go right to the red leaf in figure 2-12 despite having the same texture as all the other leaves (90mm, ISO 100, f/11 at 1/250 second).*

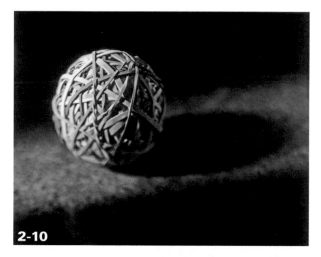

2-10

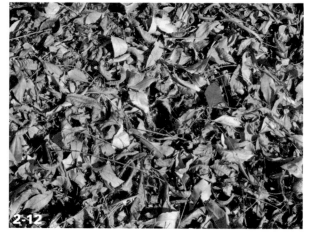

2-12

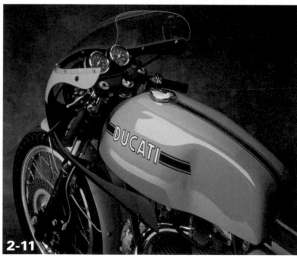

2-11

note It is worth mentioning that even if a shape does not perfectly match a preconceived form, the viewer will still interpret the shape as being that form. For example, even though the moon is not perfectly round, you assume that it is and interpret it as such when you only see a portion of it.

ARRANGING DESIGN ELEMENTS IN THE FRAME

As critical as it is to learn about the various elements of design, knowing where to place those elements within the frame is what really makes your photos exciting. Your decisions about subject placement are affected by the shape of the camera's frame and the camera's orientation. In addition, you should consider whether you want your image to involve a focal point, whether you want your image to be symmetrical or asymmetrical, and whether you want the image to be harmonious or disharmonious. Finally, the *Rule of Thirds* is one way to help you determine just where the key visual elements of your photos belong. Everything within the frame should have a reason for being there, if not, you should recompose your shot.

 Frame, also called *format*, refers to the visible area that makes up an image file. It typically comprises the view in your finder or camera's screen. Frame also refers to the shape of your pictures as determined by your digital sensor. Your frame is typically rectangular.

FRAME SHAPES

Every camera uses a specific format, or shape, to frame images. This format is typically one of three shapes: a rectangle (see 2-13), a square (see 2-14), or a panoramic rectangle (see 2-15). (A *panoramic rectangle* is one whose width is at least twice its height. A popular size is 2.25 in. by 6.75 in., for a 3:1 aspect ratio.) If the format is rectangular, it typically has either a 3:2 ratio, which is the 35mm format, or a 4:3 ratio, which mirrors the shape of a television screen.

Many digital cameras offer a choice of frame formats, enabling the photographer to easily switch from rectangular to square to panoramic. The format you choose depends on the scene in front

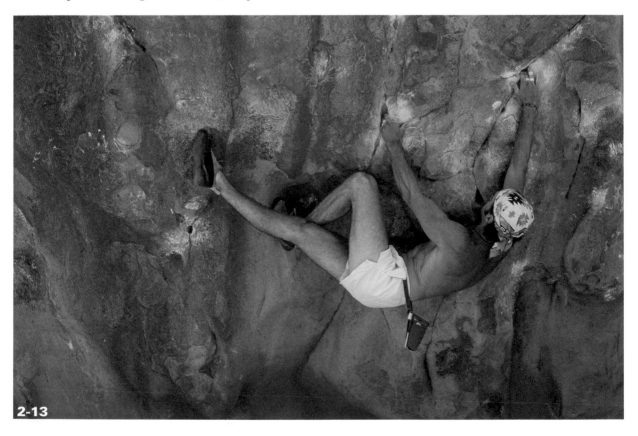

2-13

ABOUT THIS PHOTO *This photograph has a rectangular format. Shot in open shade with a 81B warming filter (85mm, ISO 100, f/8 at 1/125 second).*

ABOUT THIS PHOTO
The Racetrack in Death Valley National Monument. With a square format, it takes some conscious effort not to center each composition in the middle of the frame (150mm, ISO 100, f/16 at 1/125 second).

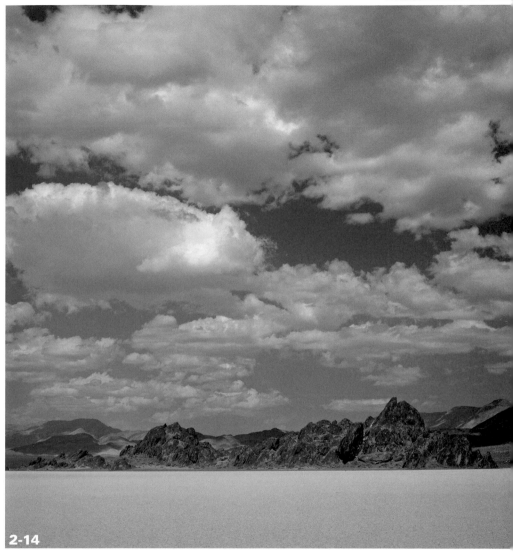

2-14

of you. If the scene is obviously long and thin, choose the panoramic format. If it reads more square, choose the square format. Otherwise, choose the rectangular format. Regardless of which format you choose, however, you should make it a practice to move your subject off center. Doing so will yield a more interesting composition.

Be aware, however, that a digital camera's chip, which is used to capture light, is a fixed shape — typically a rectangle, resulting in a rectangular frame format. When you switch the camera setting to a square or panoramic format, you don't change the shape of the chip; instead, you instruct the camera to use only a certain portion of the chip to capture light. As a result, resolution and quality is reduced.

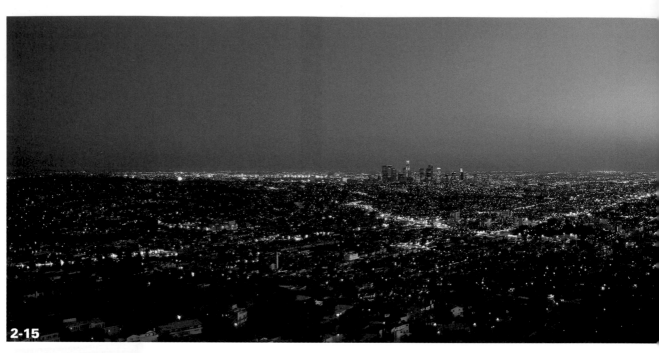

2-15

ORIENTATION

After you have established your frame shape, assuming you have a rectangular or panoramic frame, the next decision is whether to use a vertical or horizontal camera orientation. Most people's natural tendency is to hold the camera in the horizontal position because that's how camera manufacturers have designed them to fit most comfortably in your hand, but that doesn't mean you can't turn the camera sideways to shoot vertically. You can, and sometimes you should.

I once showed legendary landscape photographer Ansel Adams a photo I had taken of a seascape, which I had cropped vertically. He pointed out that because the dominant compositional elements were horizontal — namely, the horizon and waves breaking — the photograph should be oriented horizontally. He noted that when composing an image, his first step

was to determine whether the dominant element in the scene was vertical or horizontal. This should be your first step, too. To get a handle on how camera orientation affects a photograph, look at the examples in 2-16 and 2-17. Both images depict the same scene, but the results are subtly different.

Of course, some scenes can actually be shot both ways and work equally well. In fact, when covering a location, I shoot the same scene both vertically and horizontally whenever possible, just to hedge my bets.

> **ⓟ note** Some of the more sophisticated cameras have an extra shutter release button positioned on one of the short ends of the camera to make it easier to shoot vertically. (Usually, this button can be locked to prevent you from pressing the button accidentally when shooting horizontally.)

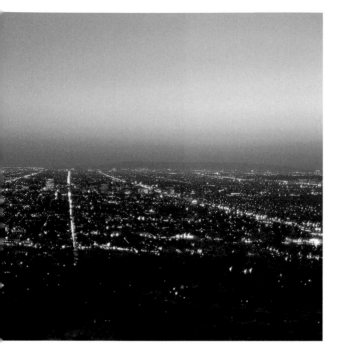

ABOUT THIS PHOTO *This is a panoramic format image of a little bit of sprawling Los Angeles at dusk. I shoot skylines right after a storm to get the clearest air. It's usually cold and windy, so bring gloves where the fingers can be uncovered quickly (105mm, ISO 50, center-weighted neutral-density filter, f/32.3 at 12 seconds).*

ABOUT THIS PHOTO
The horizontal orientation emphasizes the horizon line and the fog, which your eye is lead to by the beautiful curving coast. The unusual fog made me get out onto the edge of this cliff (24mm, 50 ISO, f/16 at 1/60 second).

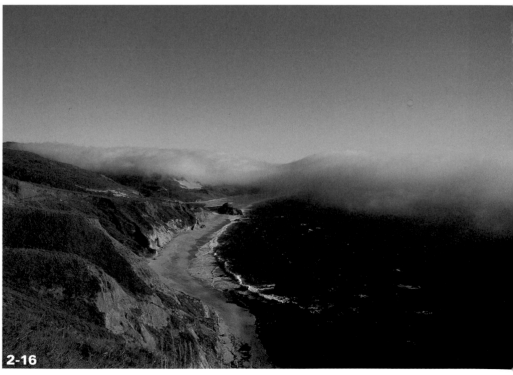

2-16

FOCAL POINT

Using a focal point, also referred to as the *center of interest*, is among the most effective ways to visually convey an idea. The *focal point* is the area of emphasis in your composition; it's the portion of the image to which the eye is naturally drawn and where the eye comes to rest. When used effectively, the focal point leaves no question as to your intentions (see 2-18).

Although a focal point can immediately convey your idea to the viewer, a focal point is not strictly required. This is true if you come upon a scene that involves a clearly visible pattern — for example, a cluster of autumn leaves, a spray of pebbles on the seashore, or, as in 2-19, a huge "brick" of compressed recycled metal and cans.

> **ⓟ x-ref** A focal point is strictly the center of interest relating to a composition. Your critical plane of focus is the area where you focused and an optical phenomenon. You learn more about this in Chapter 3.

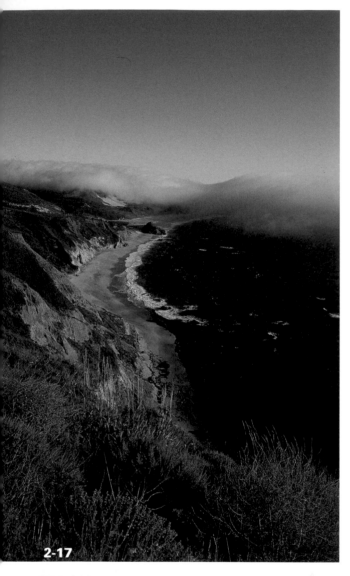

2-17

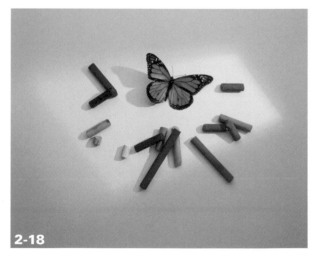

2-18

Generally speaking, if you're shooting a landscape, you want to shoot it horizontally — unless the subject of the landscape is distinctly vertical in nature. If, on the other hand, you're shooting a portrait, especially if it's of just one person, you typically want to shoot it vertically in order to better fill the frame with the subject.

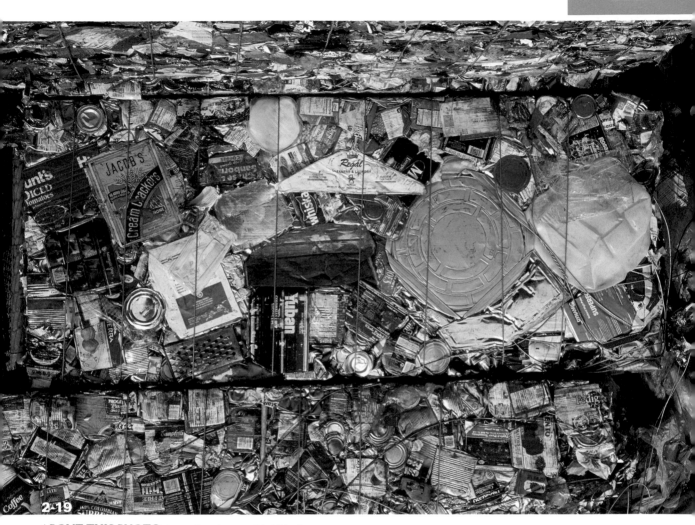

ABOUT THIS PHOTO *A recycling plant provided this all-over composition of smashed metal (24mm, ISO 100, f/11 at 1/250 second).*

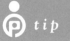 *tip*

If you have trouble determining what design elements in a scene should serve as your focal point, try holding up to the scene a frame mat with an opening that matches the shape of your camera's picture frame. If you don't have a frame mat handy, another trick is to form a frame with your fingers, the way movie directors often do. This helps you isolate your view and is especially helpful when shooting landscapes.

FINDING A PROJECT Photographers and other artists often work on a theme for extended periods of time. This allows them to fully develop an idea or concept, often leading to an exhibition or book on the subject matter. For example, in addition to my ongoing love affair with close-ups of seed pods, I am working on a series of identical twins (of which I am one). First, I shoot them symmetrically, in a straightforward way, and then in an environment that has meaning to them. Sometimes, I'll stop a project after a dozen images, but sometimes my projects go on for years. I urge you to cultivate an ongoing project of your own, choosing a theme that has special meaning to you.

SYMMETRICAL VERSUS ASYMMETRICAL

A *symmetrical* composition is one with identical forms on each side of the picture. Symmetrical photographs can employ a center of interest; alternatively, they can feature a pattern-based design, with no clear focal point. Symmetrical compositions typically work best to illustrate the inherent symmetry of a subject, such as a seedpod or even twins, as shown in 2-20 and 2-21.

Asymmetrical designs, on the other hand, do not contain mirrored forms or patterns — making them more flexible and, therefore, more commonly used. These types of designs can involve a center of interest or can appear more abstract, as shown in 2-22. Asymmetrical images can also range from very simple to quite complex. In general, asymmetrical designs are more active than symmetrical ones, providing your viewer with more interesting subject combinations at which to look.

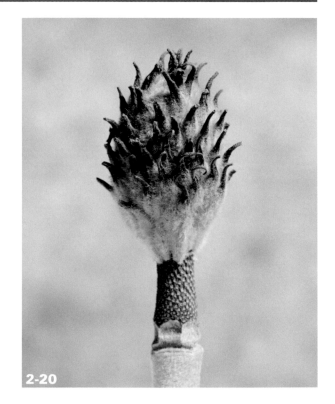

2-20

ABOUT THIS PHOTO *The texture and apparent symmetry of this seedpod caught my eye; I then went on to photograph a whole series of them (150mm, ISO 100, f/45.3 at 1/60 second).*

ABOUT THIS PHOTO
Symmetrical compositions can also be set up with people. Notice how your eye automatically scans the twins for differences (80mm, ISO 100, f/16 at 1/60 second).

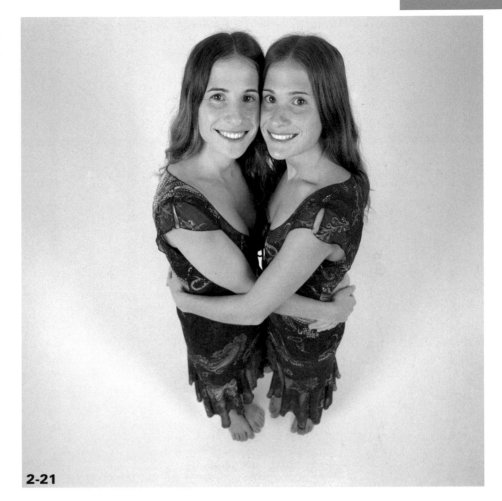

2-21

HARMONY VERSUS DISHARMONY

A harmonious composition is one in which the component parts relate to each other in an integrated and pleasing way, such as related in scale, design, color, or texture. For example, oranges and apples are related; basketballs and bananas are not. When the component parts do not relate, the composition is disharmonious;

that is, it lacks a cohesive structure. If your eye is moving chaotically all over the frame, it is not a harmonious composition. Most of the time, you will use a harmonious design, as your message is more accessible that way (see 2-23). That said, if your subject matter is chaotic, then using a chaotic composition both complements the scene and strengthens the image's message (see 2-24).

ABOUT THIS PHOTO *Although the objective was to show off the stereo wall, the red chair is a counterpoint to the plane of gray and white, making the composition asymmetrical (90mm, ISO 50, center-weighted neutral-density filter, f/45 at 1/15 second).*

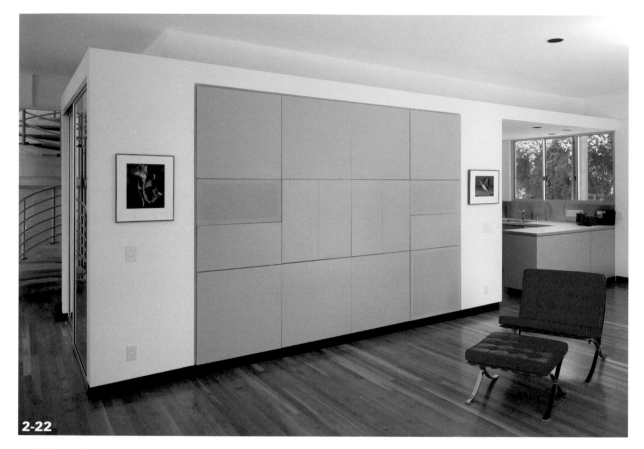

2-22

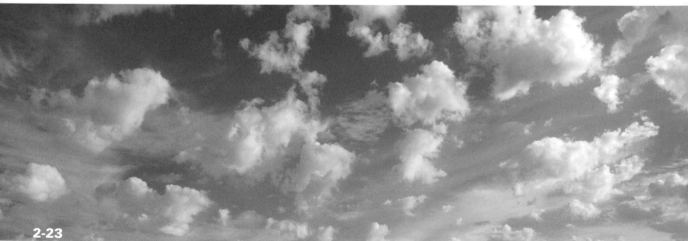

2-23

ABOUT THIS PHOTO *Route 66 sky: The cloud shapes are similar enough that they work together (105mm, ISO 50, center-weighted neutral-density filter, f/22.3 at 1/8 second).*

ABOUT THIS PHOTO *Inside of a Mexican bakery. Because your eye has no place to rest, it tires of the scene rather quickly (90mm, ISO 100, f/4 at 1/30 second).*

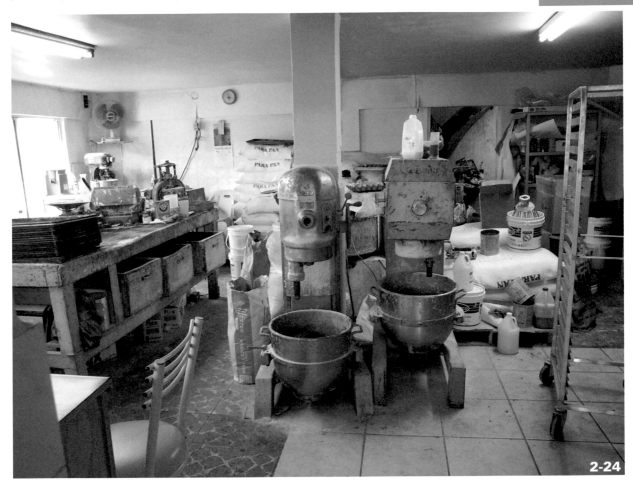

2-24

THE RULE OF THIRDS

If you're like many people, you believe that rules have no place in art — and for the most part, I'd agree with you. One rule, however, is an indispensable tool for any photographer: the *Rule of Thirds*. It dictates that a picture be divided into nine equal parts by two equally spaced horizontal lines and two equally spaced vertical lines (or, put another way, by a tic-tac-toe grid, as shown in 2-25). Then, instead of placing the key design elements in the scene in the center square, as novice photographers tend to do, you arrange them at any of the four points where the vertical and horizontal lines cross. Doing so helps to convey a sense of tension and energy and helps to pique the viewer's interest as in 2-26.

> **tip** As discussed in Chapter 1, people in Western cultures read from left to right. One compositional trick, then, is to place the focal point of your photo on one of the left cross points. This exploits a viewer's natural tendency to scan an image from left to right, enabling him to immediately hone in on your photo's area of interest.

IN THIS FIGURE *Divide the frame into nine equal parts.*

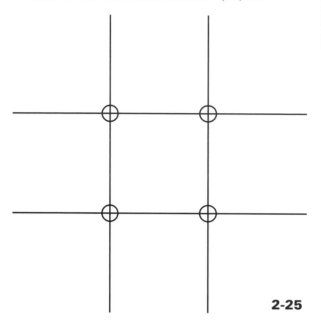

2-25

ⓟ *tip* Some digital cameras can display a grid on the LCD viewfinder, allowing you to organize your image around the lines and cross-points. You can typically enable or disable this option as you please.

In addition to using the grid's cross-points as guides when composing your image, you can also use the lines themselves; the line you choose affects which portion of the image is emphasized. For example, suppose that you're photographing a landscape. If you align the horizon in your shot with the top horizontal line, the emphasis in the image is on the subject matter below the horizon as illustrated in 2-27. In contrast, if the horizon is aligned with the bottom horizontal line, the emphasis is on the expanse above the line as demonstrated in 2-28.

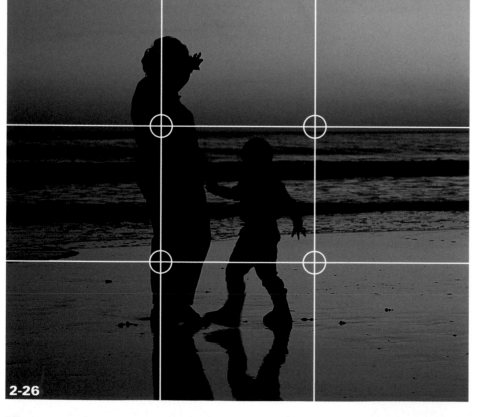

2-26

ABOUT THIS PHOTO
I placed my mother on the left, falling right on the vertical grid of the Rule of Thirds. She is the dominant element of the composition, leading you to the child, my son, Zack, ready to break free at any moment (105mm, ISO 50, f/11 at 1/60 second).

ABOUT THIS PHOTO *This freshly asphalted road's black color contrasting with the Utah red desert caught my eye. Roads are symbols for journeys, and this one filled the area below the horizon nicely (105mm, ISO 50, center-weighted neutral-density filter, f/45.5 at 1/2 second).*

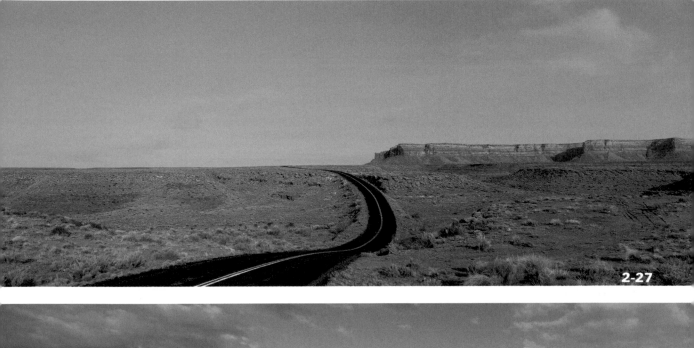

2-27

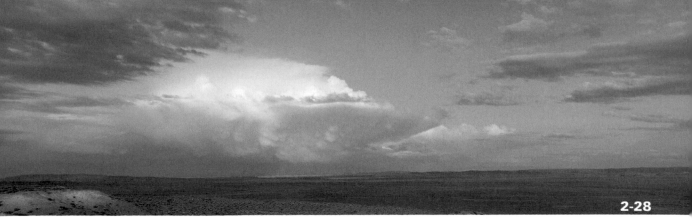

2-28

ABOUT THIS PHOTO *I used the Rule of Thirds so the large rain cloud filled the upper part of the frame above the horizon line perfectly (105mm, ISO 50, center-weighted neutral-density filter, f/22.3 at 1/15 second).*

Note that you don't have to align the points of interest in your image precisely with the lines or cross-points in the grid. If your subject matter simply won't cooperate — for example, if placing one element of design on a cross-point wildly skews the placement of another element — then getting the subject matter close enough is adequate. And, of course, you might opt to deliberately break this rule if following it won't yield the effect you're after.

THE GOLDEN RECTANGLE

What do the 35mm photography format, the Parthenon, and the *Mona Lisa* have in common? Each involves the use of *golden rectangles* (see 2-29). Believed to possess the most harmonious proportions of any rectangular shape, golden rectangles are so named because the relationship between

their long and short sides is dictated by the golden ratio. The *golden ratio* is a mathematical concept first explored by the ancient Greeks. Instances of the golden ratio, referred to by Renaissance scholars as the *Divine Proportion*, have been discovered in such diverse fields as art, architecture, music — even psychology and biology. Indeed, Leonardo Da Vinci maintained that many proportions of the human body approximate the golden ratio and involve golden rectangles, illustrating his assertion in his famous *Vitruvian Man*. Specifically, the golden ratio is 1.618:1; in the case of a golden rectangle, then, the long sides of the shape are 1.618 times larger than the short sides. One distinctive feature of the golden rectangle is that if you create a square within the rectangle, the remaining portion of the rectangle will itself be a golden rectangle.

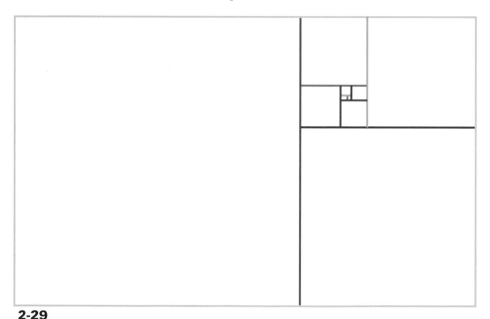

2-29

ABOUT THIS FIGURE
The golden rectangle. Creating a square within the rectangle creates another golden rectangle as illustrated here.

Assignment

Seeking the S-curve

Your assignment is to photograph an outdoor scene in which an S-curve is the dominant compositional element. It could be the water rushing up to the sand at the beach, a road, or trees along a mountain ridge. First, walk the perimeter of what you want to shoot, looking for the best angles and composition. Next, pick up your camera and shoot away. Photograph the scene in a number of different ways.

I was hired by the Santa Monica Visitors Bureau to photograph different areas of Santa Monica, mostly around the beach, and particularly the bike path that has skaters, bikers, and pedestrians meandering along its way. I shot standing along the path in a number of different spots.

Whenever possible, I like to shoot from above to show an aerial view. I figured out that I could shoot from a bluff looking down from a quarter mile away. I needed a 300mm lens, which I rented. What got me excited was when I found this view of the S-curve of the path with the palm trees, the ocean, and a big stretch of open sand! Now, I had my shot with all those elements in it. In order to get everything in, I had to compose the S-curve tight against the vertical palm trees, which counter-balanced the curve and open expanse of sand. The tight crop was to eliminate an ugly restroom and messy grassy area to the right of the palm trees.

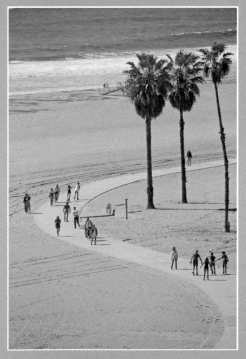

Don't forget to go to www.pwsbooks.com when you complete this assignment so you can share your best photo and see what other readers have come up with for this assignment. You can also post and read comments, encouraging suggestions, and feedback.

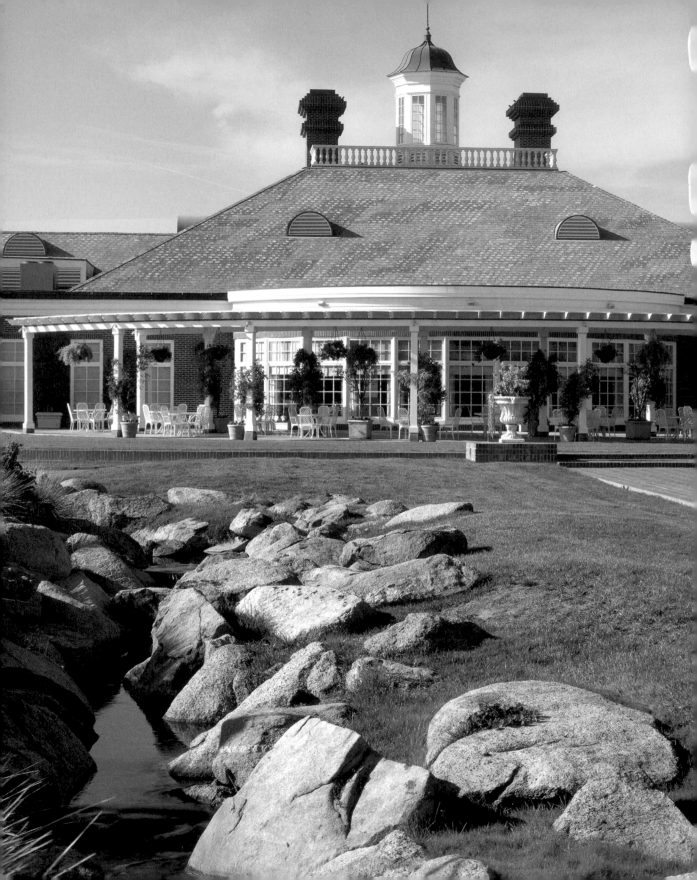

Composing a photograph is all about choices. For example, you choose the shape of your photograph — square, rectangular, or panoramic. You pick the orientation: landscape or portrait. You select various elements of design to populate your image, and you select how those elements of design should be arranged in order to effectively convey your message. Yet another choice that factors into an image's composition is *depth of field*, which is the amount of space in front of and behind the subject of your photograph that appears in focus, sometimes referred to as the *zone of focus*. In this chapter, you learn how you can control the depth of field when composing your photos.

THE PLANE OF CRITICAL FOCUS

The portion of the scene where you focus your camera's lens is called the *plane of critical focus*. It's the area that appears absolutely sharp in your photograph. Think of the plane of critical focus as being a glass pane that is parallel to your camera's digital sensor chip. Any objects in front of or behind the glass pane might appear in focus, but they won't be as tack-sharp as the objects that are on the glass pane. The farther away from the pane an object is, the less sharp it appears.

Depth of field refers to the zone of focus — or the amount of space in front of and behind the plane of critical focus that appears sharp in an image. By changing the f-stop settings on your camera that affect depth of field, you can greatly alter the outcome of your photographic shoot and where the viewer looks first.

To see an example, look at figures 3-1 and 3-2. Both photos depict the same subject, shot from the same vantage point. Compositionally speaking, however, the two images are quite different. The background in 3-1 is considerably more out-of-focus than the background in 3-2. That's because the image in 3-1 has a shallow depth of field. That is, only those areas in the scene that are immediately in front of and behind the subject, located in the plane of critical focus, are sharp. This both emphasizes the object that is in focus and creates a sense of distance between the object and what's behind it. In contrast, the image in 3-2 has a *deep* depth of field. Not only is the subject in focus, but the background is as well — which means that the image's message might be more difficult to decipher. In this case, your viewer relies more on the elements of design contained in your image to ascertain its meaning.

> *tip* In addition to using your camera's aperture or f-stop settings to tinker with an image's depth of field, you can also change your own position relative to the subject of your photograph. Experiment with moving closer to and farther away from the subject to see how your final image is affected. You should find that, camera settings being equal, the closer you get to your subject, the shallower the depth of field, and vice versa.

UNDERSTANDING APERTURE

In Chapter 1, you learned that light waves pass through the eye's pupil en route to the retina. To manage how much light enters the eye, the pupil expands or contracts. That is, in low-light conditions, the pupil expands to allow more light into the eye; when the light conditions are brighter, the pupil contracts to limit the amount of light that passes through. Similarly, light enters a camera through an opening called an *aperture*, whose size can be adjusted to allow more or less light to

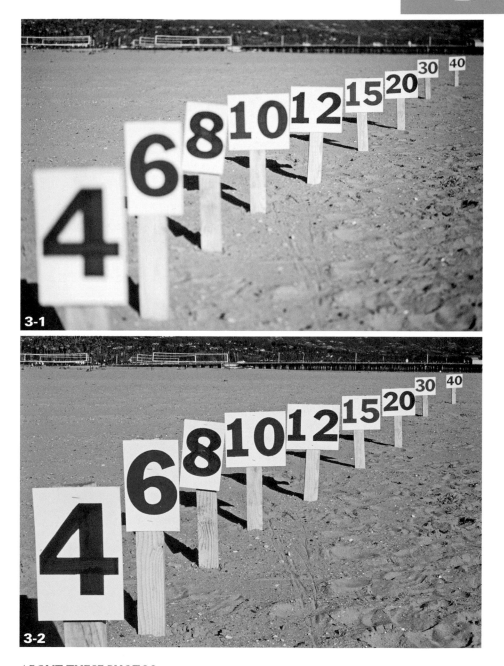

ABOUT THESE PHOTOS *Figure 3-1 has a shallow depth of field. Focus is at 12', and you can see the limited depth of field at f/2.8 (55 macro, ISO 100, f/2.8 at 1/4000 second). Figure 3-2 has a deep depth of field. This is the same setup as 3-1, with a focus at 12'. Now you see the greatly extended depth of field when shot at a much smaller aperture of f/22 (55 macro, ISO 100, f/22 at 1/60 second).*

enter. Widening the aperture, or *opening up*, allows more light to penetrate the camera and strike the digital sensor chip inside; narrowing the aperture, or *closing down*, minimizes the amount of light that passes through the aperture. In conjunction with the shutter speed, the size of the aperture, measured in *f-stops*, determines the correct exposure for a scene given the existing light conditions. ISO and your lens selection also play a role in determining the correct exposure.

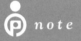 **x-ref** Learn more about how shutter speed and ISO affect exposure in Chapter 4.

note When a lens has a large aperture, it is considered *fast*. For example, an f/2 lens is considered faster than an f/4 lens. Stated another way, when a lens' largest aperture is f/4, it is said to be slower than an f/2 lens. When you use a faster lens — that is, a lens with a larger aperture — your ability to shoot in lower light conditions increases. Because faster lenses contain more glass, they also cost more money — but they're worth it.

F-STOPS

Although you might reasonably assume that using a lower f-stop setting results in a smaller aperture, the opposite is true. The lower the f-stop, the *larger* the aperture — and the more light that enters your camera. So, for example, an f-stop setting of f/2 allows more light than an f-stop setting of f/4; f/4 allows more light than f/8; and so on. This is because an f-stop measurement represents a ratio between the focal length of your camera's lens and the diameter of the aperture. For example, if you attach a 200mm lens to your camera and you set the f-stop to f/2, the diameter of the aperture becomes 100mm (200mm divided by 2).

Bumping the f-stop to f/4 reduces the diameter of the aperture to 50mm (200mm divided by 4). Using an f-stop of, say, f/22 results in an incredibly small aperture — in this case, just over 9mm. In contrast, using an f-stop of f/2, f/4, or f/22 with a 100mm lens yields an aperture with a diameter of 50mm, 25mm, and 4.5mm, respectively.

note The *f* in *f-stop* stands for *focal length*, with *stop* referring to the act of closing a hole, or aperture, by covering it, filling it in, or plugging it up. Interestingly enough, early cameras did not have adjustable apertures. To vary the amount of light that entered the lens, photographers inserted a gadget called a *Waterhouse stop* — precut pieces of wood (or, later, metal) with different-sized circles drilled out — behind the camera's lens.

ABOUT THIS PHOTO *A volcanic rock quarry off California Highway 395. The small aperture and the use of hyperfocal distance focusing maximized the zone of sharp focus (105mm, ISO 50, center-weighted neutral-density filter, f/32.5 at 1/4 second).*

3-3

CIRCLES OF CONFUSION

In addition to dictating how much light passes into the camera, the size of the aperture also determines the resulting image's depth of field. When the points of light on your subject that are in focus strike the digital sensor chip in your camera, they are smaller than the points of light on the subject that are out of focus. These points of light are called, appropriately enough, *circles of confusion*. When your camera's aperture is smaller (think f/22), these circles of confusion are likewise smaller, meaning that a larger portion of the image appears in focus — that is, the image has a deeper depth of field (see 3-3). In contrast, a larger aperture, such as f/2, results in larger, often overlapping circles of confusion, causing a blurring effect. In other words, the image's depth of field is shallow.

SELECTING LENSES

A camera's aperture setting isn't the only factor with regard to depth of field. The camera's lens (that is, the part of the camera that concentrates light and focuses the image) also comes into play. Lenses come in many varieties—some designed to shoot at close range; others designed to shoot from a distance; and still others designed to distort the scene before them.

With regard to depth of field, a lens' focal length and angle of view relate to your final image's zone of focus. In part, this relates to how far a lens' center is to the digital sensor on your camera. For example, a wide-angle lens' center is closer to the digital sensor, so its depth of field is deeper for all apertures. The opposite is true of telephoto lenses. Because the center of a telephoto lens is farther away from the sensor, the result is a shallower depth of field.

FOCAL LENGTH

A key characteristic of a lens is its *focal length*, which is a numerical value, usually in millimeters, that represents the distance between the lens' rear nodal point (the point where light that has entered the lens converges) to the camera's focal plane (the area in the camera that houses the camera's digital sensor chip) when the lens is focused at infinity.

Focal lengths can be broken into three main categories:

■ **Normal.** A normal focal length lens simulates your angle of view. That is, it sees the scene before it in much the same way as your eyes do, as shown in 3-4. Typically, normal lenses are cheaper, lighter, and faster than other lenses. Remember that a faster lens better enables you to shoot in lower light conditions without supplemental light or a tripod, because its aperture is wider. A normal lens is typically one that, when focused at infinity using the smallest aperture, projects a circle of light onto the sensor that completely covers the

sensor. (If the circle of light doesn't cover the sensor completely, the result is a darkening around the edges, also called *vignetting*.)

■ **Wide.** This type of lens, sometimes referred to as *short* because it has a shorter focal length than a normal lens, provides a wider angle of view than a normal lens. When a scene is photographed using a shorter focal length lens, more of the surrounding scene is captured than with a normal lens, but the objects present in the scene appear smaller (see 3-5). With respect to depth of field, short lenses offer incredible range; indeed, a 15mm lens at f/16 can focus from 3 inches to infinity! See 3-6 for the 15mm look of Santa Barbara Harbor. Note, too, that wide lenses also tend to distort in such a way to make the subject appear larger than it really is when close to the lens. Also, the wider the lens, the more it will cost.

3-4

3-5

ABOUT THESE PHOTOS *In figure 3-4, a normal lens approximates the angle of view of your eyes (ISO 50, f/16.5 at 1/60). In figure 3-5, a wide-angle lens includes more of your subject, in effect making everything smaller on your image. This is the same view as 3-4 (28mm PC, ISO 50, f/16.5 at 1/60).*

3-6

■ **Telephoto.** A telephoto lens, which is longer than a normal lens, provides a narrower angle of view — and shallower depth of field — than a normal lens. When a scene is photographed using a long lens, less of the surrounding scene is captured than with a normal lens, but the objects present in the scene appear larger (see 3-7). Notice the greater magnification of 3-8, when an even longer lens is used. Long lenses come in handy when you are unable or unwilling to get close to your subject (for example, if you are shooting wild animals or screaming children). A longer lens also enables you to blow out your background — meaning throw it out of focus thereby de-emphasizing it and strengthening those areas of the image that *are* in focus. Be aware, however, that the weight of a long lens might necessitate the use of a tripod to prevent the camera from shaking unless you use a shutter speed of 1/250 second or faster, and unless your camera has an image-stabilization feature, in which case you might have a bit more leeway.

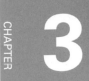

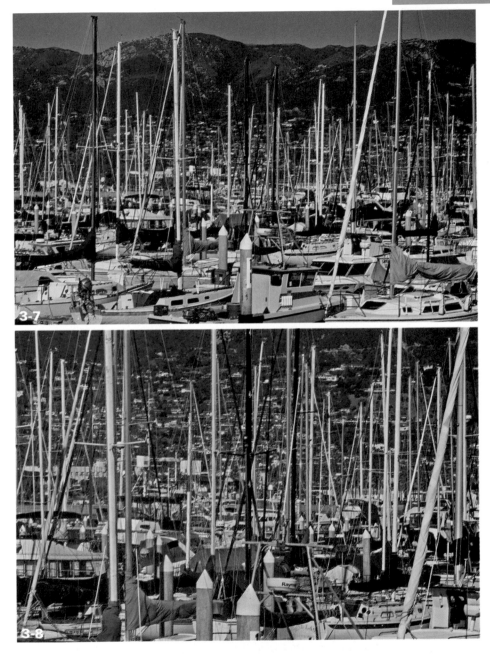

ABOUT THESE PHOTOS *Figure 3-7 was taken with a short telephoto lens. You can see everything starts to enlarge on your sensor (105mm, ISO 50, f/16.5 at 1/60 second). In figure 3-8, was taken from the same shooting spot as all the other shots in this series, but with more enlargement of the initial image and background by shooting with a longer telephoto (180mm, ISO 50, f/16.5 at 1/60 second).*

A BIT ABOUT ZOOM LENSES Zoom lenses combine multiple focal lengths in one lens; you switch from one focal length to another by moving the lens barrel. The advantage of using a zoom lens is that you can get away with carrying fewer lenses, allowing for a lighter camera bag and quicker shooting capabilities. The disadvantage of using most zoom lenses is that they are not as critically sharp as fixed focal length lenses, which can be problematic if you are shooting for a publication or if the image will be printed in a larger format (think poster or billboard).

ANGLE OF VIEW

Different types of lenses feature different angles of view. *Angle of view* refers to how much of a scene a lens can see. For example, a 50mm lens, which is considered normal for a 35mm camera, boasts a 47-degree angle of view; a 28mm lens has an angle of view of 75 degrees; and a 15mm lens has a 110-degree angle of view. In contrast, an 85mm lens has a 28-degree angle of view, while a 300mm lens offers a piddly 8-degree angle of view. Compositionally speaking, using a lens that offers a wide angle of view will results in a photograph that is very different from using a lens that offers a narrow angle of view, simply because a photograph shot with a wide-angle lens includes much more of the scene.

WHICH LENS DO I NEED?

Many photographers carry a camera bag filled with lenses, choosing which lens to use based on the shooting conditions and the scene in front of them. Other photographers stick to using one or two varieties. If you're in the process of stocking your camera bag, I suggest you add a normal lens that doubles as a macro lens; that way, you can shoot close up. Also consider adding a telephoto lens that's roughly twice the length of the normal one — say, 100mm or something close. (Eventually, you should consider doubling *that* lens as well, purchasing one in the 180-200mm range.) In the wide-angle category, add a lens that's half the focal length of the normal lens — say, 24mm or even 16mm or 14mm. Wide angles are perfect companions for shooting travel and landscapes. If you want to capture the action in sports or wildlife, telephotos work best as you can be further away from the action and literally "move in" close without changing your position Note that you can opt to buy zoom lenses to cover these ranges; two should do the trick. My suggestion on zooms: a 28-70mm covers wide to normal and a 70-200mm covers most of your telephoto needs.

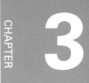

> **tip** Buy the best lenses you can afford — it *does* make a difference. Save money on a body where you don't need all the fancy functions and put that money towards a better lens.

> **note** Zoom lenses do not have a depth of field scale because a zoom lens has many possible focal lengths, and the scale differs depending on focal length.

PREVIEWING AND PREDICTING DEPTH OF FIELD

When you look through your camera's viewfinder or at its LCD screen, you see what the camera sees through an aperture that's wide open — regardless of what f-stop you've selected. That means the resulting image's depth of field might be dramatically different from that shown.

Fortunately, certain cameras include a special button that enables you to preview the resulting image's depth of field in order to determine which portions of the scene are actually in focus. If, when you engage the preview button, the viewfinder goes a bit dark, it's just because less light is finding its way to the camera's sensor. Just allow your eyes a moment to adjust to the lower light level.

If your camera doesn't have a depth of field preview button — and even if it does — chances are your lens has a depth of field scale. This scale, an example of which is shown in 3-9, enables you to estimate the zone of focus in the scene before you without actually seeing it in your camera. To use the scale (which operates a bit like a slide rule), you simply specify on the scale the aperture setting (that is, the f-stop used) and the distance between the camera and the plane of critical focus; the scale then specifies the depth of field — that is, the range of space in front of and behind the plane of critical focus that appears sharp. Alternatively, specify the focal point and the desired zone of focus on the scale to determine the necessary f-stop setting.

3-9

ABOUT THIS PHOTO *Here's an example of a depth of field scale, used to determine what's going to be in or out of focus before shooting (50mm, ISO 100, f/5.6 at 1/30 second).*

> **tip** Some photographers pre-set the focal point. For example, if the photographer knows he will always be shooting at least 8 feet from his subject, he might pre-set the focal point to 8 feet. This makes for quicker shooting — a must when you're shooting in a dark environment where low light levels make focusing difficult, or when you want to shoot in a quickly moving environment, without a moment's hesitation.

USING THE HYPERFOCAL DISTANCE TO DEEPEN DEPTH OF FIELD

Let's use the set of numbers to demonstrate how you would use the hyperfocal distance. In 3-10 the 10' sign is in sharp focus, and just about everything else is out of focus. In 3-11, the focus is at infinity or the distant pier and just about everything including the 40' sign is out of focus. To get more in focus, I stopped down to f/22, focused at 10', which brought everything from 5' to infinity in focus.

To achieve this, you must maximize your zone of focus to attain the deepest possible depth of field. You do so by aligning the plane of critical focus with the *hyperfocal distance*, which is the plane in space nearest the camera that appears sharp when the lens is focused at infinity. Shifting the plane of critical focus from infinity to the hyperfocal distance considerably expands the zone of focus, with infinity becoming the back-most plane of the zone of focus, and the front plane of the zone of focus moving closer to the camera by half. The result is an image in which both the numbers from 5 or 6 feet in the photo to the pier are in focus, as shown in 3-12.

ABOUT THIS PHOTO
I'm focused at 10' throwing everything out of focus except the 10-12' range (55mm macro, ISO 100, f/2.8 at 1/6400 second).

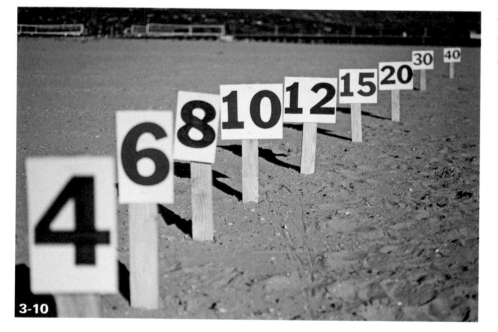

3-10

ABOUT THIS PHOTO *I'm focused at infinity throwing all but the pier in the background out of focus (55mm macro, ISO 100, f/2.8 at 1/6400 second).*

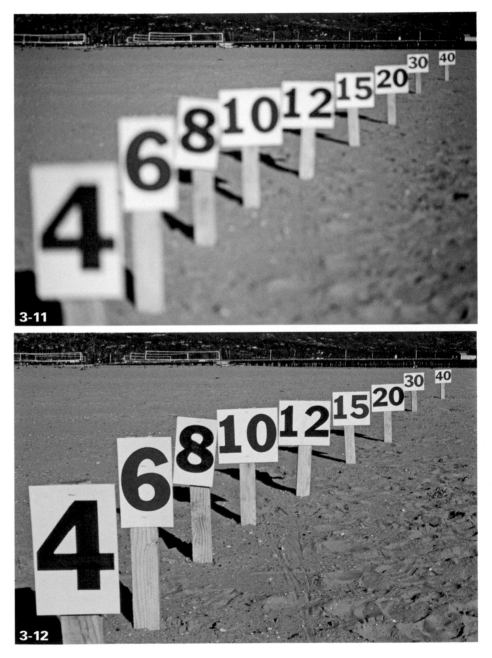

ABOUT THIS PHOTO *Using f/22 gives you depth of field to about 10 feet, but instead of focusing at infinity I moved the focus to 10 feet (the closest plane that is sharp or the hyperfocal distance), which brought the depth-of-field zone from 5' to infinity, or 5' closer than 10' (55mm macro, ISO 100, f/22 at 1/80 second).*

To determine the hyperfocal distance in the scene before you, you must use the depth of field scale discussed in the preceding section:

1. Set the focal point to infinity, usually indicated on the depth of field scale by this symbol: ∞.

2. Set the f-stop to the smallest possible setting.

3. Look at the depth of field scale; the number representing the front-most plane in the zone of focus is the hyperfocal distance.

Training yourself to focus on the hyperfocal distance rather than on the most important area of the scene before you can be difficult. After all, the area of the photograph that is most important will be less sharp than the area at the hyperfocal distance. But if you relax and trust the lens manufacturer, your shot will come out as planned.

Assignment

Creating Depth through Layers

One compositional trick is to include in your photograph something very close in the foreground, something in the middle ground, and something way off in the background. This layering forces your viewer to spend more time looking at your image and makes the composition more exciting. An excellent example of this would be a photograph with wildflowers in the foreground, trees or a rock formation in the middle ground, and a lake or mountains in the distant background.

For this assignment, I want you to shoot a scene with an object 6 feet away from you, an object 20 feet away, and an object 40 feet away or at infinity. Get all three objects in focus and make it visually interesting. You need to shoot at a small aperture, such as f/22, or use the hyperfocal distance focusing technique to sharpen all three objects.

In this photo of Christo's Umbrellas at the Tejon Ranch in Southern California, I shot using a panorama camera and ISO 50 for maximum detail and color saturation. I placed the grass about 6 feet away in the lower left corner, and the yellow umbrellas started at about 20 feet away and move to infinity at the top of the hills. Your eye moves from left to right, stops at the reflection and then moves to the trees at the edge of the pond and switches back to the upper hills on your left. I shot during early morning golden light to warm up the environment.

Look around for something with many layers where you can compose a great shot. Post your best shot and tell other readers what you like about it.

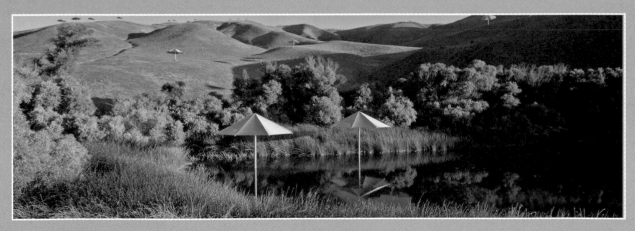

Don't forget to go to www.pwsbooks.com when you complete this assignment so you can share your best photo and see what other readers have come up with for this assignment. You can also post and read comments, encouraging suggestions, and feedback.

Photography can do more than capture time. It can make the invisible visible, exposing aspects of the world that, prior to photography, were beyond the powers of perception. Indeed, this is one of the miracles of photographs: They enable you to observe the world in ways that your eyes, on their own, cannot. Photographs have even set the stage for scientific discoveries about movement in time and space.

For example, Eadweard Muybridge — who, during the nineteenth century, captured more than 100,000 images of humans and animals moving in myriad ways — was the first to prove that when horses gallop, they have a point in their stride in which all four feet are off the ground. In fact, Muybridge's motion studies were so thorough, animators and other artists still use them as a reference. Similarly, nineteenth-century French scientist Jules-Etienne Marey was able to capture images of cats falling in order to demonstrate just how they manage to land on their feet more often than not. Beginning in the 1940s, Harold Edgerton's photographs stopped bullets in mid-air, illustrating for the first time precisely how these projectiles acted in flight (see 4-1). Edgerton, a long-time professor of electrical engineering at Massachusetts Institute of Technology, is also famous for having captured

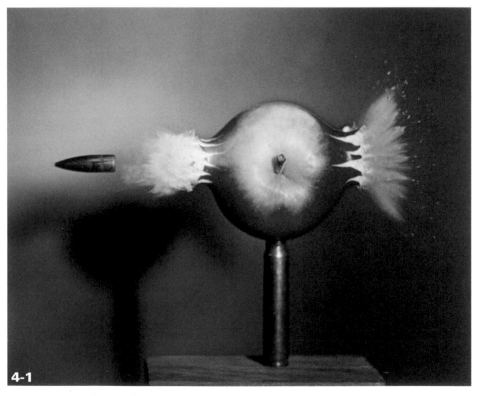

4-1

ABOUT THIS PHOTO
Harold Edgerton, the father of ultra high-speed images, stops a bullet in mid-air. Making Applesauce at MIT, 1964. 1/2 second shutter speed, flash at 1/500,000 sec. Copyright Harold & Ester Edgerton Foundation, courtesy Palm Press, Inc.

on film the fireball that expands immediately after a nuclear explosion — images that enabled scientists to ascertain, for the first time, how these fireballs (which, incidentally, were about 100 feet in diameter and three times hotter than the surface of the sun, despite taking only 1/10,000,000 second to develop) behaved.

How is it that photographs can capture such fleeting moments in time? It's thanks to *shutter speed* — that is, how long the camera's shutter remains open when you take a photograph, measured in seconds or fractions of a second. When Muybridge photographed his galloping horses, he used a shutter speed of 1/1200 second; Edgerton used a shutter speed of 1/100,000,000 to capture nuclear explosions. Although no camera on the market is as fast as Edgerton's, you

can easily obtain one that's more than six times the speed of Muybridge's; these days, small, hand-held cameras support shutter speeds as fast as 1/8000 second.

In addition to enabling you to freeze time, as shown in 4-2, your camera's shutter speed can be adjusted to enable you to capture time's passage. That is, rather than using a very fast shutter speed to stop your subject on the frame, you can use a much slower shutter speed to illustrate the movement of your subject across the frame over time, as shown in 4-3. The result is a softer, blurrier image — one that conveys an altogether different message than the crisp, clean result of shooting at high speed. In this chapter, you learn how to use shutter speed while composing your photos.

ABOUT THIS PHOTO
Figure 4-2 shows water rushing over rocks where most of the motion is frozen (28mm, ISO 100, f/2 at 1/250 second).

4-2

4-3

SHUTTER SPEED AND DEPTH OF FIELD: A DELICATE BALANCE

You might say that your camera's setup is like an ecosystem — a delicate balance of settings that results in a well-composed, correctly exposed image. One such setting in this ecosystem is the size of the aperture, which dictates how much light can penetrate the camera and strike the digital sensor chip inside. Another key setting, which works in conjunction with the aperture to determine a correct exposure given the existing light conditions, is the camera's shutter speed. A slow shutter speed, such as 1/8 second, exposes the sensor chip in your camera to light for a longer period of time than a fast shutter speed, such as 1/1000 second.

As with any ecosystem, changing one variable in your camera's setup might require the remaining settings to adapt in order to preserve the balance — that is, to achieve a correct exposure and the desired effect. For example, suppose you've determined that, given the existing lighting conditions, a camera setting with an f-stop of f/8 and a shutter speed of 1/250 second permits just the right amount of light to strike the sensor in your camera, resulting in an image that is neither underexposed nor overexposed. While composing your image, however, you decide you want a much deeper depth of field, so you bump the f-stop to f/16.

Changing the f-stop in this way does indeed allow for a deeper depth of field, but it also means that leaving your shutter speed at 1/250 results in an underexposed image. Why? Because reducing the aperture size upsets the balance of your camera's

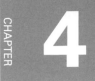

setup, allowing less light to penetrate the camera. To preserve the balance (or to ensure that the same amount of light falls on the digital sensor with the new aperture setting as with the old aperture setting, a process many photographers refer to as determining the *equivalent exposure*), you need to adjust your shutter speed — in this example, slowing it to allow light to enter the camera for a longer period of time.

EQUIVALENT EXPOSURE

The aperture and shutter-speed settings required to achieve a correct exposure differ depending on lighting conditions and on your camera's ISO settings. (You learn more about ISO settings in a moment.) As a result, the series of settings that allow for equivalent exposures differ from shoot to shoot. To give you a sense of the range of settings available to you, Table 4-1 shows a sampling of equivalent exposures. (Note that this table does not include all available f-stops; its purpose is simply to demonstrate the relationship between f-stop and shutter speed.) The table shows what

the settings should be at 100 ISO. Notice that as the aperture size decreases by 50 percent or half times, the shutter speed increases by 200 percent or 2 times, and the reverse also happens. Have your camera in front of you and see how you can change your aperture openings.

Sometimes, determining the settings necessary to achieve both a correct exposure and the desired effect can be tricky. To ensure that you get the shot you want, make it a practice to *bracket* — take multiple photographs of your subject, using slightly different settings each time. Bracketing your exposures is like buying insurance; it gives you more options in the event the correctly exposed image just doesn't look right.

Some analog cameras enable you to change f-stops and shutter speeds by turning dials on the camera body or the lens barrel. Newer electronic cameras often eliminate these dials. For these cameras, you change the settings by locating the information on your LCD readout and rotating the necessary dials or scroll through a menu to change the settings.

Table 4-1

Equivalent Exposures

Size of Aperture	f-stop	Shutter Speed	Size of Aperture	f-stop	Shutter Speed
●	f/22	1/60	●	f/5.6	1/1000
●	f/16	1/125	●	f/4	1/2000
●	f/11	1/250	○	f/2.8	1/4000
●	f/8	1/500			

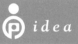

GAUGING THE AVAILABLE LIGHT

A *light meter* is a device for measuring the light that falls on a subject, is reflected by the subject, or is emitted from the subject. It works by coordinating with the "brain" of your camera, as well as the ISO, aperture, and shutter-speed settings to determine a correct exposure for the scene before you. Because your light meter reads light that either bounces off or emanates from your subject, the color, or tone, of your subject changes the reading. Any serious camera has a light meter built in; in addition to using it, you can also use a hand-held unit.

Suppose, for example, that you're shooting under a midday sun. The sun, poised above in a cloudless sky, is positioned at your back, illuminating your subject. To determine the basic daylight exposure (BDE), which gives you latitude to capture the range of contrast in the scene, you first set the ISO (say, 100) and the f-stop (for example, f/16); you the use the light meter to determine the necessary shutter speed — in this case, 1/100 or 1/125. (Alternatively, you might set the shutter speed first and adjust the f-stop to accommodate it.) To "read" the light meter, check the exposure indicator. Generally speaking, it should be at 0. If it is +1 stop or +2 stops, then the resulting image will be slightly overexposed; likewise, if it is -1 stop or -2 stops, then the resulting image will be underexposed.

The beauty of shooting digitally is that you can instantly determine whether the exposure settings you used yield the desired results. To adjust your exposure to be over or under the reading supplied by your light meter, you can use your camera's exposure compensation scale. Don't forget to check your camera's histogram (to access it, open your camera's Display menu) so the exposure is not weighted too heavily on one side or the other, yielding an underexposed or overexposed image.

FREEZE OR BLUR: HOW SHUTTER SPEED AFFECTS A SHOT

Of course, shutter speed does more than enable you to achieve a certain depth of field; it can also be used as a compositional tool in its own right, especially to depict movement. For example, using a slow shutter speed enables you to blur a moving subject, as shown in 4-4; in contrast, using a fast shutter speed can freeze a moving subject, as shown in 4-5. So if, you want to freeze your subject as it moves across the scene by increasing the shutter speed, you need to enlarge the aperture to achieve a correct exposure. Conversely, if you want your subject to appear blurry, you need to decrease the shutter speed and reduce the size of the aperture.

ABOUT THIS PHOTO *To get this shot, I was on my stomach and panned. I did not notice the intriguing shadows projected on the bushes during the first shoot, taking advantage of that on a reshoot (15mm, ISO 50, f/32 at 1/15 second).*

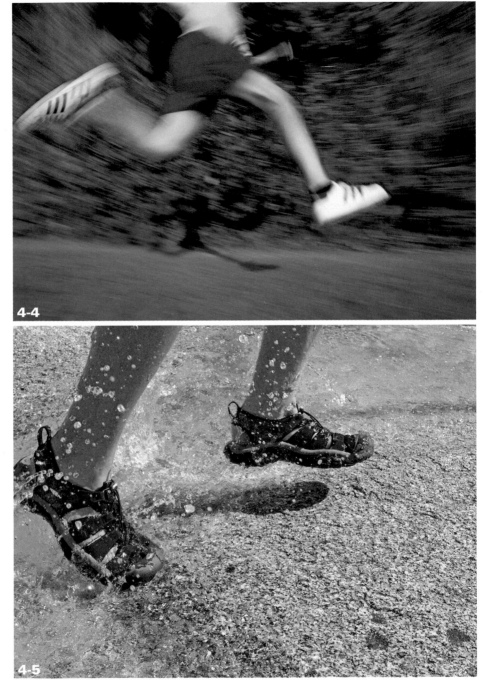

ABOUT THIS PHOTO *I initially shot this scene with a shutter speed of 1/1000 second, freezing the water drops. Switching to 1/500 second froze some drops and blurred others, creating this look (90mm, ISO 100, f/8 at 1/500 second).*

ISO

Another variable in your digital camera setup's delicate ecosystem is the ISO setting, a throwback to the film era that describes a film's speed, or its sensitivity to light. Film with an ISO setting of 50 is less light sensitive than film with an ISO setting of, say, 800; put another way, the 50 film is slow, and the 800 film is fast. ISO settings can range from the very slow 25 to the ultra fast 2500.

To mirror the effects of using film of different speeds, digital cameras include an ISO setting; changing this setting affects the sensitivity of the camera's sensor to mirror that of film. For example, if you change the ISO setting from 50 to 800, you are, in effect, configuring your chip to be as sensitive to light as 800-speed film.

Changing the ISO setting on your digital camera can have a tremendous impact on the final outcome of a photographic shoot. For example, all other things being equal, you can shoot in much lower light without a tripod to steady your camera if you use a setting of 800 rather than a setting of 50. You can also use a smaller aperture, allowing for greater depth of field. Faster shutter speeds are also possible.

Unfortunately, changing one part of your camera's ecosystem naturally throws some other part out of balance, resulting in a trade-off. Specifically, shooting with a faster ISO results in a loss in color saturation and more noise, the digital equivalent to the grain sometimes found in traditional film-based images. Grain isn't always a bad thing; in fact, you might like the way it looks. Just know that if you're seeking a shot with rich colors that's not noisy or if your image is going to be significantly enlarged, then you want to use as low an ISO setting as possible.

FREEZE FRAME

If you want to freeze your subject in action, the subject's speed largely dictates your shutter speed. For example, a car moving at 60 miles per hour might require a shutter speed of 1/500 second or faster to stop its movement. If you want to freeze drops of water dripping from a faucet, you probably need to use a shutter speed 1/1000 second or faster. In contrast, capturing a person walking toward you might require a 1/60 second shutter speed. The image shown in 4-6, part of a motor-drive sequence, was shot at 1/1000 second. (You learn more about using a motor drive a bit later in this chapter.)

SHUTTER LAG You might notice that sometimes, when you press your camera's shutter release button, a delay occurs before the photograph is actually taken — a phenomenon called *shutter lag*. Unfortunately, when you're shooting a fast-moving object, this delay can cause you to miss the shot. To avoid this, make it a habit to press the shutter release button halfway down well before you need to; then, at the instant your subject enters the frame, press it the rest of the way down. (Note that this approach is most effective when your camera's auto-focus setting is in single mode rather than continuous mode. That's because in continuous mode, the auto-focus sensor constantly updates the focus as the subject moves; in single-shot mode, the camera locks in the focus when your finger is pressed halfway down until you press the button the rest of the way down.) Alternatively, shoot using your camera's motor-drive function. Finally, ante up for a more expensive camera; pricier models are more responsive.

4-6

ABOUT THIS PHOTO *When I saw the shadow that the athlete projected on the ground, I adjusted my framing and the athlete's position to include it in my image (90mm, ISO 100, neutral-density filter, f/11 at 1/1000 second).*

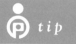
SLOWING THINGS DOWN

The fun really begins when you slow down the shutter speed; the result is an image that conveys movement and fluidity. Using a slow shutter speed can turn ordinary ocean water into misty sprays with volumes of white, foamy rivers, and can turn even the most mundane environment into a streaky, bustling scene. On running river water, particularly over rocks and rapids, the effect is mesmerizing. Even a slow-moving trickle can be made to appear larger and more voluminous.

In addition to using a slow shutter speed to photograph moving objects while you are stationary, you can use a slow shutter speed to shoot stationary objects as you (or the vehicle you're riding in) move in order to create the illusion of speed. For example, I shot the image shown in 4-7 using a slow shutter speed while hanging out of the moon roof of the car.

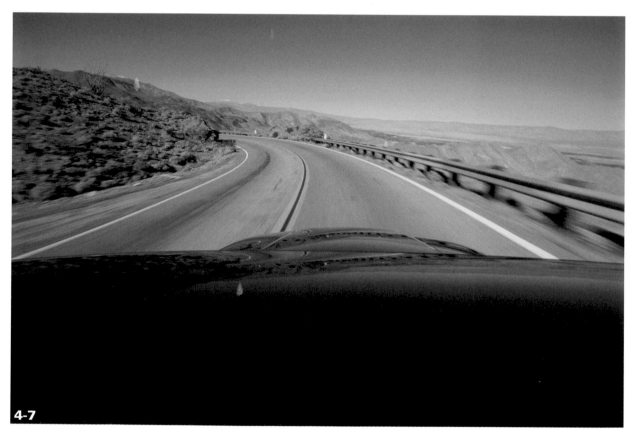

4-7

ABOUT THIS PHOTO *An ad agency bought the rights to use this image in a billboard campaign for a cell-phone company (15mm, ISO 50, f/32 at 1/15 second). Courtesy of Getty Images.*

Using a very slow shutter speed can create quite interesting results. In fact, if you can shoot at time intervals of 15 to 30 seconds, you might even see some moving objects in your scene disappear before your eyes! This happens if an object is moving too quickly to register on your camera's sensor chip. Walkways crawling with people can look empty; streets jammed with cars can appear traffic free.

Using such slow shutter speeds, however, presents some unique problems:

■ **Camera shake.** Suppose that you're photographing a moving person in relatively low light, and although you want the scene to be as sharp as possible, the low light forces you to use a slow shutter speed. The problem is, even if you drink decaf, you won't be able to prevent your camera from shaking ever so slightly as you hold it during the exposure. For this reason, you should find some way to brace the camera — by holding the camera with both hands and pressing both your elbows against your body as you shoot, holding your breath, by leaning against a wall or tree when you shoot, or, ideally, by using a tripod. (Stabilized lenses, which can help compensate for some jitter, are also available, but they are expensive.) If you do not have a cable release, with your camera on a tripod, use your self-timer to eliminate camera shake.

■ **Overexposure.** When you use a slow shutter, you might find that shooting scenes in bright light results in an overly contrasty image. Suppose that you're shooting some rocks and crevices that are partially submerged in foamy, white water. If the sun is shining brightly in the sky, you might wind up with washed-out whites and darkened shadows, resulting in a loss of image detail on both ends of the spectrum. You obtain better results by shooting under a thin cover of clouds, which diffuses the light and allows for more options with regard to equivalent exposures. If waiting out the weather isn't an option, try using neutral-density filters or your polarizer to absorb light and allow for the effective use of slower shutter speeds.

EXTENDED TIME EXPOSURES

Rather than relying on your camera to open and close the shutter for you at the speed you specify, you can open and close the shutter manually in order to obtain an *extended time exposure*, perhaps exposing your digital sensor to light for several seconds or even longer. (Note that for best results, you should use a tripod and a *cable release*, an apparatus that screws onto the camera that enables you to work the shutter remotely to avoid camera shake.) To manually open and close the shutter, set the shutter speed to B (bulb) or T (time). If you used the B setting, press the shutter release button or cable release to open the shutter; then close the shutter by pressing the shutter release button or cable release a second time. If you select the T option, simply press and hold the shutter release button or cable release; the shutter remains open until you release the button or cable release. Some cameras allow you to dial in long exposures by choosing how many seconds you want the shutter open.

MULTIPLE EXPOSURES

Similar to extended time exposures are multiple exposures, which is placing two or more extended time exposures on a single frame rather than on two separate frames. This technique is useful for creating layered effects. For example, 4-8 depicts a series of fireworks that burst one after the other rather than together. Thanks to multiple exposures, the result is a photograph of several equally intense bursts. (Note that layering works best with a dark background.)

As you create a multiple-exposure photograph, take care to avoid obscuring the image on one exposure with the images on subsequent exposures. Using the fireworks example, make an effort to judge where each burst of fireworks will explode and position your camera accordingly. I try to place the first burst in the corner and work my way around the frame from there. Mastering this technique requires time and experimentation, but it's well worth it!

USING A MOTOR DRIVE

A great way to capture motion, regardless of whether you intend for your subject to appear frozen in time or streaking across the frame, is to use a motor drive, called continuous shot mode on most digital cameras. A motor drive enables you to shoot a rapid sequence of exposures, like the ones Muybridge did, at a pre-determined rate. To use a motor drive, you simply set your shutter speed, f-stop, and number of frames per second you want to shoot — anywhere from 2 to 18 frames per second, with the most common setting being 3 to 5 frames per second — and fire away. Some cameras, in addition to enabling you to indicate

a specific number of frames per second, also allow you to simply choose Low or High, with the High setting yielding more frames per second. More advanced cameras even enable you to use the motor drive and bracket your exposures at the same time.

Using a motor drive is great for capturing images of any moving subject, be it a child going down a slide, a soccer game, or an amusement-park ride. In addition to increasing the chances that you'll capture a single amazing image, shooting with a motor drive might also enable you to hit upon a fascinating sequence like the one in figures 4-9, 4-10, and 4-11 or the one in figure 4-12.

ABOUT THIS PHOTO *This was the best of many multiple-exposure sequences, with no smoke obscuring any bursts. It helps to do this on a windless night (105mm, ISO 50, f/8 at 5 minutes).*

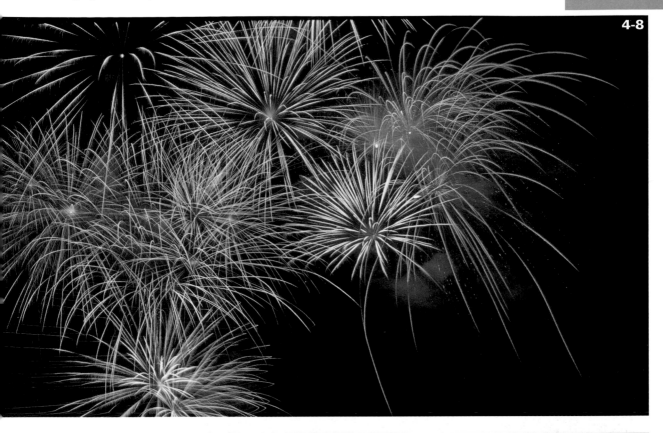

4-8

ABOUT THIS PHOTO
Notice how the height of the splashing water changes from this figure to 4-10 and 4-11 — all in less than one second (105mm, ISO 100, f/5.6 at 1/1000 second, with the motor drive set to 5 frames per second).

4-9

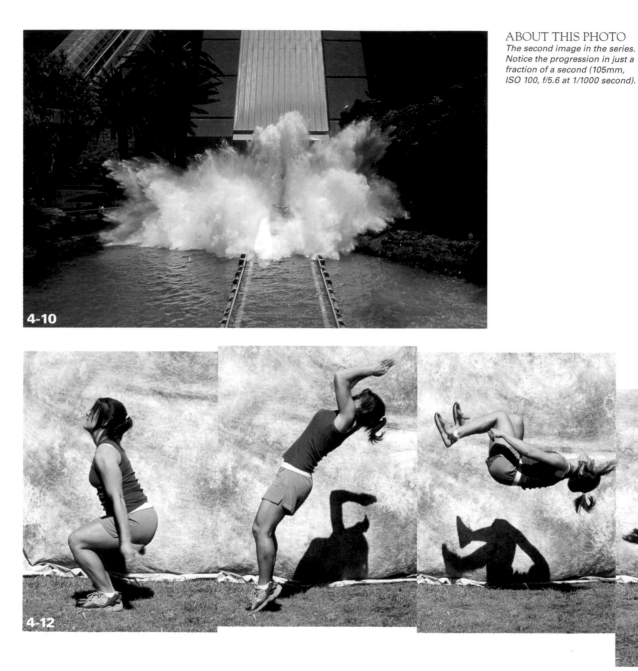

ABOUT THIS PHOTO
The second image in the series. Notice the progression in just a fraction of a second (105mm, ISO 100, f/5.6 at 1/1000 second).

4-12

ABOUT THIS PHOTO *Kelli flipping backward. I arranged this sequence so the ground lined up in each shot in order to level the images (85mm lens, ISO 100, f/5.6 at 1/1000 second, with the motor drive set to 5 frames per second).*

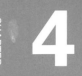

ABOUT THIS PHOTO
The spray captured at its highest less than a second after 4-9 was taken (105mm, ISO 100, f/5.6 at 1/1000 second).

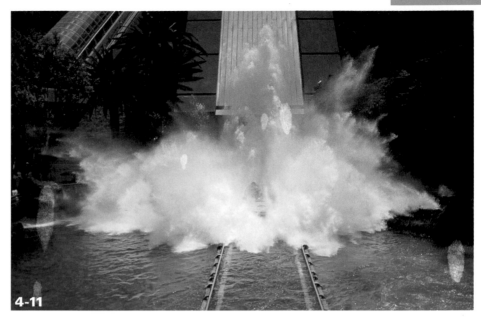

4-11

PANNING

If you really want your photograph to convey a sense of speed and movement, try *panning*, or following the motion of your subject with the camera as you press the shutter. The result is a blurred background with a sharper subject, as shown in 4-13 (this photo was later used as an ad image for a motorcycle brake company). Even if your subject is barely moving, the blurred, streaky background that often results from panning suggests speed.

tip
To determine what shutter speed you should use when panning, experiment. Because you're using a digital camera, you get immediate feedback, enabling you to adjust the settings as needed on the spot.

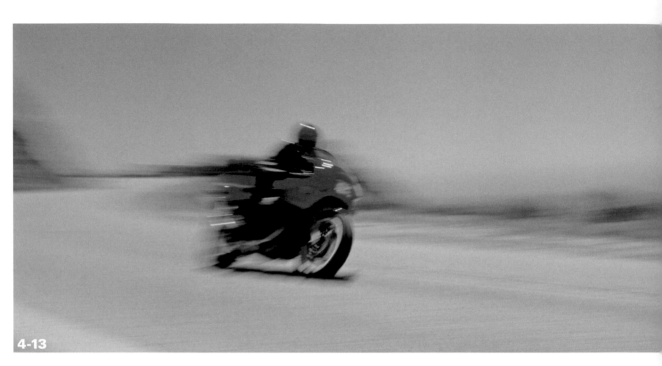

4-13

The key to panning is ensuring that the subject of the photograph is parallel to the camera's sensor. Otherwise, you wind up with an image containing a subject that is partly sharp and partly blurry, which can be confusing to the viewer. Choice of background is also very important, because it can add color to the blurry streaks that result from the pan. In fact, when shooting bikes, motorcycles, cars, and the like, professional photographers often add color to the background, knowing these colors blur to make an uninteresting background much more dynamic. For example, I chose the background of green, flowering bushes in the

image shown in 4-14 (originally shot for a car magazine) to contrast with the red car. Don't get too frustrated if your early attempts at panning don't yield the results you want; panning takes some practice.

> **tip** When panning, it might work best to move in sync with your subject. That way, you control the distance between you and your subject. Also, keeping everything in focus is a lot easier.

ABOUT THIS PHOTO *A motorcycle on the Pacific Coast Highway in Big Sur, California. I stood on an 8-foot ladder to capture more of the ocean in the distance (105mm lens, 50 ISO, center-weighted neutral-density filter, f/22.5 at 1/8 second).*

REAR CURTAIN SYNC Some advanced cameras enable you to control your flash to create an effect similar to the one you get by panning. Normally, a camera's flash pops immediately after the shutter opens. If, however, you delay the flash until the shutter is almost ready to close (a technique called *rear curtain sync*), the action that occurs in the scene before the flash is blurred due to the ambient light registering on your sensor, but the action that is occurring the instant the flash pops is frozen. The result is that a moving object appears sharp, but with a blurry trail behind it.

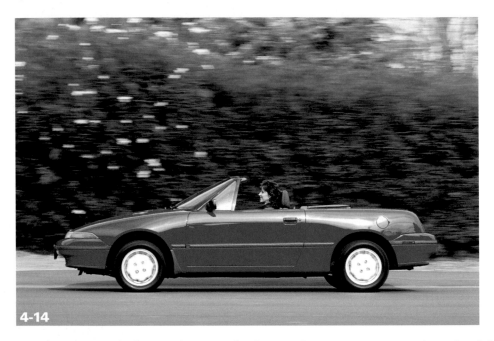

4-14

Your best bet might be to select your background first and then frame your subject in front of it. Then try to anticipate where you want your subject in the picture. Leaving more space in front of the moving object than behind it gives the picture a bit of breathing room — that is, space for your eye to complete the action. Crowding the movement on the side of the frame toward which the subject is moving results in an unbalanced feeling, as if the movement has been stopped short. Pre-focus (that is, press the shutter button halfway down) to avoid shutter lag, and work the moment to its fullest by shooting in continuous mode.

Assignment

Panning to Create Motion

Blur your image by panning — that is, moving your camera in concert with the subject. (Note that panning works best when your subject is parallel to your camera's digital sensor.) Be sure the subject you choose is colorful, as is the background. Experiment with different shutter speed/aperture combinations to get the effect you want. The scene often reveals what combination will work best: a sharp pan or a blurry one.

For example, I experimented with shutter speed and aperture combinations when shooting this Hawaiian scene, using several cameras and eventually splashing my way into 4 ft. of turquoise water with my specially prepared tripod with waterproof legs. I kept the tripod head loose enough so I could swing the camera horizontally without jerking it, which would have shown up on the final image. The windsurfer made numerous passes before I felt I got the shot. Notice how I left room in front of the windsurfer's path to give the viewer's mind space to complete the action. Taken with a 105mm lens, ISO 50, center-weighted neutral-density filter, f/16.5 at 1/15 second.

Of the many combinations of panning and stop action I took of this windsurfer, I felt this image conveyed the spirit of color and motion I wanted and felt at the time. Capture a panned image that you feel conveys the look and feel you were trying to convey and post it to the Web site.

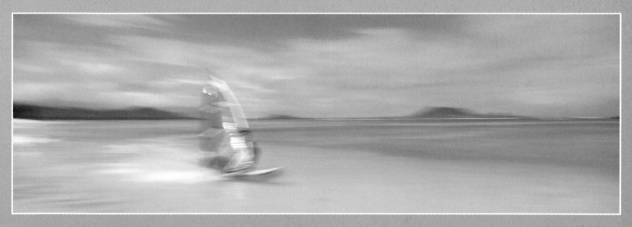

Don't forget to go to www.pwsbooks.com when you complete this assignment so you can share your best photo and see what other readers have come up with for this assignment. You can also post and read comments, encouraging suggestions, and feedback.

CAPTURING LIGHT

When composing a photograph, you do more than arrange the elements of design in the scene, determine the depth of field you want to include in your frame, and decide whether you want the subject of your photo to appear frozen or blurred. You also decide what type of light you want to capture. For example, you might choose to record the existing light (and the resulting shadows) in the scene before you as shown in 5-1; you also might decide to alter and manipulate the existing light to create an effect. A third option is to create your own light source, placing it where you want. In this chapter, you learn how the various qualities of light, combined with the direction

and intensity of the light, can be used to shape your images. But, rather than offering a treatise on the types of artificial lighting tools available to you — flashes, spots, soft boxes, and so on — this chapter discusses ambient light in more general terms.

THE QUALITY OF LIGHT

When assessing the lighting conditions for a shoot, ask yourself: What does the light feel like? Is it hard or soft? Or, put another way, is it crisp or diffuse? Both types of light — hard and soft — create their own unique effect or mood.

ABOUT THIS PHOTO *Noon sun lights up this harbor in Honfleur, France (85mm, ISO 100, f/16 at 1/125 second).*

note The advent of photography some 180 years ago knocked painters of the day off-balance, with one, Paul DeLarouche, proclaiming that "From today painting is dead!" Of course, painting did not die; it simply took a stylistic turn.

■ **Hard light.** The light that results from a point light source, such as the sun high in a cloudless sky or an electronic flash, is hard light. It's direct. Shadows in a scene with hard light have sharp, defined edges because the light rays in the scene are in near parallel formation, allowing no ambient light to bounce into the shadow zone (see 5-2). Hard light is harsh, and as such can yield a dramatic effect.

■ **Soft light.** Soft light is light that is diffuse and is the result of a reflected or broad light source. For example, when a high, thin layer of clouds covers the sky, the resulting light is soft because the light scatters as it passes through the layer of clouds, striking the subject from many angles. The edges of the shadows in a scene with soft lighting are softer, gradating from a dense center to a blurrier edge as shown in 5-3. (Note that heavy, rather than light cloud cover yields virtually shadow-less light.)

The size of your light source contributes to the hardness or softness of the light. For example, a small light source relative to the size of your subject always delivers a crisp shadow. How is it, then, that the midday sun in a cloudless sky creates hard light? Even though the sun is gigantic relative to Earth, its distance from the planet renders it a small light source. Only when a thin layer of clouds diffuses the light from the sun does it become a large source of light, creating soft shadows, as shown in 5-4.

ABOUT THESE PHOTOS *The hard light in figure 5-2 results in a crisp shadow during the late afternoon light (100mm, ISO 100, f/11 at 1/15 second). The soft light in figure 5-3 results in a more diffuse lighter shadow, and the cloud cover reduced the light by 1 stop as well as making the light cooler or bluer (10mm, ISO 100, f/11 at 1/60 second).*

5-4

ABOUT THIS PHOTO *Window in Chartres, France. I was wandering around town during rapidly changing lighting conditions and liked the way this window looked under the soft, diffused light (105mm, ISO 64, f/8 at 1/30 second).*

THE DIRECTION OF LIGHT

If you are shooting a hard-lit scene, the placement of the light source relative to your subject and the ensuing direction of the light play a significant role in your finished photograph, both influencing the length and direction of any shadows in the scene and revealing the shape, form, and texture of any objects within it as in 5-5. To determine the direction of the primary light in your scene, look at your own shadow.

■ **Back lighting.** If you've ever noticed beautiful rays of light emanating from a cloud or through a forest, you've witnessed a form of back lighting. When a subject is backlit, the light source is behind (either directly or at an angle, usually from above) the subject, pointing toward the camera. The result often is a silhouette effect, which works well for clouds, trees, even people, as shown in 5-6. Alternatively, your backlit subject might be haloed in light, as in 5-7 and 5-8. When photographing a backlit scene like the one in 5-8, you quickly notice that it is almost impossible to capture detail in the halo portion of the photo. That's because the light in the halo is so much more intense than the light falling on the front side of your subject; it is beyond the contrast range of your sensor.

> **note** Direction of light is defined by the subject's point of view, not by the photographer. For example, when a scene is backlit, it means the light source is behind the subject, pointing toward the photographer. Interestingly, the midday sun directly over, say, an old textured barn could act as a side light, revealing the barn's texture.

ABOUT THIS PHOTO
This view from atop the Empire State Building shows hard light, which, along with the resulting shadows, gives the buildings more form and shape (85mm, ISO 50, f/16 at 1/60 second).

5-5

ABOUT THIS PHOTO *To force the water to show up with detail, I exposed for the water. If I had exposed for the two figures in the foreground, the water would have been a wall of white, void of detail (90mm, ISO 100, f/5.6 at 1/250 second).*

ABOUT THIS PHOTO *Back lighting streaks through the trees, creating these rays of light off Limekiln Creek near Big Sur, California (85mm, ISO 100, f/8 at 1/30 second).*

5-6

5-7

5-8

ABOUT THIS PHOTO *These cholla plants in Joshua Tree National Monument were spectacularly backlit. They protect themselves by shooting their needles so don't get too close (105mm, ISO 50, center-weighted neutral-density filter, f/45.3 at 1/12 second).*

■ **Front lighting.** This type of lighting, typically the result of the sun being behind you or an on-camera flash, lights all subjects in the scene evenly. Although shooting a front-lit scene is preferable than shooting a scene that's mostly in shadow, most photographers prefer a more dramatic lighting. Indeed, front lighting is often referred to as flat lighting, meaning it renders everything in the scene equally such that it looks flat compared to side lighting. Front lighting also might not be the best choice, especially for outdoor shoots, because it tends to minimize detail texture (see 5-9).

If possible, try to adjust the position of either the light or the subject so that the light strikes the subject at an angle.

■ **Side lighting.** As shown in 5-10, side lighting results in long shadows, increased texture, and a better sense of depth than front lighting. Even the most ordinary of objects can be made to appear interesting with side lighting, provided they have a noticeable texture. Be aware that when using side lighting, shadows are an integral part of your composition.

5-9

5-10

ABOUT THESE PHOTOS *The beautiful adobe church in Santa Fe shown in figure 5-9 looks good lit from the front but notice how the side lighting in 5-10 reveals more of the walls' texture (105mm, ISO 50, f/16 at 1/60 second). Figure 5-10 is the same adobe church shot later in the day, when the light was skimming across the wall to accent its texture. Side lighting at its best (180mm, ISO 50, f/8 at 1/250 second).*

If you are using the sun to backlight your subject, your image might suffer from *flare*. Flare occurs when light strikes your camera's lens at an odd angle and bounces around the various lens elements, resulting in a foggy image or a series of white shapes as in 5-11. (A streak of light across the frame might also occur.) Flare often reduces contrast and softens colors — most likely not the effect you're after. To minimize flare, avoid shooting directly into the sun. Alternatively, use a lens shade, which is a black shield that attaches to the front of your lens. (Using a hat, a piece of paper,

your body, or your hand to shield the lens works in a pinch.) If you can't seem to correct the flare, and you absolutely must take the photo, go ahead and shoot; you might be able to fix it later using an image-processing program. Alternatively, you might occasionally want to use flare as a compositional element.

note | A typical lens shade is round or petal shaped; however, more expensive versions for some cameras are accordion-like bellows attachments.

5-11

86

THE INTENSITY OF LIGHT

The brightness of the light in your scene can add or detract from your image. On the one hand, your light source needs to be bright enough to register on your camera's digital sensor. Using limited or low light increases the amount of time required to capture the image, restricting your range of available f-stops; results in increased photographic noise, particularly in the shadow areas; and tends to produce overly dark images — that is, images with too much *shadow* and not much in the way of *highlights*. On the other hand, if your light source is creating a scene in which the range of highlights with details and shadows with details is beyond the range of your sensor to detect, be sure you underexpose your image so the highlights in your image — that is, the areas that are illuminated by your light source — do not appear washed out. What you're looking for is an image with a balanced ratio of shadows and highlights (see 5-12).

5-12

ABOUT THIS PHOTO *Piazza San Marco in Venice provides the perfect subject to show a variety of tones from bright white to deep black (28mm, ISO 64, f/11 at 1/125 second).*

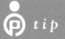
This ratio of shadows and highlights, also called *contrast,* refers to the range of brightness in an image, or the difference between the darkest and brightest parts of a scene. This ratio is measured in f-stops, as in the f-stop required to properly expose detail in the scene's highlights and the f-stop required to properly expose detail in the scene's shadows. Given proper lighting conditions, the chips on some digital cameras can support a ratio spanning eight or more stops, although the average is six stops.

If you feel that the scene before you lacks contrast, you can add lighting as needed — for example, if indoors, you can set up tungsten lights or add daylight-balanced flash (a flash with light color-balanced to match daylight at noon, for indoor or outdoor use). If shadows are too dark, add a fill flash to brighten them. If, after you add light, the highlights in the scene are too light, use a smaller f-stop or a faster shutter speed to reduce the amount of light that falls on your sensor. Hard light sources produce a higher ratio of shadows and highlights. Softer light sources produce a lower ratio of shadows and highlights.

HARNESSING SUNLIGHT

If you're shooting outdoors, your primary light source is the sun. Depending on the position of the sun in the sky, on your position, and on the atmospheric conditions, the lighting provided by the sun can yield any number of effects. Indeed, the beauty of working outdoors is this ever-changing pattern of light and its ability to reveal things you hadn't noticed before.

DAWN AND DUSK LIGHTING

Just prior to sunrise and immediately after sunset, the ambient light in the sky yields a soft-box effect — a soft, gentle, diffuse, and almost shadowless light. This light is directional, in that you know it originates in the east or the west, depending on time of day. Although this type of light is flat, it creates a beautiful glow, making it an excellent choice for creating large, soft reflections onto, say, buildings or water (see 5-13). Note that the colors of the scene are muted in dawn and dusk lighting compared to

ABOUT THIS PHOTO
The glow of the western sky reflects in the glass of the buildings of downtown Los Angeles (150mm, ISO 50, f/32 at 4 seconds).

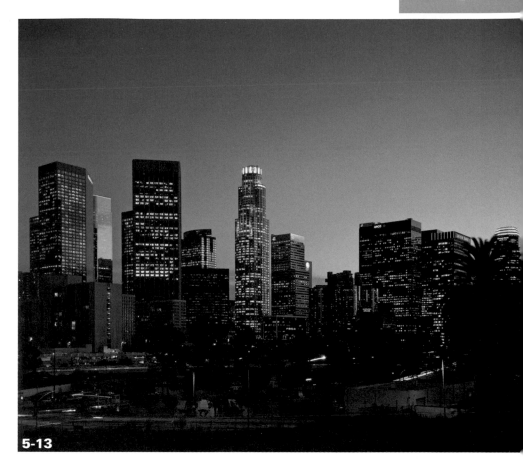

5-13

the few minutes immediately after sunrise or before sunset (see 5-14). If the scene before you is texture-rich, and if you want your photograph to convey this texture, then wait until the sun comes up to create hard directional cross-lighting.

Be aware that this type of lighting might require a longer exposure, which can result in a drop in contrast and shifts in color. For example, the resulting photograph might include purple or magenta skies when neither color was present in reality. This is due in part to the rapidly changing color temperature of your scene. Although the results might be unexpected, they can be dramatic; indeed, you might be able to use these effects to your advantage when shooting. Besides, the

beauty of digital photography is that you can adjust the colors in your image later to restore them to how you remember them or change them to what you want them to be.

> **ⓟ x-ref** You learn more about tweaking color in your image in Chapter 11.

> **ⓟ note** The slower shutter speeds required during this time of day can also leave the moon looking like an oblong blur in your frame. That's because, due to the speed at which Earth travels, a shutter speed of 1/60 or faster is required in order to capture the moon without blurring.

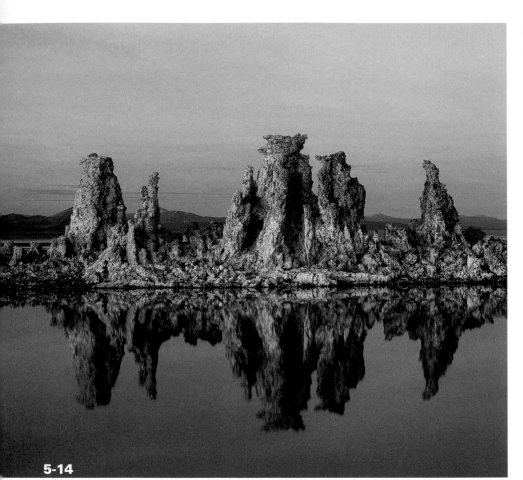

5-14

SUNRISE AND SUNSET

As the sun emerges over the horizon, the light bathes everything it strikes in a flattering golden glow (see 5-15), which is why photographers refer to this period of the day as the *golden hour* and refer to this type of light as *magic light* and why

painters have celebrated this type of light for centuries. Due to the sun's low position in the sky, it acts as a side light, creating long shadows, ideal for landscapes and for subjects with texture.

MIDDAY SUN

During the period of time spanning two hours after sunrise and two hours before sunset, the sun is overhead, resulting in downward shadows and in less-brilliant colors than during the golden-hour period (see 5-16). Hard and contrasty, midday sunlight works best for scenes in which the resulting dark shadows do not dominate. Your best option in these lighting conditions

> **tip** Make it a point to know what time the sun is slated to rise and set in your area in order to determine optimum shooting times for the type of light you want. You can likely find this information in your local newspaper or online. While you're at it, find out the projected times for the moonrise and moonset so you won't be surprised while shooting.

ABOUT THIS PHOTO
The late afternoon golden light rakes across this scene, show-casing all the different textures (105mm, ISO 50, center-weighted neutral-density filter, f/33.5 at ¼ second).

5-15

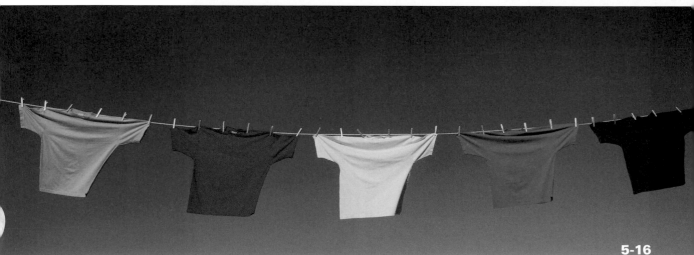

5-16

ABOUT THIS PHOTO *Midday sun can be harsh or can make a colorful scene pop out against a blue sky. It all depends on your subject matter (105mm, ISO 50, center-weighted neutral-density filter, f/22.7 at 1/8 second).*

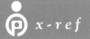 *x-ref* You need to filter appropriately when shooting in shade. If the shade is from a tree, compensate for the green cast from the leaves by using a magenta filter; if the sky is simply overcast, compensate for its blue cast using an amber 81-series filter or adjust the color balance in your camera. You learn more about filters and color balance in Chapter 6.

might be to shoot in the shade or to work in black and white. Alternatively, seek out details or grand vistas in which the shadows present don't critically alter the outcome of your shot.

OVERCAST LIGHTING

Every photographer is accustomed to shooting when the sun is bright and the sky is blue. But what about when it's foggy, raining, or overcast? You can get some great shots during these times. Indeed, a slightly overcast sky is sometimes better than one offering direct sun. Rain brings terrific reflections on wet pavement, and fog can lend your scene a moody feeling (see 5-17).

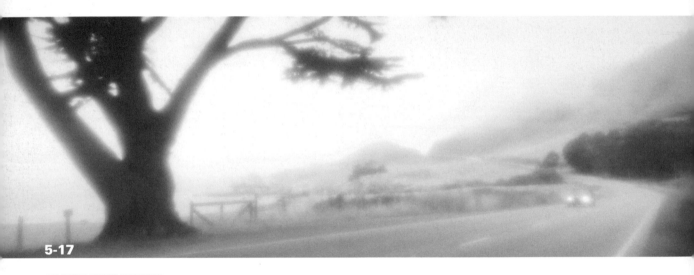

5-17

ABOUT THIS PHOTO *This foggy scene was shot for a windshield-wiper ad along Highway 1 in Big Sur, California (105mm, ISO 50, center-weighted neutral-density filter, f/22.5 at 1/8 second).*

Assignment

Late Afternoon Light with Direction

For this assignment, capture a dramatic late afternoon image in which the direction of the light and quality of the light is the principal compositional element. Rely on the quality and direction of the light to create the drama. See what you can do by waiting for just the right light. Don't be in a hurry, slow down, and observe. You might be rewarded! Post your best results to the Web site.

Before capturing the shot shown here, I had been photographing the Grand Canyon in midday light, but the colors and direction of light rendered everything flat and unexciting. Just as I began wondering how I could achieve a more interesting effect, the clouds started rolling in; as the sky grew darker, I knew my answer was coming. I just had to wait for the right moment. And so, cold, wet, and buffeted by 50 mph winds, I waited for several hours for a hole to open in the sky. To prepare, I positioned myself as needed and composed my shot; when the light finally broke through (for all of two minutes) I had just enough time to set up my camera, meter the clouds, adjust my settings (150mm, ISO 50, center-weighted neutral-density filter, f/32 at 1/4 second) and fire away — all while it was raining.

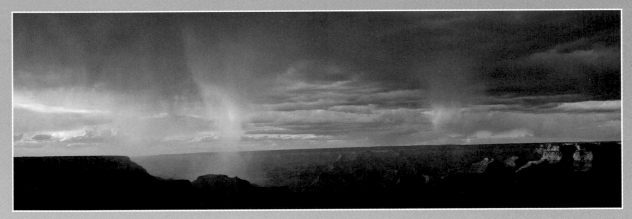

Don't forget to go to www.pwsbooks.com when you complete this assignment so you can share your best photo and see what other readers have come up with for this assignment. You can also post and read comments, encouraging suggestions, and feedback.

WORKING WITH COLOR

Colors are a critical component of the human experience. Indeed, for eons, the recognition of color — for example, the ability to use color to determine when fruits are ripe or that certain plants might be poisonous — contributed to human survival.

Early photographers interested in harnessing the power of color in their work had to simply paint colors onto black-and-white prints. Their attempts to capture color on film were hampered by the fact that the emulsions they used to capture light could not perceive red, orange, or green light. Worse, those colors that were perceived by the emulsion could not be fixed onto photographic paper. That is, the colors that the emulsion managed to capture inevitably faded when exposed to photographic paper. In time, however, reliable methods for producing color images emerged, enabling photographers to express themselves in a new, beautiful way.

Color does more than accurately record the world; it serves to enhance an image's composition. For example, some colors contain physical properties that cause them to recede in the eye of the viewer, and other colors are known to press forward in the viewer's perception. In addition, certain colors tend to evoke specific emotional responses (although these responses might vary by culture). Combining specific colors can result in harmonious compositions, and mixing others can yield discordant images. Knowing what various colors mean to your viewer and how to use this information to your advantage helps considerably in your quest to compose meaningful, moving images.

COLOR THEORY

Although historians cite Roger Bacon (1214-1294) as the first to recognize that a prism scatters colors in the visible spectrum (that is, red, orange, yellow, green, blue, indigo, and violet) when penetrated by white light, it was Sir Isaac Newton (1643-1727) who determined that those colors were inherent in the light, not added by the prism (see 6-1). These events, along with early writings by Alberti (c. 1435) and Leonardo da Vinci (c. 1490), mark the first forays into the field of color theory — that is, the study of color, of mixing color, and of the visual impact that results from the use of specific colors. See 6-2 for an example of the many colors and their impact — all of which can be achieved through the magic of light.

IN THIS FIGURE *A prism can disassemble white light, scattering colors in the visible spectrum. Were these rays to pass through another prism, they would reassemble, yielding white light.*

Prism

red
orange
yellow
green
blue
dark blue
violet

6-1

Spectrum

ABOUT THIS PHOTO
Light gives you many colors as shown in this photo of Avalon Harbor, Santa Catalina Island, California (50mm, ISO 100, f/22 at 1/60 second).

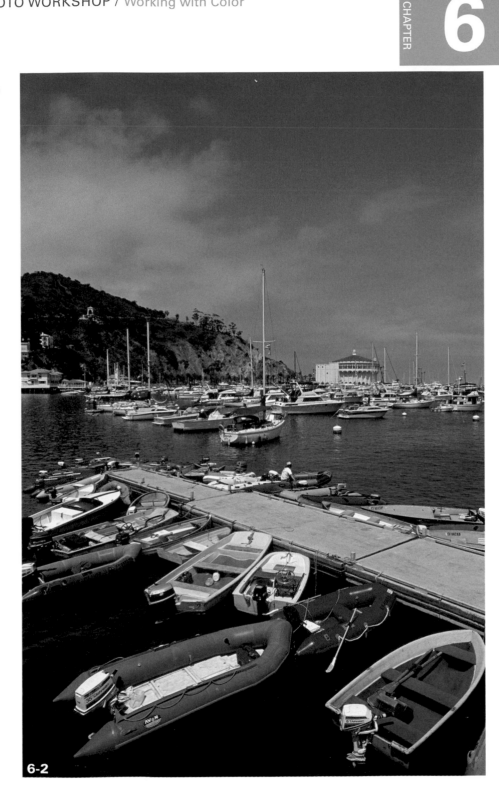

6-2

THE SCIENCE OF COLOR

Newton's writings on the topic, Opticks, used a circle to describe the relationships between various colors in the visible spectrum. In time, artists used this circle as a *color wheel,* which is a tool for understanding how paints could be mixed together to produce a wide range of colors. This color wheel categorized red, yellow, and blue as primary colors, with orange, green, and purple acting as secondary colors that could be created by mixing two primary colors. Colors opposite each other on the color wheel were considered *complementary* — when mixed, they cancel each other out to produce an achromatic (white, gray, or black) effect. Specifically, blue complements orange; red complements green; and yellow complements purple.

Although this early color system, known as RYB (Red, Yellow, and Blue), shown in 6-3, worked well to describe how pigments (that is, the coloring agents used in paints or drawing materials) behave when mixed, it did not accurately reflect how wavelengths of light acted when combined. To illustrate that, a second color system, which uses red, green, and blue as its primary colors and is referred to as the *RGB color system,* was developed (see 6-4). In this color system — which is used by, among other things, computer monitors — the secondary colors are magenta (derived from red and blue), cyan (made from green and blue), and yellow (created by mixing red and green), and mixing all the colors in the RGB system results in white. As for complementary colors, red and cyan are harmonious; green complements magenta; and yellow goes with blue.

ⓟ *x-ref* You also need a sense of color theory when you start fiddling with your photographs using an image-editing program. You learn more about editing your digital images in Chapter 11.

6-3

IN THIS FIGURE *A color wheel showing the RYB color system.*

6-4

IN THIS FIGURE *A modern color wheel, with the RGB and CMY color systems.*

ADDITIVE VERSUS SUBTRACTIVE COLOR SYSTEMS In printing, yet another color system applies: CMY, for Cyan, Magenta, and Yellow. (This color system is sometimes referred to as CYMK, with the K standing for black.) The secondary colors — red, blue, and green — in this color system reconcile somewhat the differences between the RYB and RGB systems.

One way to describe these color systems is to say the RGB and CMY systems are additive color systems, while the RYB system is a subtractive system. The RGB and CMY systems are described as additive because they generate colors by combining wavelengths of light — that is, by adding the wavelengths together. In contrast, a color in the RYB color system is derived by absorbing — or subtracting — certain wavelengths of color from the white light that illuminates it, while reflecting other color wavelengths back to the viewer.

The main colors on a color wheel in the case of the RGB system — red, orange, yellow, green, cyan, blue, violet, and magenta — are referred to as *hues*. The term brightness, sometimes referred to as value, refers to the amount of white or black that has been added to a hue. *Saturation* describes the intensity, or the degree of purity, of a hue. When a hue is pure, meaning it hasn't been mixed with its complementary color — it is said to have a saturation of 100 percent. The color that results when a hue is mixed with white is called *a tint*; in contrast, a hue mixed with black results in a *shade*. A hue mixed with gray or with its complement results *in a tone*.

So how does all this relate to composing photographs? Obtaining some understanding of how color works can help you combine and arrange the colors in your images for maximum effect.

Using complementary colors can create contrast. Indeed, when opposite hues are used, their optical properties make them appear to vibrate.

Any colors stationed in the same area of the color wheel render a harmonious, more organized color scheme, which is easier on our eyes, as shown in figure 6-5. That said, images comprised primarily of colors that are nearly the same could lead to fatigue, the result of the eye's natural tendency to search for contrast.

6-5

ABOUT THIS PHOTO *Harmonious colors, orange and red, blend well together. Notice how the blue contrasts or acts as a complementary or opposite color on the color wheel (85mm, 100 ISO, f/4 at 1/30 second).*

Certain colors — namely cooler ones, such as green, blue, and violet — recede. In contrast, other colors, such as red, orange, and yellow, pop. For example, if you compose your photograph such that it contains a brilliant red object against a green or blue background, the viewer's eye is drawn naturally to the red part of the scene, as in 6-6. In this way, color can be used to trick the viewer into perceiving a depth of field that differs from the scene as it is depicted in the photograph. (Note that this works best when you use the main colors on the color wheel, or hues, rather than colors that have been diluted with white, black, or otherwise.)

tip Look to nature for examples of harmonious arrangements of colors.

The same color looks different depending on its environment. For example, if you place gray against a red background, it looks different than it would if you place it against a blue background (see 6-7).

Looking at certain colors can result in physical after-effects. For example, after looking at a primary color situated against a white background, the eye moves from the color to the white background. It perceives the color opposite the color against the background until the cones in the eye's retina adjust.

6-6

6-7

ABOUT THIS PHOTO *Colors vibrate when their hues are pure, and they are positioned alongside a color that is complementary, or opposite on the color wheel. Here is an orange t-shirt against blue (60mm, ISO 100, f/5.6 at 1/500 second).*

ABOUT THIS PHOTO *Colors can change depending on their environment. The same orange t-shirt against a gray background takes on a different tone (60mm, ISO 100, f/5.6 at 1/500 second).*

COLOR SYMBOLISM

Have you ever noticed when you enter a room painted in a soft blue hue, you feel instantly soothed? Or why a red car just seems faster, more aggressive, than its magenta counterpart — even when it's sitting still? The fact is that people tend to associate certain colors with certain notions and emotions. Indeed, many psychological experiments have proven which colors stimulate, which colors pacify, and which colors gratify.

That said, evidence suggests that psychological reactions to a specific color differ by culture. For example, many Western cultures associate the color white with purity, but in India, the notion of purity is linked to the color red. In contrast, Chinese tend to associate the color red with celebration, luck, and prosperity, and the color white with mourning and death. Your choice of colors in your photo's composition can express a great deal.

note — In addition to having an intrinsic meaning, a color's meaning might change depending on the other colors around it. Red, already an aggressive color, takes on a particularly ominous tone when put against black. In contrast, when placed against the calming influence of blue or green, red can be mellowed.

To get a handle on color symbolism from a Westerner's perspective, read the following color descriptions.

■ **Blue.** Blue is air; it is water. Blue is present in shadows as a reflection of the sky above as in 6-8. Blue is calming, cool, enchanting, and tranquil. It is timeless, is eternal, and represents lasting values. Blue looks to the past. It brings about a sense of peace and belonging, even slowing our central nervous system. Blue also represents the expansive quality of freedom. Few people dislike blue, yet it can symbolize depression and coldness.

ABOUT THIS PHOTO
The blue of the sky darkens as it moves away from the horizon, providing a sense of freedom and escape (105mm, 50 ISO, center-weighted neutral-density filter, f/22.5 at 1/8 second).

6-8

■ **Yellow.** The brightest color, yellow is light, radiant, expansive, life-giving, and cheerful as in 6-9. It is sunlight: warm and comforting. It is relaxing. Yellow, the symbol of mental and spiritual consciousness and communication, represents wisdom and the future.

note Anytime one color is mixed to move toward another color, it adopts some of the second color's qualities and characteristics. For example, an orange with a high dose of red leans toward vitality, energy, and intensity; in contrast, an orange with a large helping of yellow radiates cheer.

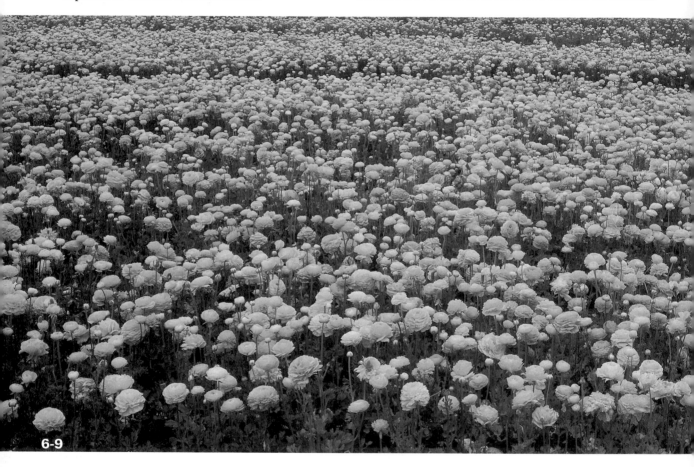

6-9

ABOUT THIS PHOTO *The famous Flower Fields off of Highway 5 in Carlsbad, California. These thousands of yellow ranunculus are a happy, joyous site (105mm, ISO 50, center-weighted neutral-density filter, f/45.5 at 1/2 second).*

■ **Red.** When a red wavelength enters the eye, it is focused behind the retina; as a result, the eye must change shape to bring it into focus. An extremely active color, red stimulates our nervous system. It advances both physiologically and psychologically. Where blue is spiritual, red is physical. It is desire: a vital life force for all our cravings. It is passion, romance, arousal, and sex. It is energy. It is warmth as in 6-10. Red is bold, driven to succeed and conquer. It is the present: alive and well, intense. Red is also aggression and rage; it is blood.

■ **Green.** A mixture of blue and yellow, green is the color of the earth, as shown in 6-11. It is grass. It symbolizes growth, fertility, birth, renewal, plants, and spring. Green is life. A color full of pride and majesty, green is relaxing, refreshing, and natural. It's calming. It's uplifting. It feels good. The hue of towering redwoods and sequoias, the tallest plants on Earth, green is impressive and persistent. Because the wavelength of green light lands directly on the retina, no eye movements are necessary to perceive and interpret it, making the color physically relaxing. Even so, green can symbolize sickness, mold, decay, and death.

ABOUT THIS PHOTO
These red ornaments attracted my attention in an outdoor shop in Mexico in July (90mm, ISO 100, f/11 at 1/125 second).

6-10

6-11

ABOUT THIS PHOTO
I never tire of looking at the lush green leaves of these aspen trees in spring. The scene is soothing and refreshing (105mm, ISO 500, center-weighted neutral-density filter, f/32.5 at 1/4 second).

■ **Orange.** A mixture of yellow and red, orange is active, radiant with energy. It is extroverted, showy and sociable and symbolizes joy. Orange is the color of fall as seen in 6-12 and present in most sunsets; orange has virtually no negative connotations. Indeed, although flames are generally orange, fire — and the dangers associated with it — is symbolized by the color red.

■ **Violet.** The result of mixing blue and red, violet's personality incorporates a bit of both, tempering the excitement of red, the conquest of red, with the tranquility and surrender of blue as demonstrated in 6-13. Used in many religions to denote piety, violet represents magic, a higher level of reality, or a longing

for this dreamlike state. Rich, luxurious, and exotic, violet is dawn and twilight — the place where day and night interchange. It is mesmerizing. Although yellow stands for consciousness, violet, its opposite, represents the unconscious and the mysterious.

note White can be added to any color to lighten it; likewise, colors can be darkened through the addition of black. Because of black's negative connotations, colors that have been darkened with black might seem more menacing than the same color lightened with white. For example, adding white to red makes it brighter, lighter, and seemingly happier; adding black to red darkens it and makes it appear more sinister.

ABOUT THIS PHOTO *When I saw the cloud cover breaking right before sunrise on this drab morning, I rushed to higher ground, where I was rewarded with this atomic sunrise (105mm, ISO 100, center-weighted neutral-density filter, f/22.5 at 1/8 second).*

6-12

6-13

ABOUT THIS PHOTO *The purple lupine contributes to a mystical mood for these ballet dancers, practicing in a burned-out forest in Yosemite National Park (105mm, ISO 64, center-weighted neutral-density filter, f/32 at 1/8 second).*

Brown. The result of mixing orange with black or blue, brown is as solid as the ground as in 6-14. It is comforting, secure, stabile, dependable, and motherly. Unlike red, which begs for attention, brown's vitality lies underneath. It is the life force of the earth, both the decay and nourishment of the plants.

Black. The absence of all color, black represents nothingness, darkness, cold, and the end of existence. It is an extreme. On the one hand, black is anxious and threatening, rebelling against life and denoting hatred and fear. On the other, it can symbolize luxury, opulence, status, and elegance.

White. The result of blending all colors of light, white is calming, restful, and clean. It's a breath of fresh air — modern, innocent, and pure. It is snow. Expansive, intense, and powerful, white is meditative. The sign of retreat, of submission, white represents the start of peace. Where black is the end, white is the beginning; where black is cold, white is hot.

Gray. The neutral ground between black and white, gray lacks emotion. It is conservative, quiet, and calming, but also dreary as in 6-15, and without life.

6-14

ABOUT THIS PHOTO
Brown makes people feel secure. These layers of brown earth strata show centuries in the building up of the ground (105mm, ISO 50, center-weighted neutral-density filter, f/22 at 1/8 second).

6-15

ABOUT THIS PHOTO *Dingy, gray, and lifeless are words to describe this former Gucci store in Beverly Hills (105mm, ISO 160, center-weighted neutral-density filter, f/22.5 at 30 seconds).*

COLOR TEMPERATURE

Visible light is often measured by its *color temperature,* gauged with the Kelvin scale. For example, at noon on a clear, cloudless day, the color temperature of daylight is 5500 Kelvin (5500K), which translates to rendering white with no other color tint. Strangely, those colors most people consider warm, such as red, orange, and yellow, in fact have a lower color temperature; likewise, colors typically considered cool, such as green, blue, purple, and most grays have a higher color temperature.

> **note** Although measurements of color temperature contradict traditional notions of warm and cool colors, designers and artists — myself included — still refer to colors with cool color temperatures as warm and vice versa. That's likely because many physical entities that are hot, such as fire, are red or orange in color, and things that are cold — think ice — appear bluish. If, as you read on, you encounter references to cool or warm colors, you can assume I'm using those words outside the context of color temperature.

By default, your camera acts as though the light in the scene before it has a measurement of 5500K; if, however, the scene before you is illuminated by light of a different temperature, this can affect how the colors in your image appear. For example, if the light in your scene has a considerably lower color temperature, shooting the scene as though the color temperature is 5500K results in an image with an amber cast. In contrast, if the color temperature of the scene is higher than 5500K, the scene appears more blue.

To compensate, you can adjust your camera's white balance setting. (This is sometimes referred to as *color balance.*) When the correct white balance setting is used, any white objects in your scene appear white in your photograph, and all other colors are adjusted accordingly, regardless of the color temperature of the light illuminating the object. In many cameras, this adjustment occurs automatically; the camera reads the dominant light source to determine the scene's average color temperature and adjusts accordingly. Other digital cameras require you to adjust the white balance setting manually by selecting the light source of your scene or, in some cases, by dialing in a specific color temperature. The effect of adjusting an image's white balance is shown in 6-16 and 6-17.

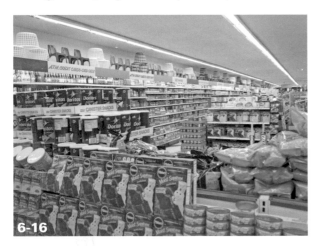

ABOUT THIS PHOTO *Daylight white balance under fluorescent lights. Notice the green filter effect of the light (90mm, ISO 100, f/11 at 1/30 second).*

ABOUT THIS PHOTO *The same image with the correct white balance and the colors look correct (90mm, ISO 100, f/11 at 1/30 second).*

 x-ref If you shoot your pictures in the RAW format, you can use certain software programs to adjust the color temperature of your image after the shot. You learn more about editing your digital images in Chapter 11.

In addition to using your camera's white balance setting to compensate for the color temperature of the scene before you, you can adjust this setting to create some interesting effects. For example, using the Tungsten setting while shooting outdoors creates the effect of shooting through a blue filter. In contrast, shooting under tungsten bulbs with the Daylight setting can add an amber or orange tint to the image.

THE COLOR OF SUNLIGHT

Just as the quality of light changes throughout the day due to the sun's position in the sky, so, too, does the sunlight's color temperature and, as a result, the color of the sky itself. For example, right after sunup, the light is very orange, measured at 3200K or less. When the sun reaches its apex, the color temperature of the light it emits is roughly 5500K (assuming the sky is void of clouds) — closer to white. At sundown, the light again measures roughly 3200K.

As a photographer, in addition to understanding the quality of light you can expect from the sun at various times of day, you also want to develop a keen sense of the color temperature of daylight as the sun arcs across the sky, as well as the color of the sky. Indeed, I never get tired of looking at how the sun colors our sky. To that end, take a moment to imagine the sun revolving around Earth, as it does each and every day:

■ In the pre-dawn hours, the sky is a deep black due to your position on Earth relative to the position of the sun, although it might be partially illuminated in spots by the moon and stars.

■ As dawn approaches, the inky sky turns a dark midnight blue — first along the horizon and then seeping into the four corners of the sky. Any visible stars slowly fade from view, their meager light overpowered by the sun's.

■ Sometimes, a burst of orange or red develops at the horizon, eventually creeping up into the dark blue. If clouds are present, they turn fluorescent pink; then, for 30 minutes or so, the sky is aflame with reds, oranges, and yellows.

■ As the sun moves upward, the sky slowly changes. A lighter blue hugs the horizon, while a darker blue blankets the light blue sky below.

■ At midday, the sun reaches its apex. The area around the sun appears much lighter in color — almost white in appearance.

■ As the position of the sun in the sky lowers, the lighting simply mirrors that produced during the sun's ascent. That is, a lighter blue begins to emerge along the horizon as shown in 6-18, followed, perhaps, by a burst of orange or red. A dark midnight blue, followed by an inky black, eventually settles across the sky.

 note Remember to place important compositional elements off-center for variety and interest. Think the rule of thirds and asymmetrical compositions.

109

As you've probably noticed, sunsets and sunrises have their own unique properties, which you must consider when composing a photograph of one of these scenes:

■ **When photographing a sunrise or sunset, you typically want to shoot directly into the sun — something you avoid under normal circumstances.** Be aware, however, that lens flare results. For this reason, in addition to shooting the sun itself, you should also make it a point to shoot the horizon immediately before the sun rises or immediately after it sets. That way, in addition to capturing the full range of light and color that occurs during these events, you obtain at least some images without lens flare.

■ **When determining how much light is present in the scene before you in order to establish the correct exposure settings, avoid metering the sun itself.** Otherwise, you end up with a radically underexposed photograph. Instead, to record an image that more closely resembles the scene before you, meter a blue area in the upper region of the sky, away from the bright spot. The result typically is an aperture setting that is larger by three to four stops than if you meter near the sun. For the image in 6-16, I metered the upper corners of the sky.

■ **When your foreground is in shadow, but the scene above the horizon is colorful and full of light, use a graduated neutral-density filter.** This helps to even out your exposure and to ensure that the resulting image looks more like the scene in reality. You learn more about graduated neutral-density filters a bit later in this chapter.

An interesting exercise to demonstrate how the color of light changes throughout the day is to photograph a subject that is pale in color and exposed to daylight for most of the day. For example, a church bell tower or a white building works well. Position yourself so your camera is pointed north or northwest and so your subject faces south. (Make sure that you have access to your shooting

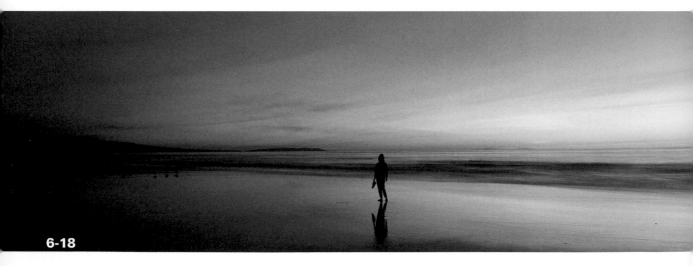

6-18

ABOUT THIS PHOTO *A typical sunset sky coloration with no clouds (105mm, 50 ISO, center-weighted neutral-density filter, f/22 at 1/8 second).*

position all day!) Then, start taking pictures 10 minutes before sunrise, at sunrise, 10 minutes after, and then every hour on the hour, 10 minutes before sunset, sunset, and 10 minutes after sunset. (Shoot on a clear day for best results.) Chances are the building you thought was white all day long appears a multitude of colors in your images, as do the dark shadows in the scene. See 6-19, 6-20, and 6-21 for an example of this.

note

Although the cycle of sunlight discussed describes the movement of the sun across the sky each and every day, its precise position in the sky relative to Earth differs depending on the time of year. For example, the sun is highest in the sky at the summer solstice, which is the longest day of the year. (For people in the Western hemisphere, this occurs around June 20 each year.) The sun is lowest in the sky on the shortest day of the year, the winter solstice (usually around December 20 each year for those in the Western hemisphere).

6-19

6-20

ABOUT THESE PHOTOS *Figure 6-19 shows the U.S. Capitol building at noon (105mm, ISO 50, f/8 at 1/250 second). Figure 6-20 show the U.S. Capitol building, one hour before sunset. Notice how the light is warming up to a yellow color (105mm, ISO 50, f/8 at 1/250 second).*

ABOUT THIS PHOTO *Here you see the U.S. Capitol building 10 minutes before sunset. The light has turned a rich golden color (105mm, ISO 50, f/8 at 1/1125 second).*

6-21

> Ⓟ *note* With improvements in image-editing software occurring almost daily, many of the filter effects discussed here can be reproduced using your computer. (I talk about some of them in Chapter 11.) Even so, knowing what these filters do is instructive.

CONTROLLING COLORS BY USING FILTERS

One way to alter the qualities of the color in your photo is to attach a *filter* to your camera's lens. A filter blocks light of certain wavelengths from penetrating the camera body. For example, you might use a filter designed to prevent blue light from entering the lens in order to warm up your shot; alternatively, you might cool down your shot by adding a filter that prevents the passage of amber light. Just how much certain wavelengths of light are blocked depends on the strength of the filter, with stronger filters offering the most blockage and color shift.

In addition to enabling you to block light of a certain wavelength, some filters, called *polarizing filters,* enable you to block light depending on direction. That is, only those rays of light that strike the filter at a prescribed angle are permitted to pass through. Other filters, called *graduated neutral-density filters,* are gradated — the bottom of the filter is clear, while the top has a tinge of gray, meant to hinder light of all colors from passing through. A graduated neutral-density filter is useful when, say, you're shooting a landscape in which the foreground is in shadow and the background is illuminated; by using the neutral-density filter, you can expose for the foreground without overexposing the background.

WRATTEN NUMBERS

Wratten filters are named after the co-founder of Wratten & Wainright, a London firm specializing in the manufacture and sale of photographic supplies that was sold to George Eastman in 1912. Although only Kodak manufactures filters under the Wratten brand, other manufacturers continue to use *Wratten numbers,* which is the system used to label filters, developed by Wratten & Wainright, to classify their filters.

One series of Wratten numbers is the 81 series (from weakest to strongest: 81, 81A, 81B, 81C,

112

 tip Depending on the strength and type of the filter you use, you might need to adjust your exposure to compensate for the amount of light the filter absorbs. To aid in this, use a light meter. Most cameras sport built-in light meters, enabling them to adjust your exposure as needed automatically.

81D, and 81EF), which is composed of amber filters that warm up an image by lowering the color temperature. You might choose to use an 81 series filter when shooting your subject to warm up the overall scene as in 6-22 and 6-23 or use its warming qualities in open shade to counteract the blue cast that results from the light in the sky or when shooting on a rainy or overcast day. On the other hand, you might want to use the blue cast to your advantage or to cool down your shot as in 6-24. Color is, after all, a matter of personal taste and of the effect or emotion you want to evoke. You can also use filters in the 82 series when the light is too warm in order to create a more natural, daylight look and raise the color temperature of your scene.

Although the filters in the 81 and 82 series, called *light-balancing filters*, enable you to fine-tune the color in your image; other filters, called *conversion filters*, allow for more radical shifts. For example, you can use the 80A, 80B, 80C, and 80D (blue) filters when shooting in tungsten light and using the daylight color balance. The photo in 6-25 shows a scene shot in tungsten light using the daylight color balance and no color filters; 6-26 shows the same scene, but with an 80A filter, which balances a 3200K tungsten light for daylight at 5500K. Alternatively, you can use the 85, 85B, and 85C (amber/orange) filters when using tungsten color balance and shooting in daylight; the 85B filter converts daylight at 5500K to tungsten light at 3200K.

ABOUT THESE PHOTOS *Figure 6-22 depicts daylight with no filter adjustment (28mm, ISO 100, f/11 at 1/250 second). Figure 6-23 shows daylight with an 81C filter. Notice how the filter warms up everything (28mm, ISO 100, f/11 at 1/250 second). Figure 6-24 is daylight with an 82C filter. This filter cools down all the colors (28mm, ISO 100, f/11 at 1/250 second).*

ABOUT THESE PHOTOS *Figure 6-25 shows daylight color balance with no filters. Note the warm/amber look of the tungsten interior lights (210mm, ISO 100, f/45 at 5 seconds). In figure 6-26, to correct for the warm tungsten interior lights, I placed an 80A filter over the lens. This renders the tungsten lights white while adding more blue to the dusk sky (210mm, ISO 100, f/45 at 20 seconds).*

Certain light sources, such as fluorescent, high-intensity discharge, and mercury vapor lights, require major color shifts. That's because the visible spectrum these light sources emit are missing certain wavelengths. If shooting under these types of lights, be aware that you might never be able to make the color in your images look normal, no matter how many color-compensating filters you use.

COLOR-COMPENSATING FILTERS

Color-compensating (CC) filters, which come in yellow (Y), magenta (M), cyan (C), red (R), green (G), and blue (B), and are sold in varying strengths (numbered, from weakest to strongest, as .025, .05, .10, .20, .40, and .50), can be used to add color to a scene by blocking the filter color's complement.

x-ref Many image-editing software programs enable you to compensate for abnormal lighting conditions using Hue and Saturation (or similarly named) settings. Alternatively, you can change the color temperature after the shot has been taken in RAW mode. For more information, see Chapter 11.

note If you use manually focused lenses, buy a linear polarizing filter. If, however, your lenses are auto focusing, then opt for a circular polarizing filter.

Smaller-density filters — that is, filters that are less strong — are useful for minor color adjustments; major changes require a strong filter. For example, using a yellow .025 filter, called CC.025Y, adds a yellowish tinge to the photo. In contrast, using a green .50 filter, called CC.50G, results in an image with very saturated greens. If you like, you can combine filters — for example, adding a CC.05B to a CC.30B to generate a CC.35B effect.

POLARIZING FILTERS

Whether you are shooting in color or black and white, the polarizing filter is a great tool. Sure, they're expensive, but they give a lot of bang for your buck. Indeed, purchase a polarizing filter before buying any other type. As mentioned earlier, polarizing filters block light by direction. That is, only those rays of light traveling in a particular direction are permitted to pass through the filter. As a result, all rays of light that are permitted to penetrate the body of the camera are parallel to each other; this reduces the glare caused by scattered light rays.

Two glass pieces comprise a polarizing filter: one that screws into your camera's lens and another that rotates around the fixed part. So say, for example, that you're pointing your camera at a landscape. As you turn the outer ring of the

polarizing filter, the entire sky, as seen through your camera's viewfinder or on its LCD screen, appears to darken or become bluer, but no other colors in the scene before you change as shown in 6-27 and 6-28. Note that for best results, the sun should be at a 90-degree angle from your subject. For example, if shooting the scene described here, you want the sun to be positioned in line with either of your shoulders. If not shot properly, only part of the sky darkens in your image, which looks strange (see 6-29).

Polarizing filters also works well when particulate matter is clogging the atmosphere; they block the reflections thrown by dust in the air. Color improves overall, with less reflection on the surface of your subject, which brings me to another key point about polarizing filters: They virtually eliminate reflections. If you don't believe me, stand at a 35-degree angle from your subject and turn the outer ring of the polarizing filter. Reflections in the scene on store-front windows, skyscrapers, and water seem to disappear. (Note that polarizing filters does not counteract reflections on metallic surfaces.)

note Be aware that polarizing filters absorb between 1.5 and 2 stops of light, which means you need to adjust your shooting speed and ISO accordingly. Be aware, too, that you can use a polarizing filter with other filters — but be careful to avoid vignetting (the cutting off of the corners of your image because the stacked filters stick out too far).

ABOUT THESE PHOTOS *Figure 6-27 shows the Santa Barbara harbor, with no filter used (85mm, ISO 50, f/16 at 1/60 second) whereas in figure 6-28, notice how the sky darkens with the use of a polarizing filter (85mm, ISO 100, f/8 at 1/125 second with polarizing filter).*

6-27

6-28

6-29

ABOUT THIS PHOTO *The sky on the left side is darker. When you use a polarizing filter, the sun must be aligned with your shoulders, not behind you as was the case here (85mm, ISO 100, f/8 at 1/125 second with polarizing filter).*

NEUTRAL-DENSITY FILTERS

Neutral-density filters are tinted filters that reduce the intensity of the light that penetrates the camera without noticeably changing the light's color. They are often tinted gray but can also be other colors such as amber (often called tobacco), enabling you to shoot a brightly lit scene with a slower shutter speed or wider aperture than would normally be required given the ISO and other settings. Using a neutral-density filter can create the effect of reducing the aperture size anywhere from .5 to 4 stops, depending on the filter's density.

Unlike neutral-density filters, *graduated neutral-density filters* are gradated; that is, the bottom of the filter is clear, and the top is tinted. Graduated neutral-density filters are ideal for exposing a dark foreground without overexposing a light background — something that often occurs when shooting landscapes in the early morning or late afternoon. Typically, using a neutral-density filter with a 1.5- or 2-stop grad evens out the scene; I usually go a bit further, employing a .6 grad (2 stops) or a .9 grad (3 stops), depending on the lighting conditions. Using a tobacco or mauve graduated neutral-density filter also helps to warm up your shot on a gray day as in 6-30.

After all, waiting around for perfect weather can be time consuming and expensive!

Graduated neutral-density filters come in hard and soft gradations. A hard grad goes from clear to the neutral density immediately, whereas, the soft grad moves to the neutral density slowly. A hard grad is best used with a horizon line that doesn't have anything else above it but sky and clouds because the line is very noticeable. Be careful to compose your photo in such a way to hide the line that separates the darker portion of the filter from the lighter area (you should be able to see the line in your camera's viewfinder or on its LCD screen; zoom in if necessary). Otherwise, the line bisects your scene. I avoid using hard graduated neutral-density filters when shooting skyline scenes for just this reason. The soft grads make the transition slowly, so the full density is near the top of the filter and there is no transition line.

Center-weighted, neutral-density filters are used with wide-angle lenses to even out falloff at the edges of an image, which can appear one to two stops darker than the image's center. For example, I use them with my panoramic cameras. These filters are usually matched to a particular lens' optics.

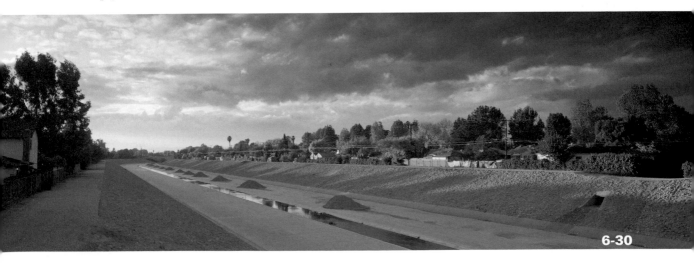

6-30

ABOUT THIS PHOTO *I used a soft mauve grad filter to account for the lighting conditions, inject drama, and warm up the gray sky in this shot (105mm, ISO 50, center-weighted, neutral-density and graduated mauve filters, f/22 at 1/2 second).*

Assignment

Bursts of Color

Look for an environment in which a natural burst of color occurs to create an image that contains a major, dominant color with minor, secondary colors also in the scene. The main element in the composition should be one color, with the second and third colors in the scene present for a second reading of the image. Post your favorite image to the Web site.

In this image, I found a beautiful field of wildflowers in California's Anza Barrego Desert. I was with a group of photography students, who were wandering all over the fields — making it difficult to find a spot in which only flowers were visible, without someone in the background. It was also windy, and the sky was a milky white color. Even so, I wanted to create a memorable image under these conditions. The field of flowers was quite large and buzzing with bees; I thought I could shoot low, up into and through the flowers. First, I shot the scene with no motion, but because I love motion, I decided to move my tripod up as I shot, creating this impressionistic image. I used a 35mm panoramic camera, 30mm, 50 ISO, center-weighted neutral-density filter, f/22 at 1/8 second.

Don't forget to go to www.pwsbooks.com when you complete this assignment so you can share your best photo and see what other readers have come up with for this assignment. You can also post and read comments, encouraging suggestions, and feedback.

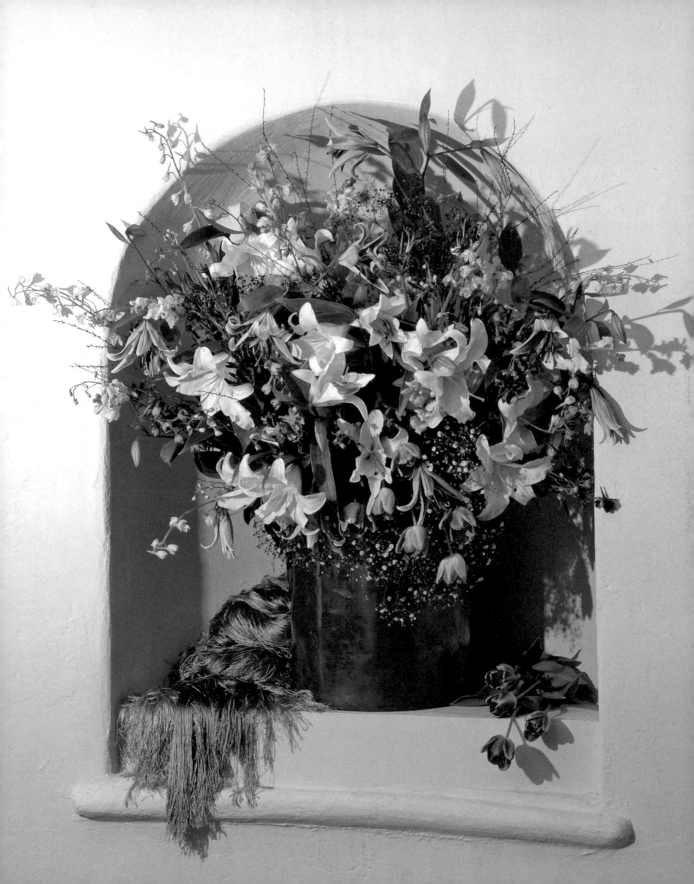

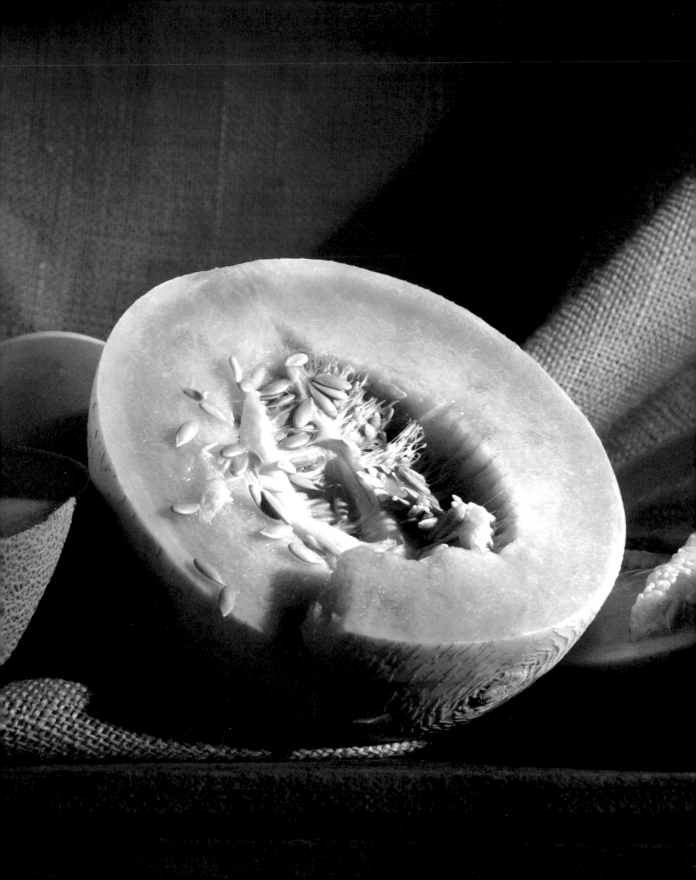

THINKING IN BLACK AND WHITE

As mesmerizing as color can be, color can overpower a photograph, muddling its meaning. If you feel that your photograph's message lies in its content or design rather than in the harmonious arrangement of color, you might decide while composing the image to shoot it in black and white; the lack of color naturally emphasizes your picture's content (see 7-1 and 7-2 to compare the same image in color and black and white).

7-1 7-2

ABOUT THESE PHOTOS *Figure 7-1 was planned as a monochromatic color image, thinking the color of the pears would pleasantly match the tones of the antique breadboards and pine table top (150mm, ISO 100, f/45 at 1/60 second). However, I decided to shoot in black and white as in figure 7-2. I like the textural components (150mm, ISO 100, f/45 at 1/60 second).*

Frequently associated with fine-art photography, black-and-white images also possess a timeless quality, hearkening back to those early photographic images that were black and white by necessity. Plus, museums and collectors alike know that black-and-white prints have more staying power. That is, if prepared and processed archivally, a black-and-white photograph outlasts a color image — although digital inkjet printer inks have progressed significantly over the last few years to increase the longevity of color prints.

Fortunately, using a digital camera enables you to easily produce black-and-white images, either by adjusting the settings on your camera to shoot in that format or by using software to convert a color digital image to black and white after the fact. In this chapter, you discover how to train your eye to see in black and white, how to meter a scene for black-and-white photography, and which filters can drastically improve your images.

THE ZONE SYSTEM

The fact is, when you shoot in black and white, the basic rules of composition remain the same (although, because black-and-white images naturally emphasize the subject of the image, your placement of that subject becomes even more important). That said, shooting in this format can be more difficult than shooting in color for one simple reason: You see in color, not in the shades of gray that comprise a black-and-white photograph. And although the fact that the human brain interprets your environment in color might well have contributed to the survival of the species, it sure makes it tricky to predict how a black-and-white picture will turn out — that is, how the various colors in the scene before you are translated to shades of gray.

note Of course, shooting digitally means you can see how your image looks right away, which means you can correct any missteps on the spot. Still, being able to predict with some accuracy how a full-color scene plays out in black and white can save you valuable time on a shoot. Note, too, that you might also be able to adjust the color on your camera's monitor to be just black and white.

If it makes you feel any better, this problem has plagued even the most venerated photographers, Ansel Adams among them. Fortunately, Adams himself, along with photographer Fred Archer, devised a clever system to help photographers envision how the full-spectrum scene before them is translated into the scale of grays that comprise a black-and-white photograph. Knowing that each color in a scene correlates to a shade of gray in a black-and-white photograph based on levels of brightness (rather than color information), Adams and Archer organized these shades of gray into 11 graduated zones (see 7-3) with each separated by one f-stop:

- **Zone 0.** This zone defines black, with no detail or texture visible.

- **Zone I.** This zone encompasses those shades of gray nearest to black. Indeed, the shades in this zone might seem indiscernible from black until they are compared to a true black. As in Zone 0, no detail is visible in the shades of gray in this zone.

- **Zone II.** This zone defines the dark range of grays that affords slight visible texture — but not much.

note Originally, Adams and Archer had only 10 zones in their system, but later developments in film and paper prompted them to readjust, expanding the system to 11 zones.

0 I II III IV V VI VII VIII IX

7-3

■ **Zone III.** The grays in this zone, although very dark, are sufficiently light to allow for a good amount of texture and detail.

■ **Zone IV.** The details in this medium-gray zone are plainly visible.

■ **Zone V.** This zone, which encompasses the range of grays that fall precisely in the middle of Adams and Archer's continuum of shades, comparable to an 18 percent gray card, represents the series of grays that result if a photograph is shot using the settings suggested by a light meter (more on this in a moment).

■ **Zone VI.** Moving toward white, this zone includes rich, mid-tone grays, with fine detail visible.

■ **Zone VII.** This zone, characterized by bright, light grays, is the uppermost zone in which details are still clearly visible.

■ **Zone VIII.** Although minimal texture is visible in the light gray-white shades present in this zone, no detail is apparent.

> *tip*
> With advances in image-editing software, it is now possible to take two or more exposures — one for the highlights and one for the shadows — and combine them for an image with expanded tonal range that cannot be achieved in a single shot. You learn more about this in Chapter 11.

■ **Zone IX.** Just as Zone I encompasses those shades of gray that are nearest to black, this zone defines those shades that are nearest to white. Indeed, the shades in this zone are indiscernible from white unless placed directly against a true white. No detail or texture is visible in this zone.

■ **Zone X.** This zone represents pure white.

METERING AND EXPOSING FOR BLACK AND WHITE

So how does understanding where the various shades of gray fall in Adams and Archer's scale help you predict how your black-and-white rendering of the scene before you looks? Simple. If you meter a scene and use the settings suggested by your light meter for the exposure, the resulting image contains the average of the scene resulting in the middle tone gray of Zone V of Adams and Archer's system. The highlight and shadow tones placement will revolve around the Zone V

> *note*
> A gray card is a gray-colored card that reflects a known amount of light. It's used as a reference to calibrate light meters. An 18 percent gray card reflects exactly 18 percent of the white light that strikes it. On the back side of most gray card is typically a *white card*, which reflects 90 percent of the white light that strikes it.

THE SUNNY 16 RULE If you're shooting under a midday sun on a clear day, if the sun is at your back, if the scene before you is fully illuminated by the sun, if no large areas of the scene are in shadow, and if you stand on one foot while clucking like a chicken (just kidding on that last one), then the *Sunny 16 rule* applies. It states that your average exposure will be f/16 and that your shutter speed will match your camera's ISO setting. For example, if your ISO is 100, the shutter speed should be 1/100 (or, barring that, 1/125, 1/90, or whatever your camera has that is closest). The deepest shadows in the scene must measure no less than f/4, with the brightest whites rating no more than f/45, if you want to ensure that detail appears throughout.

middle gray tone. Even if you meter a scene that is primarily dark or primarily light, using the meter's suggested settings results in an image with predominant Zone V grays.

Imagine that you're photographing an amazing mountain scene: fluffy snow sparkling under a cobalt sky, illuminated by a piercing midday sun. It's so bright that your eyeballs are practically on fire! You decide that a black-and-white image will best capture the eternal quality of the scene. Using your camera's light meter as your guide, you determine a correct exposure and shoot away — only to discover when you view the resulting image that the powdery snow in the scene before you has been replaced with a gray mess. What happened? Your meter, in a reflected light reading, translated the blindingly white snow — and the bright sky behind it — as middle gray, and suggested exposure settings accordingly.

Even if the scene before you is unflinchingly dark — say, a black wall — your light meter interprets it as middle gray; as such, the exposure settings it returns result in a photograph comprised primarily of tones that fall within Zone V. Likewise, if you meter a white wall, the meter's suggested exposure settings — although different from the settings suggested for a black wall — still

result in a middle-gray image. The whole idea behind the zone system is knowing where to place your mid-gray tones. You determine the area of the picture in which you want to maintain detail and make sure your sensor will capture that range of detail both in the light or highlight areas and the dark or shadow areas.

COMPENSATING FOR THE LIGHT METER'S READING

Suppose that, as you compose your image, you decide you want it to be a bit darker than the shades in Zone V (see 7-4 and 7-5). For example, maybe you want the tones in the image to look more like the ones in Zone IV (see 7-6). Knowing that each of the zones in Adams and Archer's system is separated by one f-stop, you simply overrule your meter's suggested settings, reducing the size of your camera's aperture by one stop while leaving the shutter speed the same. To darken it further, such that the tones in the image more closely match those in Zone III, reduce the size of the aperture by yet another stop. In contrast, if you want the image to involve lighter tones (see 7-7), like those in Zone VI or Zone VII, you open the aperture by one or two stops, respectively.

BRACKETING To ensure that you have maximum options when creating your final print, *bracket* your exposures — that is, take several pictures, plus or minus one stop or more in both directions. In addition to having several exposures to choose from, you might be able to use your computer to blend various exposures in order to render a scene that's closer to what you actually saw.

ABOUT THESE PHOTOS *Yosemite's Half Dome from Glacier Point, shown in figure 7-4, was taken using the Sunny 16 rule of exposure (24mm, ISO 100, f/16 at 1/125 second). Figure 7-5 shows the same exposure as 7-4, but in black and white (24mm, ISO 100, f/16 at 1/125 second). Figure 7-6 shows Yosemite's Half Dome from Glacier Point with the exposure adjusted by one stop under the basic exposure; all tones move down the scale one zone (24mm, ISO 100, f/22 at 1/125 second). In figure 7-7, I opened up one stop from the basic exposure; all tones move up the zone scale by one stop (24mm, ISO 100, f/11 at 1/125 second).*

SPOT METERING

If the scene before you is variously dark and light, your light meter averages the light values of the dark and light areas to determine a light value for the entire scene. For example, suppose you want to photograph a barn under a bright white sky. Because the light meter averages the overall light in the scene, chances are that the bright sky skews the suggested settings such that the sky, rather than appearing white in the image, looks darker — more like the Zone V grays. To prevent your meter from averaging the light from the entire scene before you, try *spot*

metering — moving your meter around the scene to meter individual highlight and shadow areas. (Some cameras include a Spot setting, which reads only one to five degrees of the scene before it rather than a large central area.) Using the barn scenario, you might opt to use a meter reading from the barn rather than from the sky or the overall scene to determine the correct exposure, perhaps opening the aperture by one or more stops. The result is a photograph with the barn depicted in Zone V grays, but a much lighter sky than in the original photo (see 7-8 and 7-9).

7-8

ABOUT THIS PHOTO *Too much white sky fooled the meter into an exposure that made the sky Zone V when it should have been more like Zone VIII (210mm, 100 ISO, f/22 at 1/60 second).*

7-9

Not every area of an exceptionally contrasty scene can be accurately recorded by a camera. Some might be too dark or too light to hold detail, assuming the rest of the scene is captured properly. If, however, as you spot meter a scene, you determine that the range of required stops is six or fewer stops, you can rest assured you'll be able to maintain detail both in the darkest shadows and in the lightest highlights. (Note that in contrast, your eyes can distinguish detail across 22 stops of light, which means they might not be a reliable guide when it comes to predicting how effectively your camera will capture the scene before you in black and white.) Use the f-stop reading of the highlight area you want to have detail and the reading of the shadow area with detail and average the two or pick the f-stop in between, provided your sensor can handle the f-stop range. If it cannot, then you need to make a choice as to which area in your image will not have detail, the highlight or shadow area, or shoot multiple exposures to merge later in post-processing.

> ℗ *note* — Spot metering is particularly useful both when your scene is backlit and in the opposite scenario, in which the scene's background is very dark, as both types of lighting can skew an overall meter reading. Spot metering is also especially helpful if you cannot physically reach your subject — for example, if it's a distant landscape or a macro subject.

> **tip** In the olden days — that is, pre-digital — the rule was to expose your images for the shadows and develop for the highlights. When capturing digitally, the opposite applies: Expose for the highlights and post-process for shadows. If you fail to capture detail in your highlights, there is no way to develop for them later.

WORKING WITH CONTRAST FILTERS

As you learned, each shade of gray in a black-and-white photograph correlates to a particular color in the scene depicted based on levels of brightness rather than color information. That means that even if two subjects contrast marvelously in color, they might well blend together when shot in black and white because they are similarly bright or, put another way, they reflect a similar amount of light. For example, imagine a red apple against green leaves. Shot in color, the apple and leaves would be brilliantly distinct. In black and white, however, their tones would be very similar because they reflect comparable levels of light.

To correct this, use a contrast filter. *A contrast filter is a colored filter that is used to affect how a certain color is translated to gray.* These filters are available in a variety of colors, each with its own range of densities, or strengths (see Table 7-1).

Table 7-1

Contrast Filter Densities

Filter	Description
Yellow Contrast Filters	
#6Y	This filter minimally blocks blue light. For best results, open your aperture by one stop when using this filter.
#8Y	This yellow contrast filter minimally blocks blue light, although a bit more than its #6Y counterpart. Again, for best results, open your aperture by one stop when using this filter.
#12Y	Often called a *minus blue filter*, a #12Y filter absorbs almost all visible blue wavelengths and requires a 1-1/3-stop increase in light.
#15Y	The #15Y filter absorbs most blue light and some green light. Like a #12Y filter, a #15Y filter requires a 1-1/3-stop increase in light.
Green Contrast Filters	
#11/G	This light yellow-green filter, which minimally blocks blue and red light, is a favorite among portrait shooters when working in black and white under tungsten lights because it renders the model's skin tones more naturally. For best results, open your aperture by two stops when using this filter.
#13/G	This yellow/green contrast filter minimally blocks blue and red light — although a bit more than its #11Y counterpart. For best results, open your aperture by 2-1/3 stops when using this filter.
#58G	To use this filter, which provides maximum blockage of blue and red light, open your aperture by three stops.

Continued

129

Table 7-1 (Continued)

Filter	Description
Red Contrast Filters	
#23A	This red-orange filter blocks green and blue light. For best results, open your aperture 2-2/3 stops when using this type of filter.
#25R	Similar to the #23A filter, the #25R filter blocks green and blue light, but to a slightly greater degree. When using this filter, open your aperture three stops.
#29R	The #29R filter yields a much deeper, more dramatic effect, especially to skies. When using this filter, open your aperture 4-1/3 stops.
Infrared Contrast Filters	
#87R	This filter blocks all visible light, allowing only infrared radiation to penetrate the camera.
Orange Contrast Filters	
#16	The #16 filter is deeper than a #15, absorbing most blue light and some green. When using this filter, open your aperture 1-2/3 stops.
Blue Contrast Filters	
#47	This #47 filter accentuates haze and fog and lightens blue tones. When using this filter, open your aperture by 2-1/3 stops.
#47B	This filter significantly lightens blue tones. To use it, increase the size of your aperture by 2-2/3 stops.

All filters are available in different degrees of intensity, with higher-intensity filters strengthening the effect. In addition, some filter manufacturers combine colors. Following are the traditional filters (note that different manufacturers might number their filters differently):

■ **Yellow (Y).** Y contrast filters block blue light. If the shadows in the scene before you are blue, or if the sky is clear and blue, using a yellow contrast filter slightly darkens those areas in the resulting black-and-white image (see 7-10 and 7-12). Conversely, if you're photographing a fall scene, replete with yellow leaves, using a yellow filter serves to brighten the leaves, thereby accentuating them, by allowing more yellow light to fall on your sensor.

7-10

7-11

ABOUT THESE FIGURES *Figure 7-10 depicts the setup for this contrast filter test in color (50mm, ISO 100, f/22 at 1/125 second). Figure 7-11 depicts the same setup shot in black and white (50mm, 100 ISO, f/22 at 1/125 second).*

ABOUT THIS FIGURE *Here you see the same setting as shown in 7-10 and 7-11, but this time using a yellow #12 filter. Notice how the yellow lemon starts to lighten (50mm, ISO 100, f/22 at 1/1125 second).*

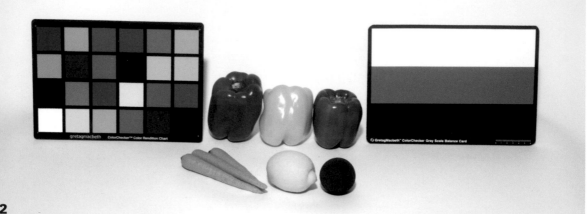

7-12

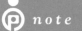 *note* | Rather than using a contrast filter on your camera, you can use an image-processing program to apply similar tonal changes to your photographs after the fact. That said, having this knowledge assists you in choosing the tool in the image-processing program that will best achieve the effect you want. For more information, see Chapter 11.

■ **Green (G).** G contrast filters block red light (see 7-13). You might use a green contrast filter when, for example, shooting the red apple/green leaves scene to darken the apple. Because this filter darkens reds while lightening greens and green-blues, it is ideal for rendering skin and lips. Because it emphasizes greens, creating contrast among varying shades, a G contrast filter works well for photographing foliage.

■ **Red (R).** If the effect you're after is white fluffy clouds against a black sky, then a red filter is the way to go. Red filters block green and blue light while brightening red and orange tones, resulting in images that are very high in contrast (see 7-14).

tip | For an even more dramatic effect, try using a red contrast filter in conjunction with a polarizing filter.

■ **Infrared.** For even greater contrast, use an infrared filter. It whitens foliage while reducing haze, as shown in 7-15.

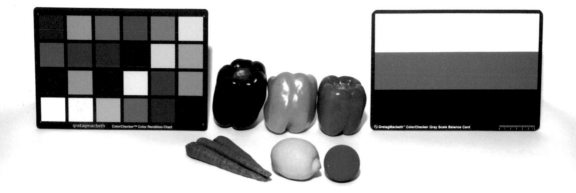

7-13

7-14

ABOUT THESE FIGURES *In 7-13, a green #58 filter, which lightens the green pepper and darkens the red one (50mm, ISO 100, f/16.5 at 1/125 second). In 7-14, a red #29 filter lightens the red pepper and darkens the green (50mm, ISO 100, f/11 at 1/1125 second).*

note Certain camera manufacturers and after-market companies can modify your digital camera to shoot only infrared images by permanently covering your digital sensor with an infrared filter. Indeed, this filter is so dark that when it is put in front of your lens, you cannot see through it (infrared light focuses at a slightly different place than visible light). This is a fun way to make use of an older, lower-megapixel camera that's sitting around collecting dust. Consult your camera's manual for how to adjust your focus for infrared light and stop down sufficiently to increase your depth of field.

■ **Orange (O).** The O filter, milder than a red filter but more robust than a yellow one, darkens blues and green tones (see 7-16). It's ideal for photographing mountain and marine environments.

■ **Blue (B).** Blue contrast filters, which block yellow and green tones, are often used in portraits to enhance skin tone. They can also be used to lighten and enhance the appearance of the atmosphere in outdoor shots and to darken foliage (see 7-17).

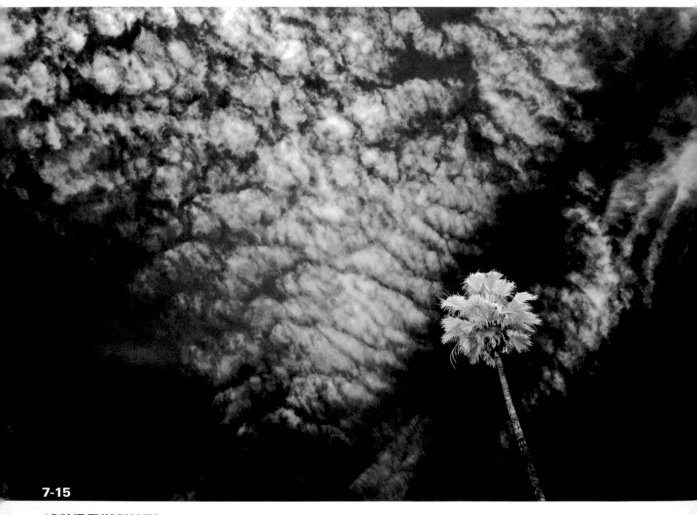

7-15

ABOUT THIS PHOTO *An infrared filter placed over the sensor yields this dynamic effect. Living green plants go white, and the skies become a dark black (24mm, ISO 400, f/8 at 1/60 second [www.lifepixel.com provided the conversion]).*

 i d e a To get a handle on how these various filters work, arrange a red pepper, green pepper, yellow pepper, and orange pepper on a blue tablecloth. Also place a white board, a gray board, a black board, and a color chart in the scene. Photograph the scene in color and then in black and white using the various contrast filters. You'll undoubtedly observe some interesting shifts in tones!

7-16

7-17

ABOUT THESE FIGURES *In 7-16, the yellow/orange #16 lightens yellow and orange objects (50mm, ISO 100, f/22 at 1/125 second). In 7-17, the blue #47 lightens the blue ball and darkens almost everything else (50mm, ISO 100, f/11 at 1/125 second).*

Assignment

Seeing Texture

For this assignment, seek out a scene that is very rich in texture. The lighting will probably be raking across the subjects to create this texture. Create a dynamic composition that looks good in black and white. Early morning or late afternoon light usually provides this cross-lighting effect when outdoors. You can use midday lighting as a source to create texture, but your subject needs to be top lit for the high sun to act as a cross-light. Old buildings with peeling paint and weathered wood work well. Take you best shot and post it on the Web site.

The picture shown here was taken in Sedona, Arizona. The early-morning light turned the earth and rock formations a spectacular red color. I decided to shoot this scene in black and white because as the sun got higher in the sky, the dramatic red color faded quickly, and the foreground, previously in shadow, had streaks of light beaming across it. I thought the textures rather than the color would read better in black and white. I increased the foreground area by shooting low to the ground. I shot at f/22 for maximum depth of field, at 1/30 second at 100 IS0, with an 80mm lens.

Don't forget to go to www.pwsbooks.com when you complete this assignment so you can share your best photo and see what other readers have come up with for this assignment. You can also post and read comments, encouraging suggestions, and feedback.

136

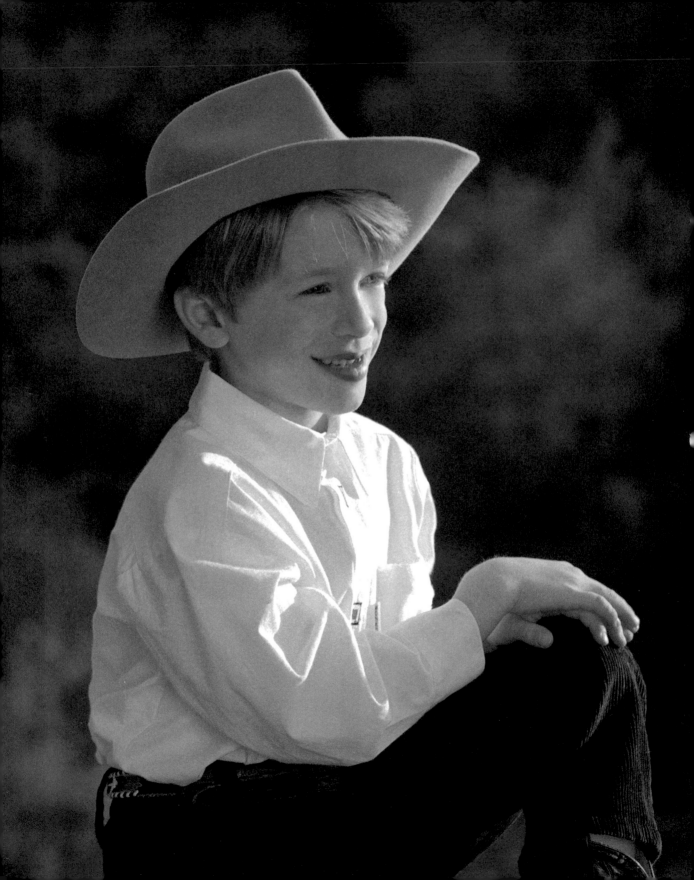

CHAPTER

8

ARRANGING APPEALING PORTRAITS

In this chapter, you learn how to take portraits that go beyond merely recording how your subject looks. You discover how to compose your portraits in such a way that the essence of your subject is conveyed. Specifically, you explore the basic ins and outs of portrait photography — that is, framing your photograph, lighting your subject, and working with your subjects. From there, you discover some key considerations for composing photographs of individuals (including kids), couples, and groups in such a way that the resulting image is pleasing and conveys your desired message.

A LITTLE HISTORY

In 2006, a French pensioner, spelunking in a Bordeaux cave, stumbled upon what many believe to be the oldest representation of a human face — or, put another way, the oldest portrait — ever discovered. Indeed, scientists estimate that the image — which was drawn with calcium carbonate and consists of two horizontal lines for eyes, a horizontal line for a mouth, and a vertical line for a nose — dates back some 27,000 years. In the ensuing millennia, the human form has inspired countless artists, resulting in portraits designed to depict a subject's basic appearance and, in some cases, to capture some aspect of the subject's personality.

This urge to render the human form contributed greatly to the success of the daguerreotype and, later, the photograph. Indeed, many credit the demand for inexpensive portraits for the explosion of photography studios during the mid-nineteenth

ON TORTURING YOUR SUBJECTS In photography's early days, a single portrait exposure could take 30 minutes. To ensure that the resulting image was not blurred, subjects often posed using iron braces on their head and body in order to keep still. Although advances in camera technology has minimized exposure time to fractions of a second, portrait photography still presents some unique challenges.

Photographing people is a bit different from photographing, say, an apple in that people are emotional beings, and some come with limited patience and short attention spans and are used to posing for quick snapshots that take only a second or two to shoot. To accommodate this, come to the shoot prepared, work with purpose, and keep the session as brief as possible. Also, remember that you're the director of your shoot; that means it's up to you to take control and tell your subjects what you want them to do. In fact, I recommend that you meet with your subjects beforehand both to prepare them with regard to what to expect during the shoot as well as to get to know them.

The rapport established between the photographer and the subject is of utmost importance. Be prepared to connect with your subjects. Loosen them up by asking them about themselves. When you are genuinely interested in what they have to say, they forget about the camera and relax. If you want to energize your subjects, project your own energy toward them. Yell, scream, or laugh to infect your model's mood. And by all means, make it a fun experience. Keep things light and enjoy yourself. A relaxed shoot results in radiant photos!

century, some of which developed 500 or more plates a day. Eastman Kodak's creation of roll film in 1888, which made it possible for amateurs to take their own photographs (which were then developed and printed by the company), enabled individuals from all walks of life to obtain images of themselves and their loved ones. Seeking to document their lives in a way that was never before possible, people everywhere began filling albums with photographs of their friends, their relatives, even their pets.

The compositions of early photographic portraits reflected the technical limitations of the day: namely, the long exposure times required to capture an image and the cumbersome equipment used. Because subjects were required to sit still, usually against a plain background, for the duration of the exposure — often 30 seconds or more — portraits in this era were static with no smiles. As a result, although they adequately recorded the subject's physical appearance, these early images typically did not capture the subject's personality (see 8-1). Advances in photography, however, have expanded the photographer's compositional options. No longer constrained by long exposure times, photographers can capture their subjects as they move and breathe; and because camera equipment is far more portable now than in days past, photographers have the mobility to stage their portraits in a wider range of settings (see 8-2).

8-1

IN THIS FIGURE *Early portraits were hampered by the technical limitations of the day: long exposure times and cumbersome equipment. Notice how the clothes are too large; he was clearly dressed up.*

8-2

FRAMING YOUR PHOTO

As mentioned, the goal of the modern portrait photographer is typically two-fold: to record the subject's physical appearance and to capture the essence of the subject — that ineffable quality that makes the subject *the subject*. Beyond that, a portrait photograph might have a broader purpose: for example, to convey a concept such as loneliness or isolation (see 8-3). How effectively a photographer achieves these objectives depends on how the portrait is composed. For example, in 8-3, the environment plays a big part in conveying the concept.

As you compose a portrait, you'll first want to consider how the subject should be framed. You have three basic options: head shot, upper-body/midrange shot, and environmental portrait.

HEAD SHOT

This type of image, sometimes called a *close-up*, includes the subject's head and, perhaps, her shoulders (see 8-4); the tighter the cropping, the less background will be visible. (To further subdue the background, open up your aperture to throw the background out of focus.) Used to capture the expressions of your subject as well as in glamour photography, head shots require soft, diffuse lighting unless your intent is to reveal any wrinkles or other small facial details, in which case the light should be hard and come from the side or from the top. The lighting used in 8-4 is a ring light, which is a flash tube that circles the front of the lens. This type of light is typically used in beauty and fashion shots or for macro photographs.

COMPOSITION PHOTO WORKSHOP / Arranging Appealing Portraits

ABOUT THIS PHOTO *This image, depicting my friend Donn, age 59, at the 59th St. subway station in Manhattan, conveys a sense of isolation (105mm, ISO 100, center-weighted neutral-density filter, CC30M filter, f/22.5 at 1 second).*

8-3

ABOUT THIS PHOTO
This classic head shot shows off the model's eye makeup (70mm, ISO 100, f/16 at 1/250 second).

8-4

tip When shooting head shots, I try to use an f-stop of f/8 or smaller — f/11 or f/16. That way, the subject's eyes, the tip of his nose, and the front edge of the ears are in focus.

Shooting your subject close-up can result in some unflattering images. Here are a few tips to ensure your subjects look their best:

- **Use a telephoto or zoom lens (90mm or longer) to play down unflattering features such as a large nose.** (Using a telephoto lens enables you to work farther away from your subject, resulting in a flattening of prominent features; shooting too close to the subject exaggerates features.)

- **If your subject has a long or angular nose, ask him to look straight into the camera and tilt the face up slightly.**

- **If your subject has a narrow chin, tilt his head upward.** Compensate for a double chin by asking your subject to tilt his head upward and outward; then position the light source above the subject to place the area beneath the chin in shadow.

- **If your subject is heavyset, ask him to wear dark clothing and position him in front of a dark background.**

- **Compensate for a thin face by positioning your subject's face in a three-quarters view toward the light source, with minimal shadow away from the camera.** In contrast, if your subject has a round face, position his face in a three-quarters view away from light, so the shadow side of the face is visible and the highlight side is away from the camera, thus slimming the face. Remember, your viewer's eye goes to the brightest part (highlight side) first.

UPPER BODY SHOT/MIDRANGE PORTRAIT

These types of shots include more of the background than a head shot does, as well as more of the subject's body (see 8-5). As with head shots, a 90mm fixed telephoto works well for midrange portraits — unless your photograph includes multiple subjects, in which case you want to opt for a normal lens.

note If your subject is uncomfortable being photographed, a midrange portrait might be the way to go. Odds are he will be a bit more relaxed and a bit less self-conscious. In addition, using a telephoto lens can come in handy, because you can work farther away from your subject.

INCORPORATING THE BACKGROUND (OR NOT) If you want to de-emphasize the background in your photograph, move in closer to the subject or use a longer lens to create an out-of-focus effect. Alternatively, you can use the background to complement your subject, as is often the case in midrange and environmental portraits. If you do decide to incorporate the background into your composition, be certain it relates in some way to the subject of the image.

8-5

ABOUT THIS PHOTO *Instead of a simple, clean midrange portrait, I packed Liz into a very detailed and textured scene, inside her antique hardware store in Los Angeles (90mm, ISO 100, f/11 at 1/125 second).*

ENVIRONMENTAL PORTRAITS

To reveal more about your subject — for example, where he lives, works, or plays — take an *environmental portrait* (see 8-6). In an environmental portrait, the environment typically serves as the principal compositional element, with the surroundings providing character and a necessary backdrop. With environmental portraits, all the standard rules of composition apply. Note that environmental portraits usually involve supplemental lighting; for example, the image shown in 8-7 required the use of umbrellas with flashes. In this case, I had to raise the light level in the room to prevent the outside daylight from appearing dark through the window.

8-6

ABOUT THIS PHOTO
I found this old roadhouse while shooting a clothing ad in Alaska. A local dog wandered onto the scene, adding to the atmosphere. It was raining, hence the slower exposure (80mm, ISO 100, f/8 at 1/15 second).

8-7

ABOUT THIS PHOTO *A zoology professor in his classroom. Notice how the birds point to him. For another workable composition, you could crop the left quarter of the image, or even some off the right (30mm, ISO 100, center-weighted neutral-density filter, f/5.6 at 1/30 second).*

LIGHTING THE SCENE

Regardless of whether you plan to shoot a head shot, a midrange portrait, or an environmental portrait, lighting — be it natural or artificial — plays a key part in composing your image (see 8-8 and 8-9). For example, soft, diffuse light tends to flatter the subject, but harsh, hard light empha-sizes wrinkles and other flaws. Although a treatise on lighting for portraits is beyond the scope of this book, following are a few key points to consider.

ⓟ *tip* If your subject's back is to the sun, it means your camera is likely point-ing toward the sun. To prevent lens flare, discussed in Chapter 5, equip your lens with a lens hood or block the sun with a piece of paper or a hat to prevent the sun's rays from striking the lens.

8-8

ABOUT THIS FIGURE *The lighting setup for a shoot at MOMS Pies in Julian, California. There's another light behind the pie racks to brighten that area. I took the shot as the sun came up so the blue light outside would contrast with the warmth of the pies inside.*

147

8-9

KEY LIGHT SOURCES

The primary light source for your scene is called the *key light source.* If you are using the sun as your key light source, be aware that midday light on a sunny day can give even the most youthful and untroubled subject dark circles under his eyes. If you can't delay the shoot until a more overcast day or until the golden hours immediately after sunrise and before sunset to correct for this unflattering effect, simply position your subject such that his back is to the sun. As an added bonus, the sun creates a nice halo of light around your subject's hair, both accentuating it and separating it from the background (see 8-10). Additionally, because the subject's back is to the sun, the harsh light prevents the subject's eyes from squinting or tearing up. Another way to shoot in midday sun is to use flash to fill in the shadows on the face.

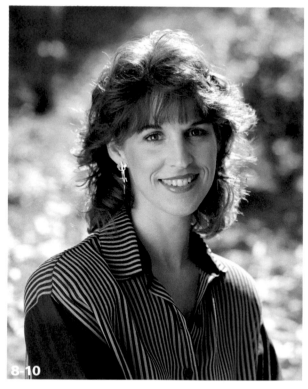

8-10

ABOUT THIS PHOTO *Notice the sunlight ringing the subject's hair and the reflection of the fill card, used to bounce light onto her face, in her eyes (150mm, ISO 125, f/11 at 1/60 second).*

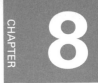

tip To duplicate outdoor lighting in a studio or other indoor environment, use artificial light, such as a flash unit or tungsten light, as the key light source. Mimic the outdoor cloud cover that yields soft diffuse light using light panels constructed from soft, translucent fabric.

note The little pop-up flash built into your camera is adequate for use as a fill flash, provided your subject is no more than six feet away. Beyond that, you need a more powerful external flash, which attaches to your camera via the hot shoe. Be warned, however, that if the external flash unit is too powerful, you might wind up using the flash as your key light and the sun as your fill light, which will likely result in a different compositional effect.

FILL LIGHT SOURCES

If the key light — be it natural or artificial — isn't adequate for capturing your subject's face, or if the light illuminating the subject's face is less intense than the background's lighting, add a fill light. One way to add a fill light is to use a flash; alternatively, corral a helper or use a stand to hold up a reflector (this might be something as simple as a piece of white poster board) in order to bounce light from the sun onto the subject's face. Alternatively, position the subject near a light-colored wall or structure; it can act as a reflector. (Take care when using a reflector; if positioned just so, it might cause your subject to squint.) Note that in addition to illuminating your subject's face, the fill light is reflected in the eyes of your subject, livening them up and adding dimension. This reflected light source in the eye is called a *catch light.*

In figure 8-10, I used fill cards on either side to bounce sunlight back into the subject's face to brighten up what would have been a very dark scene. You can see the reflector card on the left as a catch light in both eyes. By using a reflector,

I brought the light level on my beautiful wife's face up to the point where the background light registered normal. If I had not used a reflector, and instead opened up my exposure, then that nice, out-of-focus background would have been a white mass without any detail at all.

COLOR VERSUS BLACK AND WHITE

Another choice you need to make when composing your portrait is whether it should be shot in color or black and white — or both (see 8-11 and 8-12). As you learned in Chapter 7, black-and-white images, frequently associated with fine art photography, possess a timeless quality; if that idea is part of the message you want to convey, then black and white might be the way to go. And as with any black-and-white image, the lack of color focuses the viewer solely on the subject and composition of your photograph.

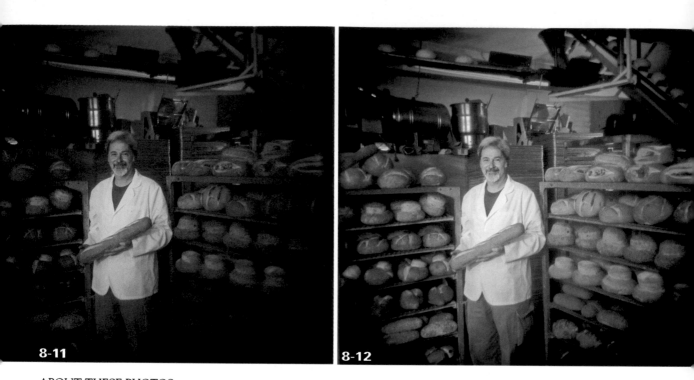

8-11 8-12

ABOUT THESE PHOTOS *I spent four hours arranging and lighting the shots in 8-11 and 8-12, which were taken in a very hot bakery! I surrounded the owner with all his artisan breads (80mm, 100 ISO, f/8 at 1/125 second). The black-and-white version of the shot in figure 8-12 removes emphasis from the colors and adds emphasis to the environment. The vignetting around the edges was caused by the camera I used (80mm, 100 ISO, f/8 at 1/125 second).*

METERING THE SCENE

In Chapter 7, you learned how to use Ansel Adams and Fred Archer's zone system to determine the correct exposure for a black-and-white image. Although the zones defined by Adams and Archer related specifically to translating the colors in a scene into shades of gray, some of the zone system's principles apply to metering portrait scenes. That's because the range of skin tones is not terribly different from a gray scale, ranging from very pale to very dark.

In order to expose for the most important area of the portrait — the subject's face — you want to move in close to meter the facial skin. Specifically,

meter the highlight side of the face, taking either a spot reading or an ambient light reading. As you learned in Chapter 6, the meter reads any area it gauges as a mid-tone, regardless of its appearance in reality and suggests exposure settings accordingly. That means, for example, that if your subject has light Caucasian skin, you likely need to open your aperture by 2/3 or one stop in order to expose the skin tone properly. That is,

 tip

As you move in close to meter your subject's face, avoid blocking the light falling on your subject.

> **tip** Until you get the hang of metering for skin tones, make it a point to bracket your exposures by one stop in either direction, writing down which settings you used for each exposure. I carry a little spiral-bound notebook on every shoot to write down the lighting conditions, which camera and lens I used, the ISO setting, the shutter speed, and the f-stop of each photograph I take.

if the meter suggests an aperture setting of f/16, you should shoot at f/11. Note, however, that if your subject has very dark skin, you want to use the settings suggested by the meter; that way, the dark skin is sufficiently brightened to reveal the face's rich detail.

Problems can arise when you have multiple subjects with a mixture of skin tones. If possible, try to position subjects with darker skin such that they are closer to the key light source. If this is not possible, choose a meter setting to split the difference; in other words, when all else fails, bracket your exposures.

Of course, if you meter for the subject's skin, and if the skin is significantly brighter or darker than the background in your scene, the result is a properly exposed subject fronting an improperly exposed background. If you're shooting a head shot, that's probably not a problem. If, however, you're shooting an environmental portrait, in which the background is a critical component of the composition, you need some way to rectify the improper exposure. In that case, work to even out the lighting in the scene, adding more light to your subject (or, as the case may be, to the background) as needed. Your best bet usually is to use a flash to brighten up the subject and to use a slower shutter speed to brighten the background or a faster shutter speed to darken your background. Make sure if you are using an external flash unit that you use a shutter speed that syncs with your flash, generally 1/125 second or slower.

POSING

The easiest way to photograph a person is to simply line him up facing the camera and snap the shutter. But unless you work for the Bureau of Motor Vehicles, odds are this approach won't please you or your subject. For best results, as you compose your image, you want to *pose* your subject.

Pay particular attention to what's going on in the background as you pose your model. Indeed, you might decide on your background first, and then place your subject accordingly.

POSING SINGLES

When photographing just one person, avoid the aforementioned driver's license effect by slightly tilting the subject's head. This subtle angle activates the whole composition, particularly if you are shooting a head shot (see 8-13). Note, however, that the key word here is "subtle"; if the head is tilted too dramatically, it appears as though your subject has broken his neck! Another trick is to give your subject something to do — for example, holding his favorite object or leaning against a chair, wall, or table for support.

> **note** A common mistake — one that just about everyone makes when photographing just one person — is to shoot only in the horizontal orientation. If the dominant element in the picture is vertical, then you should consider shooting it vertically.

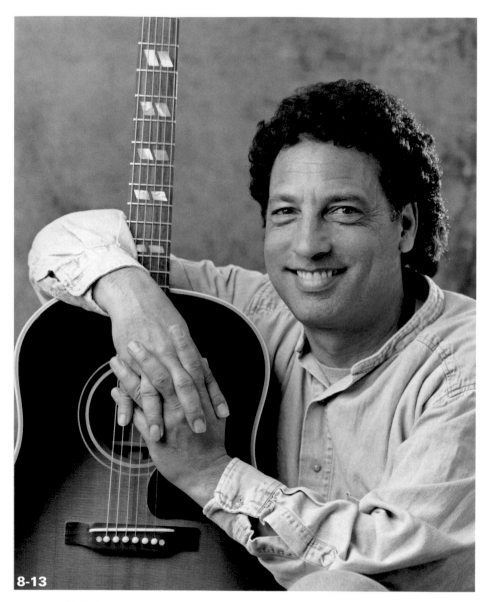

8-13

ABOUT THIS PHOTO
Musicians often need head shots. Try incorporating his instrument into your composition (80mm, ISO 100, f/16 at 1/125 second).

You should also indicate where the subject should direct his gaze. Right at the camera's lens is one option and can create a certain tension for the viewer when he looks at your photograph. Another option is to direct the subject's gaze away from the camera; where the subject's eyes are focused and the intensity of his gaze can alter your photograph's message. Your best bet might be to snap a few photos of your subject gazing at the camera's lens and a few others with his eyes directed away from it. (Note that if your subject looks at you rather than at the camera's lens, the resulting image, in which the subject is looking slightly up, can look a bit forced and unnatural.)

With the subject set, you're ready to start shooting. I usually begin with full-body shots, including the subject's feet. I then move in closer, cropping the frame at mid-calf, and closer still, eventually ending with close-ups of the subject. As I work, I try to include all body parts that are major design components, cropping out those that don't make sense. (Note that I tend to avoid cropping right at a joint, such as the subject's knees or elbows; it just seems awkward.) Be aware that if you come in too close, you might experience some distortion; that's because the portion of the subject's body that is closest to the lens looks larger than the portions that are farther away. A wide-angle lens exaggerates this distortion, creating cartoon-like images (see 8-14).

> **idea** Gather your own collection of poses — effective standbys to which you can return time and time again. That way, when photographing people, you have many ways to arrange your subjects for variety and interest. For inspiration, rifle through magazines and newspapers; when you find a pose you like, cut it out and paste it into a notebook so you can reference it later.

> **tip** If you want your composition to convey connectedness, ensure that the gaze of both subjects is the same — directed at each other or at the same focal point.

POSING PAIRS

The guidelines discussed in the preceding section about posing singles also apply for pairs. In addition, regardless of whether the individuals in your photograph are siblings, spouses, friends, family, or what have you, you want to compose your photograph such that your subjects are arranged in the frame in an appealing way, and that the nature of their relationship is conveyed. Here are a few compositional tricks to help you achieve this:

■ **Focal point.** Where your subjects are looking can say a great deal about how they relate to each other. One approach is to ask both subjects to direct their gaze at the camera's lens; another is to instruct them to look at each other (see 8-15). A third is to direct their eyes at an object away from the camera (see 8-16). I usually provide a specific object for the subjects to look at; that way, their eyes are in focus, without that distant glaze that can occur when someone stares off in the distance. For best results, situate this object such that the subject does not need to look up or down to focus on it.

8-14

ABOUT THIS PHOTO *The funny distorting effect of a 15mm wide-angle lens. The camera was only a few inches away from her head. For the most part, you want to take more flattering pictures (15mm, ISO 100, f/11 at 1/125 second).*

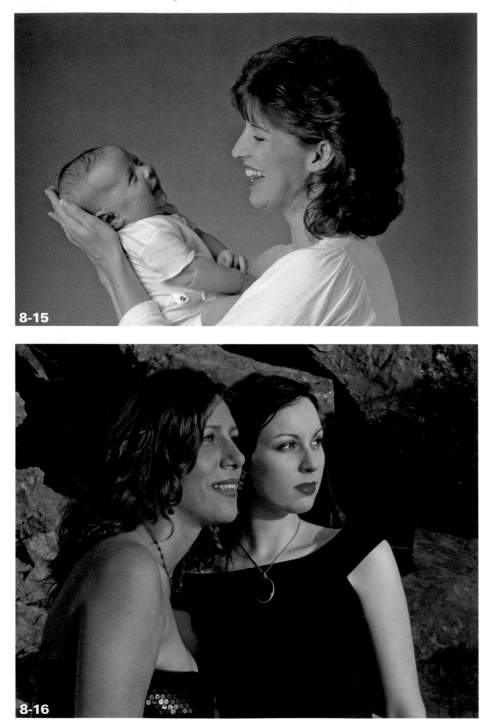

8-15

8-16

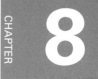

■ **Touch.** If you want your image to convey a sense of intimacy or familiarity, pose your subjects such that they are touching — for example, with their arms around each other, as in 8-17, or holding hands.

■ **Position.** To prevent one person's head from appearing significantly larger or smaller than the other's, position your subjects on a single plane, parallel to the camera's image sensor. Otherwise, the head of the person who is

ABOUT THIS PHOTO
Notice how these twin sisters — photographed outside with flash fill, using the sun as a hair light — have their arms around each other. Notice, too, that they are missing opposite front teeth (80mm, ISO 100, f/11 at 1/60 second).

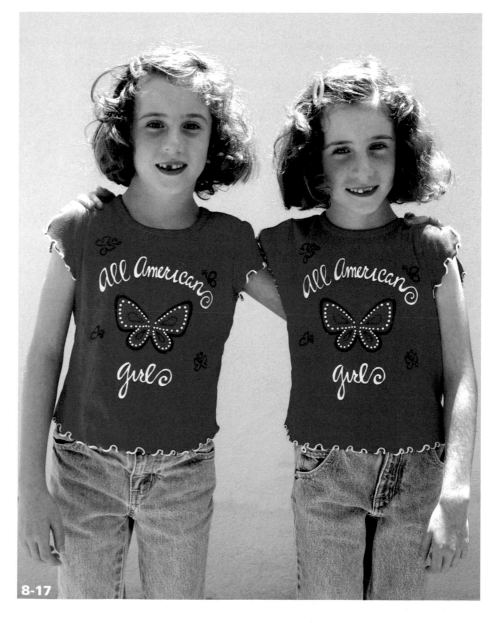

8-17

closer to the camera appears disproportionately large. Also, a nifty trick is to position your subjects such that one individual's eyes are roughly level with the other individual's mouth (see 8-18). This prevents your subjects from mirroring each other, which can be a static composition. Finally, to convey a sense of intimacy, instruct your subjects to lean their heads toward each other.

8-18

ABOUT THIS PHOTO *Notice how the little girl's eyes take you to her Mom's mouth and around the heads. The eye/mouth alignment breaks up the symmetry of the composition, enlivening the portrait (150mm, ISO 100, f/11 at 1/125 second).*

POSING GROUPS

The key to photographing groups of three or more, whether they are members of the same family, are friends, or are related in some other way, is arranging the heads of your various subjects in a pleasing way, either symmetrically or asymmetrically. One approach is to arrange the subjects' heads in a triangle shape; a diamond shape is another option. As shown in 8-19, checkmarks, Vs, and ovals are also good shapes to use when arranging the heads of your subjects.

Here are a few other points to keep in mind:

■ **Color-coordinated clothing.** Rather than photographing people wearing a mixed bag of polka dots, solids, pastels, primary hues, stripes, and paisleys, opt for a coordinated effect. This prevents the subjects' clothing from distracting the viewer from the subjects' faces. I once photographed 125 people at a family reunion; each family group wore the same-color t-shirts so that even if they were not together in the frame, the viewer could determine who belonged to which family group.

8-19

ABOUT THIS PHOTO *Arranging your subjects in a triangle, diamond, V, checkmark, or oval, or in this case an inverted V, results in a more pleasing composition (35mm, 100 ISO, f/16 at 1/125 second).*

■ **Location.** Spend some time talking to the group you want to photograph to decide on a location that really reflects who they are. For example, if they love to ski, then photograph them on the slopes. If the beach is their idea of heaven, then shoot them there. If home is where it's at, then look around their property, both inside and outside, for a good spot to shoot, taking into consideration lighting, time of day, and ease of setting up the shot

(see 8-20). If you're shooting outdoors, and the group you intend to photograph is composed of multiple generations of the same family, find a large tree to use as a prop; it speaks to the idea of a family tree (see 8-21).

p *tip*　If the group you're photographing includes little kids, allow for frequent breaks. Shoot a few frames, let them loose, rearrange the group, and then call the kids back together.

8-20

8-21

ABOUT THIS PHOTO
I have shot this multigenerational family several times; here, I placed the oldest members of the family in the center. The old oak tree speaks to the timelessness of the image (80mm, ISO 100, f/16 at 1/30 second).

PHOTOGRAPHING KIDS

Kids — when they're cute, they're cute. When they're not — well, you get the idea. Because kids tend to be unpredictable, you want to be extra prepared for any shoot in which they're a factor. If you are photographing very young children, bring lots of stuff to keep them distracted — noise-makers, toys, whatever it takes. Expect to make a fool of yourself, making animal noises or engaging in other silliness to make them smile or laugh.

That said, don't bribe kids during a shoot, or else they really work you over. If all else fails, photograph them in their misery; the results can be quite funny. For best results, shoot at their level, on the floor if need be. Also, if your camera has a motor drive, use it! Finally, keep the session short. You might only have time for one or two great images before your subject is off and running or changes expressions (see 8-22).

ABOUT THIS PHOTO
Normally, this baby has a cute, bubbly personality — but not on this day! I shot this priceless picture of him anyway. Be prepared, moments like this do not pause or duplicate themselves (15mm, ISO 100, f/8 at 1/125 second).

8-22

Older kids can be a bit easier to photograph in that they're at least mature enough to follow directions. In lieu of animal noises and other juvenile behavior, engage older kids in conversation about something that interests them. Alternatively, urge them to be active and shoot them as they move. Also, you're shooting digitally; involve them in the process, showing them your results as you work. It might slow things down a bit, but not for long — and it will likely help you maintain your subject's attention.

> **tip** If you're shooting kids with their parents, tell the parents to look at the camera — regardless of what the kiddies are doing. If they're always checking on the children to see what they're doing, they won't be ready for the shot.

Assignment

Environmental Portrait

Arrange to create a portrait of someone in an environment that relates to his style of living or work for this assignment. First, talk to your subject and come up with a spot that makes sense — that will tell your viewer something about your subject without using words. Next, figure out the time of day you need to shoot; the light should be just right, illuminating both your subject and the environment. Post your best portrait to the Web site.

I got the idea for the portrait shown here after photographing the subject's home on Oahu for an annual report. I loved the lushness of his front yard. In about 10 minutes, I and my assistant set up the shot. The subject had this great weathered teak chair on his patio, which gave him a place to sit along with his bird. With the chair in place, I used the vegetation and door to frame my subject; as dusk fell, I used the ambient light of the western sky to create a soft light on his face. I used a long shutter speed of 5 seconds to let the warmth of the inside lights register — notice that you can see the movement in the bird's tail —(150mm, ISO 100, f/8 at 5 seconds).

Don't forget to go to www.pwsbooks.com when you complete this assignment so you can share your best photo and see what other readers have come up with for this assignment. You can also post and read comments, encouraging suggestions, and feedback.

Prior to the end of the Paleolithic period, prehistoric humans subsisted for more than two million years by organizing in hunter-gatherer societies, characterized chiefly by a nomadic existence. One might argue, then, that modern people's seemingly innate desire to travel is a remnant of these early ancestors' survival instincts. After all, who among us does not love travel? It is the rare individual indeed who would rather stay home than visit someplace new. This might explain why, although people represent the most common subjects for photographers, travel destinations — scenic landscapes, vibrant cityscapes, and the like — rank a close second (see 9-1).

There is nothing like landing in a fresh environment — whether it's the heretofore unexplored woods down the road from your home or a city in a country you've never visited before — to get the photographer's creative juices flowing. In this chapter, you learn how to capture dynamic and exciting scenic photographs, including skylines, monuments, buildings, marketplaces, signs, and landscapes, plus the people you meet along the way. The result: images that make your viewer want to hop the first flight to the scene you've photographed (see 9-2).

Traveling doesn't have to mean going abroad; looking around your own hometown with the eye of a first-time visitor can sharpen your skills for when you actually do visit a new place. You might discover that the garden outside a certain house you pass everyday on your way to the market is especially beautiful when the morning light strikes its flowers, making them glow as if they are the center of the universe. Notice the moment and capture it. Every spot on the planet, whether it's around the corner or around the globe, has its own unique qualities and characteristics; it's your job as a photographer to uncover them, expose them, and share their beauty.

9-1

ABOUT THIS PHOTO *Try to sum up what's unique about a location. In this image of a Baja resort, it's the curving stretch of beach from the pool (105mm, ISO 100, center-weighted neutral-density filter, f/22.5 at 1/8 second).*

9-2

ABOUT THIS PHOTO *Hired to shoot a panoramic cover of this resort on Lana'i, Hawaii, for an annual report, I decided an aerial shot would show off its physical attributes best (105mm, ISO 100, center-weighted neutral-density filter, f/22 at 1/125 second).*

PACKING YOUR CAMERA BAG

In order to take photographs during your travels, you need your camera with you at all times — day and night. Assuming you have time to return to a site in order to photograph it is a mistake; chances are you'll be barreling toward the next city or country on your itinerary. For this reason, you should take extra care when packing your camera bag to ensure that it contains all the equipment you need — but not so much that you require a mule to carry it. Here are my suggestions:

- **Your camera.** Also consider bringing an extra camera body in the event yours malfunctions.

- **Lenses.** Pack a 24mm wide angle, a 50mm normal/macro, a 100mm short telephoto or 24-70mm zoom, and an 80-200mm zoom.

- **Filters.** Include a polarizing filter and a clear skylight or UV filter to protect your lens from dust or rain.

- **Memory cards.** At a minimum, bring two 2GB cards. Depending on the length of your trip, you might want to bring more.

- **Batteries.** Bring at least two batteries, plus the charger. If you are traveling internationally, be sure to bring any necessary electrical conversion devices.

- **Lens-cleaning tissue and fluid or micro-fiber cleaning cloth.** These are essential for keeping lenses clean and free of dirt.

- **Your camera's instruction booklet.** This is essential reading and comes in handy for reference in the event something goes wrong with your camera.

tip When cleaning your lens, squirt the fluid onto the tissue, not onto the lens, then clean with circular motions from the center out to the edge.

- **A travel tripod.** These have legs that are about six inches long and, when folded up, are quite small.

- **External storage device.** You can download your memory cards onto this while on location. In addition to freeing up your cards, it serves as a backup.

- **Laptop.** Use this to back up your memory cards, burn CDs or DVDs, and edit your images on rainy days and during the airplane trip home.

- **Backpack.** To hold all of your equipment, find a backpack that suits you. I suggest finding one that has a built-in rain sleeve or plastic sheet attached, handy for protecting the pack from rain or for setting the bag down on wet or muddy ground.

As mentioned, rather than carrying your gear in a camera bag, opt for a small padded backpack. That way, you can carry your gear on your back, leaving your hands free for looking at maps. Using a backpack also hides the fact that you're lugging expensive camera gear around. I use a small daypack that also has room for a sweater or light jacket (I like to wrap this around any loose equipment to prevent it from being jostled), a bottle of water, a compass, snacks (that is, chocolate), a phone, and maps.

> **note** If you attempt to set up your tripod in public, you might be required to fill out a form stating that you will not use your photographs for commercial purposes, regardless of whether you are a professional photographer. Alternatively, you might be prohibited from shooting altogether, as is often the case on observation decks, where many tourists tend to crowd into a small area; Indian reservations in the United States; and national parks.

SCOPING OUT YOUR LOCATION

Your first step at any new location is to determine what makes this location unique — such as unusual modes of transportation, geographical features, or architectural offerings. When you arrive at a scene you want to photograph, walk around the entire site; just by slowing down, by really looking, you'll notice many angles and details that might be more photo-worthy than the scene as you saw it initially. If your time in this location is limited, consider taking a bus tour to get oriented. Alternatively, hiring a driver who knows the locale can save you time and energy. At the very least, come armed with a good map.

> **tip** If you're visiting a city or town, start your exploration at the center. That's where you are likely to find historic buildings and squares and lots of people. From there, work your way toward the perimeter.

As you explore your location, look specifically for sites that afford these types of compositions:

- Establishing shots

- Medium views

- Close-ups

ESTABLISHING SHOTS

Just as a film director includes *establishing shots* in her work (long-range images of a geographical location designed to establish the setting and orient the audience) so, too, should you when photographing a location. These establishing shots might be photographed from above, overlooking the location — for example, from an

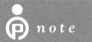

note At any site, I generally try for the big view first. Then, with each shot, I zoom closer and closer, until I am taking photographs of such small details that no one would ever be able to guess where I am simply by looking at my images. That said, your establishing shot doesn't have to be the first shot you take at a new location. It might come to you as you move about and explore. Bottom line: If you see something interesting, shoot it, regardless of whether it's an establishing shot, a medium view, or a close-up, because you might not return.

observation deck atop a skyscraper, from a hill-top, or even from the air. If you can, book your hotel in an area stocked with photographic subjects, and be sure to request a room with a view so you can shoot from your window. Simply press your camera's lens against the glass, take your meter reading, and you're ready to shoot (see 9-3). If there is no high ground, a simple wide-angle image that depicts the location in a broad sense might serve as an establishing shot. Wide-angle lenses work best for establishing shots

because normal lenses limit your ability to provide a true overview of the site.

Composing long-range images, such as establishing shots, can be tricky. The challenge lies in ensuring that the viewer isn't overwhelmed, that her eye finds at least a few places to land. To achieve this, try composing your image such that it contains something in the foreground, something in the middle ground, and something in the background (see 9-4). In addition to creating natural stopping points for the viewer's eye, it also lends interest and depth to the image.

tip For dramatic photographs, try shooting during the late afternoon or at dusk — 10 minutes before or after the sun sets (shooting much later yields images that are too dark). To accommodate the low light levels, use your travel tripod to steady your camera. Place it on a ledge, the hood of a car (preferably your own), or a window sill.

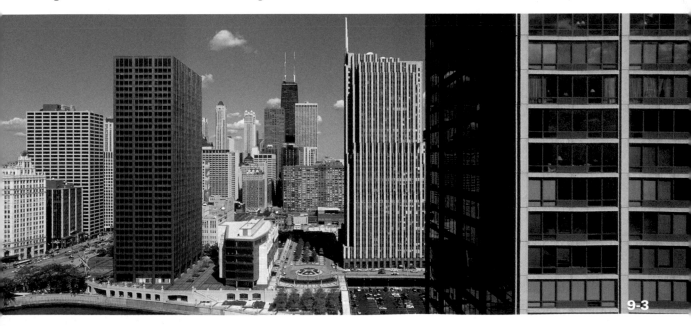

9-3

ABOUT THIS PHOTO *This image of Chicago was taken from my hotel room. I simply placed my camera's lens right up against the window, metered the scene, and shot away (30mm, ISO 50, f/5.6 at 1/60 second).*

ABOUT THIS PHOTO *Notice how your eye moves through the layers of the scene, experiencing the successive planes of distance (105mm, ISO 100, center-weighted neutral-density filter, coral gradated neutral-density filter, and golden amber filter, f/22.5 at 1/2 second).*

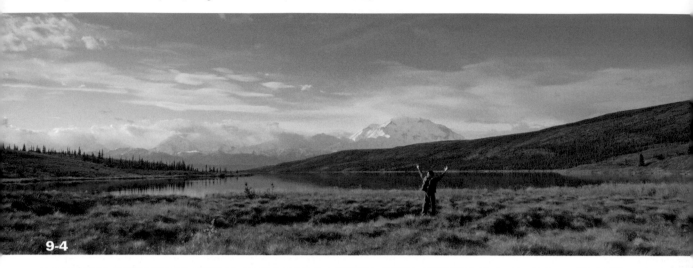

9-4

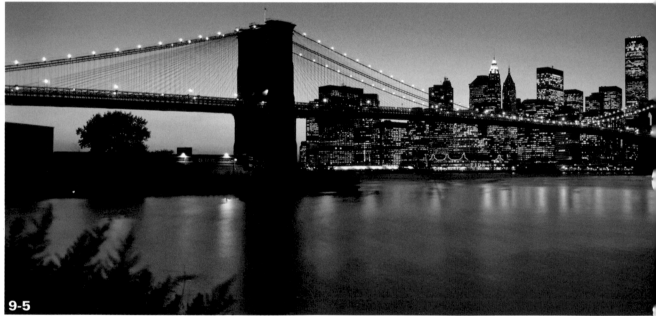

9-5

ABOUT THIS PHOTO *The New York skyline from Brooklyn Heights, right after a rain storm cleared the skies (105mm, ISO 50, center-weighted neutral-density filter, f/22 at 30 seconds).*

tip Every location has its own signature image; you just need to find it. In more famous locales, such as famous cities, this signature image is usually pretty obvious. The signature image of Paris is the Eiffel Tower. If the signature image in your locale is equally recognizable, you must strive to offer your viewer a fresh perspective, something unique and different. Shoot during the day and at all hours of the night, while hovering above in a helicopter, while riding in a taxicab, while lying down underneath it...you get the idea.

Another point to consider is that when the viewer peruses an establishing shot, she should be able to glean some specific information about the scene shown, such as the region in the world in which the scene is located. To achieve this, look for a wide-angle view that includes something unique about your locale, such as landmarks, signs, or local people (you learn more about photographing the locals in a moment). For example, 9-5 shows the Brooklyn Bridge, a recognizable New York City landmark; 9-6 shows Manhattan photographed from atop the Empire State Building.

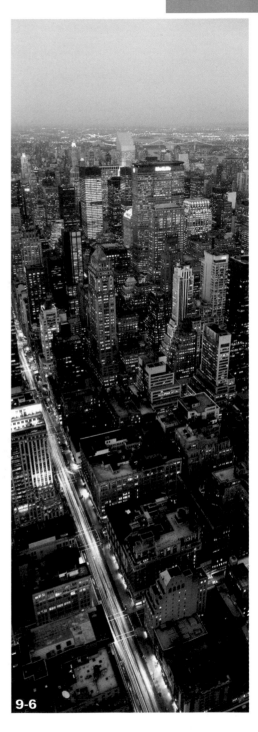

ABOUT THIS PHOTO
A hazy night, shot from atop the Empire State Building. The use of black and white gives the image a timeless quality; it would have looked terrible in color (105mm, ISO 200, center-weighted neutral-density filter, f/22 at 4 seconds).

9-6

MEDIUM VIEWS

If establishing shots serve to orient the viewer, medium views — a unique series of buildings or interesting shop fronts, a monument (see 9-7),

9-7

ABOUT THIS PHOTO *A late afternoon view of the Washington Monument. This image was reflected onto the hood of a car in Los Angeles for an establishing shot for a TV series (105mm, ISO 50, center-weighted neutral-density filter, f/22 at 1/4 second).*

a fountain in a park, people on the street during a local festival, crowds in a museum, the fruit at an outdoor market — are designed to convey a more intimate sense of what it's like to be at the locale. They reveal a sense of space in the place — whether it's wide open, with large boulevards or vast expanses of open space, or crowded, with people and buildings pressed in on each other. To locate subjects for medium-view photos, work each area as though you are a detective, searching for clues to the essence of your locale. One approach is to attempt to include all or a portion of a landmark such as a bridge or a memorial as the background of your image, with, say, a local fair or street market in the foreground.

Here are a few compositional tips for shooting medium views:

■ **An excellent way to compose medium-view shots is to use a *framing device* to create a frame within the picture frame (see 9-8).** This might be an archway that gives way to a cobblestone street or even the curving branch of a tree, in silhouette or in full sun. The framing device adds foreground interest, and leads your viewer deeper into the picture space.

■ **Use window reflections to add character to your shots (see 9-9).** For example, you might photograph a store front, both revealing what's for sale behind the shop window as well as passersby. Years from now, as styles change and prices rise, the items in the window become historically important; at the same time, this approach enables you to photograph the people in your scene without putting a camera in their face.

ABOUT THIS PHOTO *View of the church of St. Francis of Assisi at the Taos Pueblo, New Mexico. The opening helps frame the location, also adding depth to the image (28mm, ISO 100, f/16 at 1/60 second).*

■ **If you eat in outdoor cafes, include the food you order in the foreground of a shot to create some ambience.** Food also serves as an excellent subject for close-ups, discussed next. (By the way, photograph your meal before you dig in; half-eaten plates of food are not that appetizing to look at.)

■ **Make an effort to get up and moving early, before the popular sites at your location are milling with people.** The relative lack of crowds renders those sites considerably more photogenic (see 9-10). You also find some interesting shots just by observing early-morning activities — shopkeepers sweeping their stoops, deliverymen unloading their lorries, and so on.

tip

When you locate a vantage point from which you want to shoot, take a moment to carefully examine the scene. (Binoculars come in handy here.) Does any trash or other junk mar the landscape? If so, spend a few minutes to clean it up now so you won't have to do it later in post-processing.

ABOUT THIS PHOTO *Reflections can add a unique look to a popular spot. This is The Getty Center in Los Angeles (30mm, ISO 50, center-weighted neutral-density filter, f/11 at 1/60 second).*

CLOSE-UPS

Finally, shoot all the close-ups — images depicting the details of the locale — you can. These, too, can convey to the viewer a sense of the locale (see 9-11 and 9-12). I often focus on obtaining close-ups during the middle of the day, when the overhead light is too contrasty for most scenes, or when weather issues, such as mist (see 9-13),

9-10

9-11

ABOUT THIS PHOTO *I like to wander the streets early in the morning, looking for signature images such as this scene in Paris' Latin Quarter. This image was later used in a French airline travel brochure (85mm, ISO 100, f/4 at 1/30 second).*

ABOUT THIS PHOTO *Early morning in Paris's Latin Quarter. As the shops were setting up, I found this arrangement of baguettes (55mm, ISO 64, f/8 at 1/30 second).*

ABOUT THIS PHOTO
I also like to wander around at night. I shot this fire juggler with my small tripod on the cobblestones in the Latin Quarter of Paris (24mm, ISO 100, f/5.6 at 30 seconds).

9-12

ABOUT THIS PHOTO
Misty days are still good for shooting, as with this stone farmhouse in Burgundy, France (50mm, ISO 100, f/8 at 1/60 second).

9-13

tip Don't let a little wet weather prevent you from photographing a location. Indeed, this type of weather represents a great opportunity to stretch yourself photographically. Wet pavement reflects the buildings and people on site, adding an interesting dimension to your shots. Wet pavement at night and dusk is particularly incredible, reflecting the city lights.

ABOUT THIS PHOTO *A black-and-white image with fog, which I created by breathing on the lens. I shot this right after the image in 9-5 (ISO 200, center-weighted neutral-filter, f/22 at 30 seconds).*

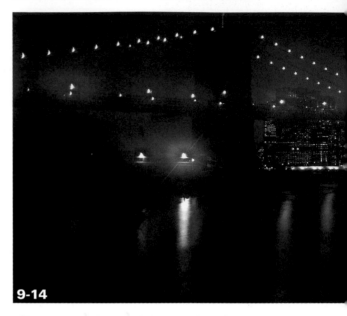

9-14

prevent me from obtaining establishing shots and medium-view photos. Local farmers markets can provide you colorful images of flowers and food. I also look for interesting textures on the ground, walls, fences, or hanging objects.

OTHER CONSIDERATIONS

Regardless of whether you're shooting an establishing shot, a medium view, or a close-up, here are a few other points to keep in mind when shooting a travel or other scenic shot:

- **Shoot as many photos as you can.** Shoot from a variety of angles and distances, using all the lenses available to you. After all, you might never pass this way again!

- **Adjust your point of view.** Try shooting above, below, behind, and around. Alter your standing position, too.

- **Seek out different centers of interest and all-over compositions.**

- **Shoot both horizontally and vertically.**

- **Hunt for details.** An interesting rock, tree, or river, when placed in the foreground, pulls your viewer right into the scene.

- **Set your aperture and focus to include both the foreground and background elements.** This helps to keep everything sharp; then change your focal point and vary your depth of field for variety.

- **Change your output from color to black and white (see 9-14).**

- **Don't forget to bracket your exposures if you are nervous about getting the right one.**

- **Stay a while, spending all day at the site if you can.** As the sun arcs overhead, the changing light against the textures in the landscape can generate drama; the golden hours of the late afternoon likely yield exceptional views of the scene. Even better, a change in the weather might occur. Certainly, blue skies are happy skies — but clouds make for a more striking image than an empty cerulean dome (see 9-15).

- **Leave the place you are visiting cleaner than you found it.** Tread lightly and carry out what you brought in — plus a bit more.

idea Need fog in your shot? No problem! Breathe on your lens! Cheap special effects.

9-15

ABOUT THIS PHOTO *Clouds are always different, wherever you travel. I shoot them for stock images, which I have sold for movie backgrounds, cellular phone sites, computer ads, and more (30mm, ISO 50, f/5.6 at 1/60 second).*

PHOTOGRAPHING PEOPLE ON LOCATION

If traveling with friends or family members, you want to photograph them at the famous locations you visit to prove you were there. To compose photos that rise above the level of snapshots, keep these points in mind:

- **Persuade your traveling companions to dress in simple-colored shirts and pants.** This prevents their clothing from distracting from the rest of photo.

- **Involve your subjects in some way.** Have them jump for joy, point out a landmark, or look at a map with a puzzled expression.

- **For an even better shot, try to capture local people, either interacting with your subjects or on their own (see 9-16 and 9-17).** One way to do so is to photograph locals doing their jobs — police officers on patrol, chefs cooking, shopkeepers selling newspapers, farmers plowing, and so on. Use a longer lens if you want to be unobtrusive.

note Including local people, especially if they look to you to be quaint and colorful, in your photographs can add lots of interest to a photograph. Do not assume, however, that you should photograph someone without her permission. If someone declines to be photographed — after all, chances are you aren't the first tourist to corner them with a camera — be respectful; point your lens elsewhere.

tip If you hope to sell any of your travel photographs — for example, to a magazine or other publication — then you should secure permission from your subjects, or models. Ask them to sign a *model release*, which grants you the right to use the image for commercial purposes.

- **Unless absolutely necessary, move your subjects out of the center.** This creates an asymmetrical composition with more visual interest.

- **Try to vary the distances of the various subjects in your scene.** For example, place your human subjects in the foreground, with the major landmark well behind them.

- **Have your subject participate in a local activity.** Try rollerblading beneath the Eiffel Tower or skiing in the Alps.

9-16

ABOUT THIS PHOTO *Capturing local talent: a palm reader on a rainy day at the colorful Les Puces flea market in Paris (50mm, ISO 100, f/8 at 1/30 second).*

ABOUT THIS PHOTO
Always keep your camera close by, in your backpack or on the seat of your car. This farmer along a country road in Spain didn't plow for very long. If I'd had to scramble for my camera, I would have missed the shot (180mm, ISO 100, f/11 at 1/250 second).

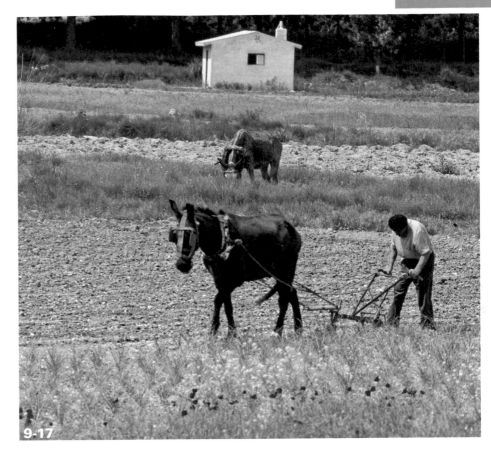

9-17

Assignment

A Travel Story

For this assignment, shoot a cityscape or landscape that has a foreground, a middle ground, and a background. Your picture should tell a story about the place you are shooting. Emphasize the characteristics that make your chosen place special. Post your image to the Web site to share with others.

In this scene in Bath, England, I was struck by the beauty of the landscape, the rolling green hills, the river Avon in the foreground, and the grazing sheep. To me, all these elements came together in this photo. I used a 180mm lens, ISO 100, f/11 at 1/250 second. The colors of the boat in the river draw your attention there, with your eye then moving about the picture. All these elements summed up my experience in this rural English town.

Don't forget to go to www.pwsbooks.com when you complete this assignment so you can share your best photo and see what other readers have come up with for this assignment. You can also post and read comments, encouraging suggestions, and feedback.

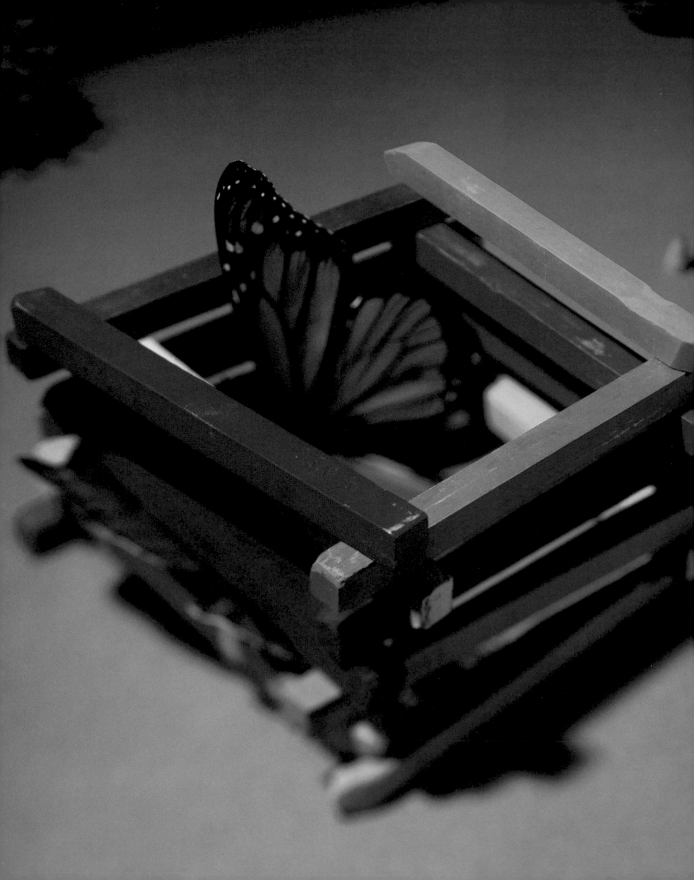

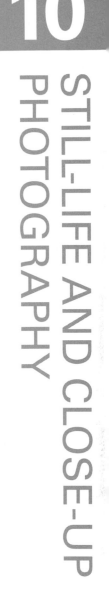

STILL-LIFE AND CLOSE-UP PHOTOGRAPHY

Still-life photographs depict small, inanimate objects, typically on a tabletop, carefully arranged to achieve a composition that is aesthetically pleasing, symbolic, or both (see 10-1). Perhaps even more so than in portraits, landscapes, or other photographic genres, composition is critical in still-life photography; indeed, in many cases, composition is what a still-life photograph is about. That is, the very message of the image relates both to the choice of objects depicted and to how those objects are arranged.

For example, in 10-1, I wanted to showcase the tapestry, a reproduction of a famous Italian fresco. I added the lilies, as a friend had many blooming in her garden at the time. I bought the slab of granite for a table top, used a piece of fabric to give it a classic look, and created a yellow shaft of light for additional compositional interest.

I wanted the viewer's eye to move from the yellow light to the horse to the flowers. The horizontal line of granite was meant to stabilize, or anchor, the bottom of the image so the viewer's eye wouldn't move out of the frame. The other colored flowers were purposely placed to add secondary interest and keep the viewer's eye moving around, processing all the details.

Fortunately, still-life photographs also offer the most flexibility with regard to composition. With portraits, you can adjust the manner in which your subject is posing, but certain limitations prevail; rearranging the face of your subject is generally not an option. Likewise, physically altering the landscape for a photograph, while certainly possible, likely requires more labor and/or earth-moving equipment than is feasible. In contrast, moving the objects comprising a

10-1

ABOUT THIS PHOTO
I started out wanting to showcase the tapestry and this elaborate setup grew from there (210mm, ISO 50, f/64 at 10 seconds to burn in the yellow light).

ABOUT THESE PHOTOS
Figure 10-2 shows ice cubes in a beveled glass photographed in liquid, 1:1 magnification (100mm macro, ISO 100, f/22 at 1/125 second). The same glass shown here, in figure 10-3, from farther out. To get the reflection, the glass was set on black Plexiglas, which acted as a mirror (100mm macro, ISO 100, f/22 at 1/125 second).

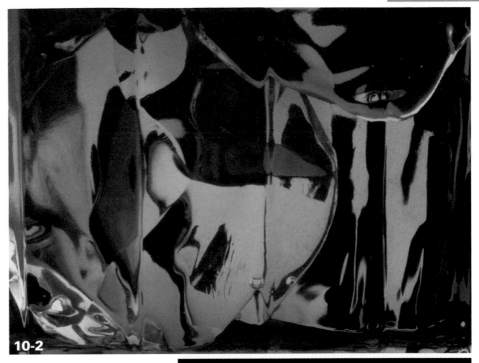

10-2

still-life scene in order to achieve the desired look couldn't be easier — you simply pick them up and put them back down. This might explain why artists have drawn, painted, and photographed still-life images for centuries. Still life is easy, the objects don't talk back, and they stay put.

Where composing still-life images typically involves assembling a series of objects such that they interact in an interesting way, macro and close-up photography typically entail shooting a single object at extremely close range. Viewing an object in this manner — up close and personal — can reveal textures and patterns that typically pass unobserved. The result is an image that gives the viewer pause as she tries to determine just what is being shown, as in 10-2. (Look carefully, and you see the vertical lines of a glass and the abstract pattern of ice cubes shot up close; 10-3 shows the setup shot from a bit farther out.)

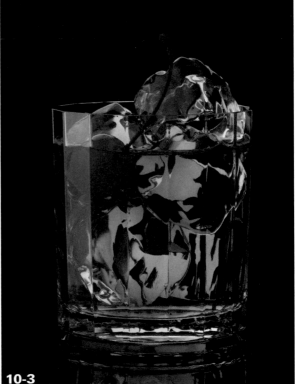

10-3

PHOTOGRAPHING STILL-LIFE IMAGES

Before you can begin composing a still-life image, you must first decide on your subject. Common subjects of still-life images include natural objects (flowers, food, sea shells, bird's nests, leaves, and so on) to man-made items (ordinary household items such as tableware or cutlery, personal effects such as a pocket watch or spectacles, toys, and the like). Still-life photography is also commonly used in advertising — for example, to showcase a product (see 10-4).

Your still-life shoot might be inspired by the color of a particular fruit in season, the beauty of light falling on a collection of wine corks, or the memory of your mother using an old set of dishes. Alternatively, it might be sparked by an object you like, or an item to which you have some emotional attachment. Collections, too, make great still-life subjects. If you or someone you know collects objects of any kind — say, Pez dispensers, matchbooks, coins, stamps, or *Star Wars* action figures — consider using them in your composition. For example, 10-5 shows my collection of international bills. I deliberately arranged the setup such that no single bill stood out, thus increasing the image's salability.

ASSEMBLING THE SET

With your main subject selected, begin assembling your set — that is, arranging your subject and any additional items that factor into the

10-4

ABOUT THIS PHOTO *I shot this ad for Speedo swimming caps in the studio with simulated early-morning daylight (150mm, ISO 50, f/45 at 1/125 second).*

composition on the surface on which they will be photographed — and setting up any necessary lights, reflectors, and other equipment (more on that in a moment). Place the main subject on the set first; then build your composition by adding — or removing — objects until you achieve the desired effect (see 10-6 and 10-7).

ABOUT THIS PHOTO
This image, which shows a collection of international currency, has been sold hundreds of times around the world. It took me nine months to collect the perfectly new bills (150mm, ISO 100, f/32 at 1/60 second).

10-5

10-6

10-7

note Anything you include in your still-life photograph must contribute in some way to the overall composition. In fact, especially in these types of images, every inch of your scene should be valued and accounted for because your viewer examines it closely.

Of course, this is easier said than done. Deciding what goes where involves trial and error. For example, remembering that my objective is to guide the viewer's eye around the set, I often place an item in my composition, study it for a while, and decide whether its placement is in keeping with my goal. If so, the object stays; if not, I move it or set it aside. Conversely, I might decide what goes where by first studying the set to determine whether any areas in the picture look empty, placing additional objects accordingly. For example, I worked and reworked the image in 10-8 for more than three weeks before I felt it all worked together as a composition. I used a variety of nests I had collected, old rusty tin cans, and numerous light sources. The surface (background) is made up of tin cans "aged" with water, salt, vinegar, and lemon juice!

In addition to the objects arranged on the set, your composition must also factor in the surface on which these objects are placed. This surface should do more than support the items you want to photograph; it should enhance the scene, adding texture and interest. Excellent surfaces for photographing still-life images include butcher blocks and cutting boards, granite counters, old wooden doors that have been removed from their

tip If you get stuck while assembling your set, walk away. Do something else for awhile. If necessary, sleep on the problem. Later, come back to your set with a fresh mind; something usually clicks. If all else fails, start over; scrap the set and redo it.

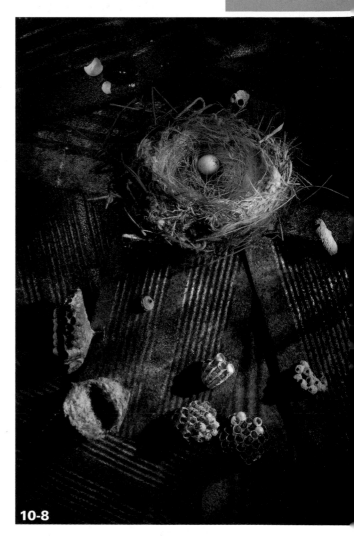

10-8

ABOUT THIS PHOTO *I rearranged this composition 26 times before I got it right (150mm, ISO 100, f/45 at 5 minutes [I painted with a flashlight in parts of the image to precisely control the light]).*

tip Peruse garage sales, flea markets, swap meets, and antique stores to find props and surfaces for your still-life photographs. If something catches your eye, buy it — even if you have no immediate plans to use it. Likewise, if you notice a surface or prop that is not available for sale but that would work well in a still life, photograph it; using the photo as a guide, you might be able to reproduce the item yourself.

hinges and laid flat, or exotic paper such as rice paper, perhaps flecked with gold or silver or with small flowers embedded in the paper. The same applies to your background materials: These might range from wallpaper to metal to wood. For example, I used a pine table (which, incidentally, I built myself and distressed using a hammer, a chain, stain, and shoe polish) as the surface in the scene shown in 10-9 to complement the wildflowers displayed; the weathered redwood fence (also built, aged, and distressed by hand) behind it further enhances the scene. (Being a collector — or, more precisely, a pack rat — I saved that fence and used it again a couple of years later in my Smilin' Jack O'Lantern shot, shown in 10-10, which was sold as a greeting card.)

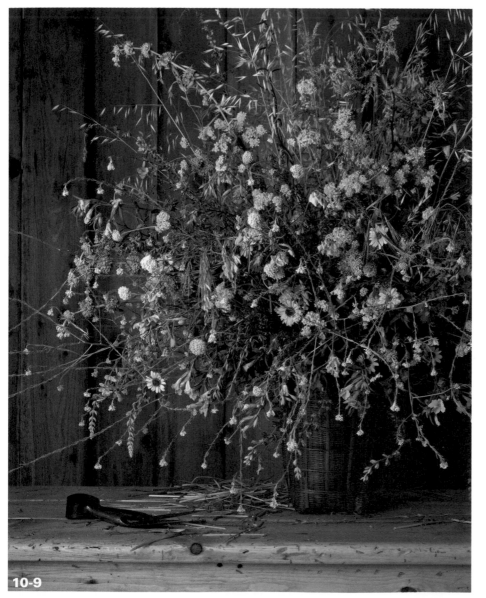

10-9

ABOUT THIS PHOTO
My friend Judy collected and arranged these local wildflowers for me after I built the set in anticipation of the peak wildflower season (210mm, ISO 50, f/64 at 1/125 second).

ABOUT THIS PHOTO
The surface was a bale of hay with maize arranged around the pumpkin. To light the inner part of the pumpkin, I placed a tungsten bulb inside (210mm, ISO 100, f/45 at 12 seconds).

10-10

LIGHTING THE SCENE

One way to light your assembled still-life set is to assemble it near a window in order to use the sun as your key light source. If necessary, you can soften the light by covering the window with a length of white translucent fabric. If no window is available, or if a window does not offer adequate light, use a soft box with flash pack or battery-operated flash unit as your key light source. A third option is to use a combination of sources — for example, a window as your key light source and a secondary source, such as a flash or a soft box, as your fill light. (Note that because you are shooting fairly close in, the pop-up flash on your camera might do the trick, particularly if you can adjust its output — that is, make it stronger or weaker.) Alternatively, use a reflector to redirect any existing or artificial light to the scene. Regardless of the light source, you generally want to orient the scene such that it is lit from the side rather than from the back or the front. In this way, you ensure that any texture in your scene is made visible. The precise angle of the side light might vary; play around with this to see which angle brings out the most texture. The image in 10-11 demonstrates this; it's one of a series of floral arrangements, shot for the greeting-card market. (The lemons are there because I loved their color and thought the composition needed some objects to counter the riot of hues above.)

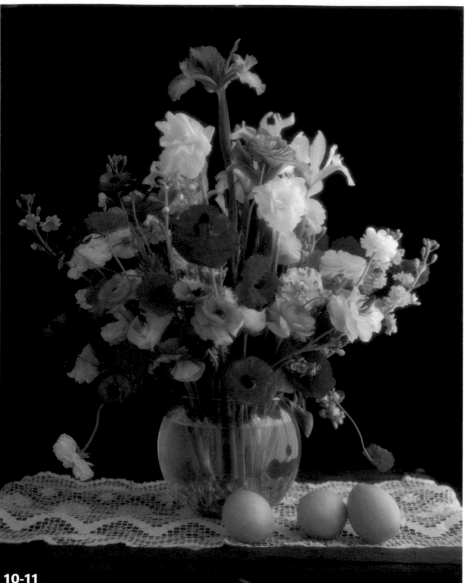

ABOUT THIS PHOTO
*I placed a dark velvet back-
ground behind this window-
light still life (150mm, ISO 100,
f/45 at 4 seconds).*

10-11

PHOTOGRAPHING THE SCENE

Usually, I want my still-life images to be sharp and with maximum depth of field. This requires the use of a tripod, a slower shutter speed, and a low ISO for supreme detail capture. A normal or wide-angle lens is generally the way to go; by nature of their design, telephotos tend to not have the greatest depth of field. Of course, your mileage might vary depending on what you are photographing.

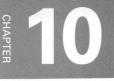

STILL-LIFE SCENARIO A

To better understand the process of developing an idea for a still-life image, assembling a set, configuring the lighting, and photographing the scene, consider the image in 10-12. The idea for this photograph was sparked by some pears I saw at my local market. I loved the color of these pears, so I bought several, choosing ones with interesting shapes and no dings or bruises.

After eating a few of the pears, I simply looked at them, searching for the tones and textures that set them apart from other pears I'd seen. In time, I concluded that the red patina that tinged the pears' skin was what made them unusual, and was not unlike the texture and color of old bricks. Armed with this observation, I hoofed it to a building-supply yard and purchased some aged bricks — bricks with a sense of history.

Bricks and pears in hand, I assembled my set on a small tabletop. As I worked, I realized that placing a few additional objects in and around the bricks would generate interest, so I inserted a knife, spiders' nests, a hummingbird nest, leaves, an old railroad spike, and colored chalk dust. It took me several hours to compose an arrangement I liked. Knowing it would take a while to get everything arranged, I used one pear as a body double, just like actors have on movie sets. When all was ready, I made one final trip to the market for my "hero" pear.

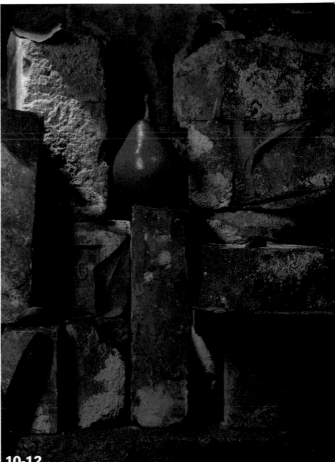

10-12

ABOUT THIS PHOTO *This image, depicting pears and some old bricks, was used as a note card. Look closely to find all the "hidden" objects (150 mm, ISO 50, f/45 at 1/4 second).*

The next step was to decide on the lighting. Although I could have lit this set using daylight from a window, I chose to light it artificially with a soft box so as to enjoy total control over the end result. Although the soft box effectively lit the scene with a soft, general light, I felt the composition lacked zip; for this reason, I added a shaft of yellow light. In addition to serving as a compositional element in its own right, this shaft also highlighted the pear, drawing the viewer's eye there first. Finally, as noted in the image's caption, I photographed the scene with a 150mm lens using an ISO setting of 50, an aperture of f/45, and a shutter speed of 1/4 second.

STILL-LIFE SCENARIO B

The seafood image in 10-13 was shot for a restaurant chain with an old English theme. One dish the restaurant was especially noted for was its bouillabaisse entrée. I started my work for the chain with a discussion with company representatives about the overall feeling they wanted to convey in their advertising — in this case, an Old World look and elegance. Working with a stylist, I found an old plate and various props, including an antique dresser as a tabletop setting. I hired a food stylist, who prepared the food, having shopped for all the ingredients the morning of the shoot. The result was an image used by the restaurant chain for many years. Again, I like a lot of detail in my shots, and this was no exception; the time needed to prepare this shot was six hours on set.

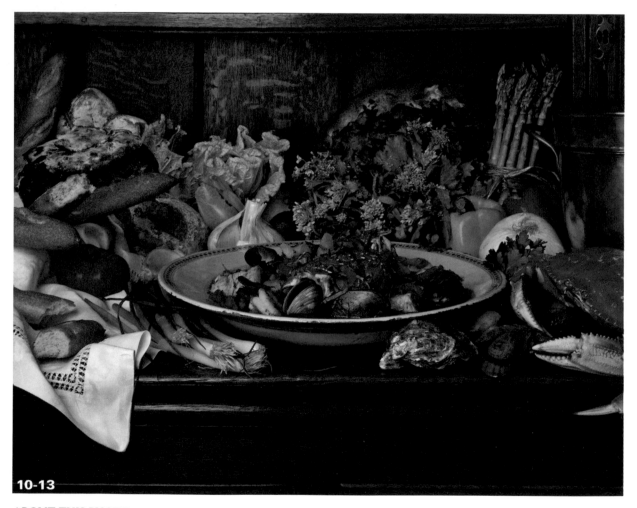

10-13

ABOUT THIS PHOTO *A complex food still life prepared for a restaurant chain ad. A center plate surrounded by lots of details gives the shot an old master painting feeling (210mm, ISO 100, f/45 at 1/60 second).*

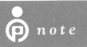

note While I may have had stylists to help me prep for the image shown in figure 10-13, you can create the same kind of look and feel in your own still life photos with patience and attention to detail. Ultimately, if you are happy with the results, then the shoot is a success.

MACRO AND CLOSE-UP PHOTOGRAPHY

Just about any object can serve as the subject of a macro or close-up photograph, although items with interesting colors or textures work best. Food makes for an excellent subject, as do plants, such as the seed pod shown in 10-14, and flowers. In addition to offering brilliant color and texture, they are plentiful and easy to grow. Old worn-out fences, stairs, toys, dolls, rocks, or whatever has special memories for you works. In fact, having an emotional connection with your object makes the resulting image more meaningful for you. Remember, every picture should tell a story.

CHOOSING A BACKDROP

Unlike still-life images, macro or close-up photographs require little with regard to a set. Often, you are too close to the object being photographed to require additional items in your scene. That said, you want to think carefully about your image's backdrop, be it the surface on which the subject of the photograph rests and the background. For example, suppose that you want to photograph a flower. You might plant a colored card behind the flower or shoot from below such that the blue sky acts as the backdrop. Alternatively, if the flower

10-14

ABOUT THIS PHOTO *This image of a seed pod is a good example of close-up photography. Notice how side lighting reveals the texture of the pod, magnified 2x life size (150mm, ISO 100, f/5.6 at 1/125 second).*

you want to photograph is one among many, your backdrop might be more flowers, but out-of-focus (see 10-15). Whatever you choose, ensure that the backdrop complements your subject.

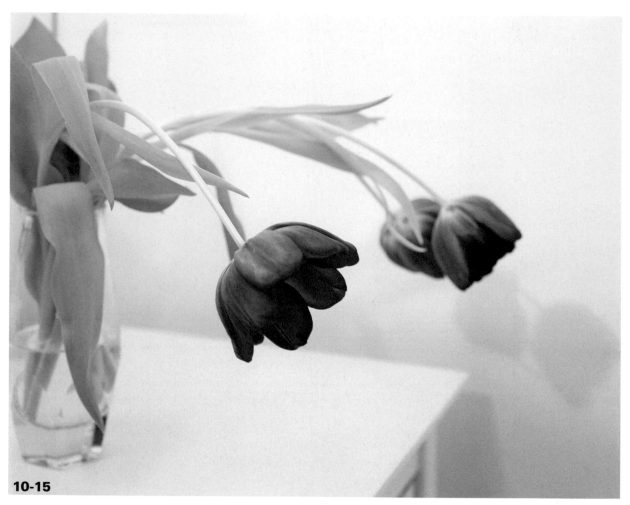

10-15

LIGHTING THE SUBJECT

Typical approaches to lighting a macro photograph include situating the subject in open shade, employing reflectors to bounce daylight onto the subject, applying a flash, or drawing on some combination of the three. In general, although a hard key light can work for a close-up, soft light tends to be more effective. Regardless of your approach, be aware that side-lighting,

or *cross-lighting*, raking across your subject is the most effective way to reveal texture. For example, notice how the cross-lighting in 10-16 reveals the texture of the jeans. In contrast, direct lighting would flatten this texture out, resulting in a less visually exciting image. I reflected a red light into a mirror and angled the mirror into the shadow-side edge to activate that area of the composition.

ABOUT THIS PHOTO
Notice how the cross-lighting of the blue-jeans rivet reveals the texture of the jeans (150mm, ISO 50, f/45 at 1/30 second).

10-16

PHOTOGRAPHING THE SUBJECT

Because of the extreme close-up nature of macro photographs — specifically, the inability of most normal lenses to focus at such close range — you can benefit from using some special equipment.

One option is to use a *close-up filter*. These filters, available in various intensities, are clear pieces of glass that either magnify the image or enable you to shoot it at closer range.

Another option is to use *extension tubes* or a *bellows attachment.* Both extend the distance between the camera's lens and its digital sensor, allowing for a closer focusing distance and greater magnification — although the resulting image is darker, requiring longer exposure times. Extension tubes of various lengths can be stacked together to generate increasing levels of magnification, although each addition to the stack reduces the *working distance* (the distance between your camera and the subject of your photograph necessary to obtain an image that is properly focused and exposed), thereby diminishing your lighting options somewhat. That's because when you shoot close-up, your camera and lens are so close to your subject, there's not enough room to use a regular flash or a white card to bounce light into the shadow areas. In contrast, although the accordion-like bellows attachments generally cannot be stacked, they are adjustable (although they, too, reduce your working distance). One option for lighting is to use a ring flash, which, as you learned in Chapter 8, surrounds your lens and provides a way to evenly light your subject.

Another better option is to use a *macro lens.* They work much like a normal lens, but enable you to maintain focus even as you move in close to your subject. For example, if your normal lens' closest focusing distance is 3 feet, then a macro might take you to 9 inches. Many macro lenses perform best at a magnification of 1:1; others are designed to magnify a wee object by as much as 5:1, revealing miniscule objects — such as pollen on a flower, snowflakes, or fly eyes — in detailed focus. For example, 10-17 shows a quarter-inch bulb for a flashlight, magnified by a power of 10. Telephoto versions of macro lenses enable you to photograph your subject from a bit farther away, giving you more lighting options.

note In addition to bellows attachments and extension tubes, a *telephoto extender* can be used to increase the distance between the camera's lens and its sensor. Unlike extension tubes, using a telephoto extender does not reduce your working distance and increases the telephoto magnification with some light loss and image degradation.

10-17

ABOUT THIS PHOTO *A bulb for a flashlight that is only 1/4-inch long was photographed using a macro bellows attachment (110mm macro lens, f/22 at 1/12 second, bellow attachment).*

Regardless of which avenue you choose — close-up filter, extension tubes, telephoto extender, bellows attachments, or a macro lens — you are likely to need to use the widest available aperture. That's because each one sucks up light, requiring you to open up a stop or two for light loss. That means, of course, that your depth of field is very shallow.

Even with limited depth of field, you can control where your viewer looks first by composing your photograph using *selective focus* — that is, deliberately focusing on one area of your subject, leaving the other areas out-of-focus, as in this close-up of a dandelion (see 10-18).

ABOUT THIS PHOTO
I placed the focus on the spores at the edge, forcing you to look there first (150mm macro, ISO 100, f/22 at 1/60 second).

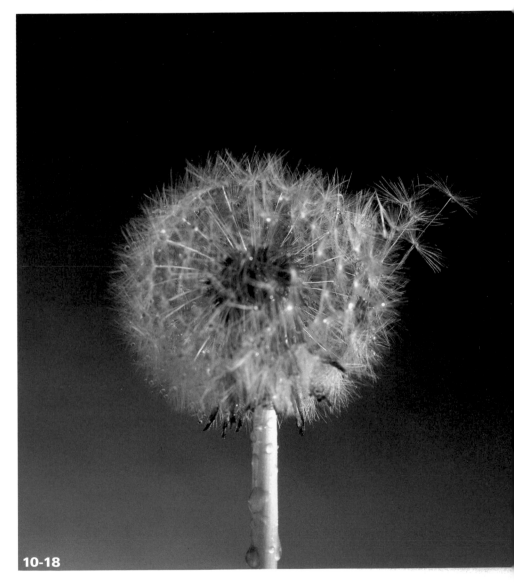

10-18

A CLOSE-UP SCENARIO

To better understand the process of developing an idea for a close-up or macro image, choosing a backdrop, configuring the lighting, and photographing the subject, consider the image in 10-19. I got the idea for this image by simply noticing how a Life Saver candy I was about to eat glowed in backlight.

I set an orange Life Saver on its side, like a wheel, next to a slab of marble I had on hand, which I thought might add some interest; as it happened, the marble looked remarkably like a block of chocolate in the finished photograph — a happy accident. To accentuate the candy's translucency, I placed the key light source above and behind the candy. I then used a white index

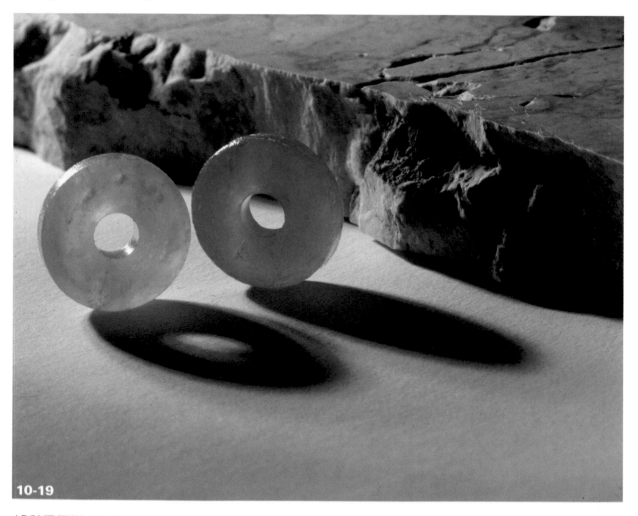

10-19

ABOUT THIS PHOTO *I used a bellows extension to get very close to the candy (150mm, ISO 50, f/45 at 1/60 second).*

card as a fill card — placing it off to the right, out of my camera's view — to bounce light back toward the front of the candy. Finally, as noted in the image's caption, I photographed the set (which was no larger than 6 by 10 inches) with a 150mm lens and a lot of bellows extension. Because I am a twin, I decided to experiment with two centers of interest, and I added a green Life Saver.

note Another way to reduce the necessary aperture width is to boost light levels — perhaps by adding a fill light source such as a reflector card or flash. Note, however, that this only works if there is sufficient distance between the camera and the subject of your photo to allow for additional lighting.

Assignment

Stylish Still Life

Shoot a still life using props for this assignment. Think about your lighting and center of interest. Use window lighting. Compose your best shot and use as many of the compositional elements that are appropriate for your subject. Once you get the best arrangement for your purposes, take your shots and post your best to the Web site.

The seminal idea for this image came to me when I bought this copper bucket at a local antique store. A friend of mine, Judy, had planted ranunculus bulbs in her garden; come spring, we decided to produce this shot as part of a series of floral note cards. The fireplace in Judy's house, constructed of what looked like melted bricks, became the backdrop. I shot this image using a 150mm lens, ISO 100 film, f/22 at 4 seconds. A white card bounced the window light from the left into the shadow side of the arrangement on the right. I cropped it fairly tightly so all that color and texture would be the center of attention, leaving little room for your eyes to stray but with plenty of detail to explore. I used a diffusion filter on the lens to give the image a dreamlike feeling. The diffusion filter caused the highlight areas to bloom or spread.

Don't forget to go to www.pwsbooks.com when you complete this assignment so you can share your best photo and see what other readers have come up with for this assignment. You can also post and read comments, encouraging suggestions, and feedback.

The composition process does not necessarily end with the click of the camera's shutter. Indeed, you might argue that the moment a picture is taken is when the true compositional work begins. This work, made possible by advances in imaging technology, ranges from cropping an image to more powerfully expressing the image's message, adjusting the image's contrast and color, correcting imperfections in the image, fixing any problems with the lighting used, and even applying special effects (see 11-1). Indeed, if you desire, you can use the technology available today to totally rework your image!

In addition to editing your photographs to enhance them after the shutter clicks, you can also improve them both by continuing your quest to understand the technical aspects of composition and by exploring ways to develop your own unique style. In this chapter, you discover myriad ways to edit your digital images using computer software as well as find practical advice for moving forward with your photography. Depending on how involved you want to be in post processing, you can work on an image for as short a time as a few minutes or as long a time as many hours.

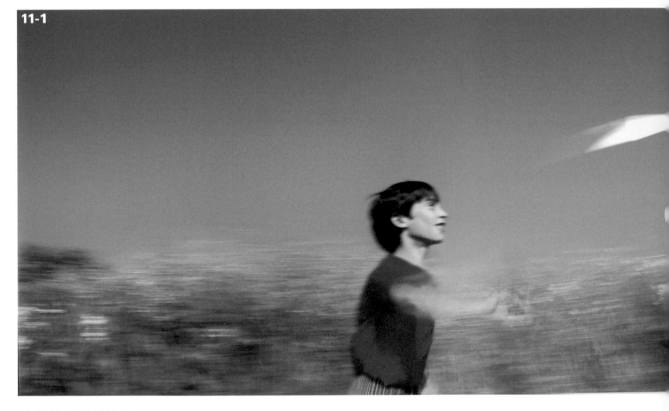

11-1

ABOUT THIS PHOTO *Twelve separate images were used to create this composite image; note, too, the motion effect added to the paper airplane (24mm, ISO 50, f/22 at 1/30 second; compilation and expert retouching by photoshopdude.com).*

CHAPTER 11

UNDERSTANDING FILE FORMATS

In the days of film, photographers edited their images — that is, they cropped, corrected, enlarged, and otherwise adjusted them — in a darkroom using a laborious, time-intensive process. The advent of digital photography — more specifically, of image-editing software — has significantly reduced the amount of time required to edit photographs. These advancements enable you to enhance your image's composition with the click of a button.

When you edit an image, you are, in effect, altering its *image data* — that is, its pixels. *Pixels* are the smallest dots of color that, together, comprise an image. It follows, then, that your ability to edit an image relates directly to the number of pixels the image contains, with greater numbers of pixels yielding more flexibility. The number of pixels your digital camera records per frame ranges in the millions, with one million pixels equaling one megapixel.

Your digital camera stores image data in *image files*, of which there are a few key formats. The format you choose depends on how much detail you want your image to contain, how quickly you need to be able to shoot, and the amount of space your memory cards contain.

note Although image-editing programs offer great tools for correcting images, it's best to try to get your images right using your camera settings, proper exposure, correct lighting, and composition techniques. Basically, by spending more time shooting, you can spend less time in front of a computer, fixing something you should have gotten right in the first place. That said, sometimes cleaning up trash at a scene is quicker on the computer than on site; likewise, it's great knowing you can open up shadows in post-production without sacrificing highlight details in a very contrasty environment.

tip Before you make edits of any type to your image, you should save the image with a new name in order to preserve the original. In fact, you should set up a consistent system to archive your images.

- **JPEG (.jpg).** JPEG files compress image data so that you can fit more photographs on your camera's memory card. This compression does not reduce a photo's *resolution* (the number of pixels per inch) but can affect its detail and clarity and can introduce *artifacts* (odd colorations peppered across the image). Repeated saves of a JPEG file result in more image degradation. Because of this loss in quality, JPEG compression is referred to as *lossy*.

- **TIFF (.tif).** Unlike JPEG files, TIFF files are uncompressed, meaning that TIFF images are not degraded in any way. Although the TIFF format offers excellent image quality, TIFF images are significantly larger than their JPEG counterparts, which can make them impractical if you have limited memory space. Specifically, in addition to limiting the number of image files that can fit on a single memory card, shooting in the TIFF format also increases the amount of time it takes your camera to process and transfer your images to the memory card, reducing the number of frames you can shoot per second or continuously, before the camera pauses to play catch-up.

- **PSD (.psd).** This file format results in large, uncompressed files and does not lose data when copied or saved. It can be used only in Adobe Photoshop.

- **RAW.** The RAW file format equates to the negative in film photography. It's the raw pixel information captured by the camera's sensor. Like TIFF files, RAW files are larger than JPEGs; as such, they are subject to the same limitations as their TIFF counterparts. The file extension on RAW files varies by camera manufacturer.

By default, most cameras automatically convert RAW files into JPEG or TIFF images — a process that involves *demosaicing* the image (interpolating a complete image from the raw data recorded by the sensor), as well as, among other things, adjusting its white balance, color saturation, contrast, and sharpness depth. Because each of these operations consumes time, cameras typically use algorithms that sacrifice quality for speed. For this reason, many photographers prefer to keep the RAW versions of their images intact in order to manage this process themselves using a computer. (You learn more about the tools available for the various steps in the process in a moment.) If you know you will be adjusting your images in an image-editing program, shoot RAW for maximum image data manipulation possibilities.

CROPPING OR RESIZING AN IMAGE

As you review an image file, you might discover that your camera recorded a few things in the scene before it that you failed to notice during the composition phase. For example, you might find that your subject appears to have a palm tree sprouting from her left shoulder. Alternatively, you might realize that your photo's message would be more clearly conveyed if you homed in on your subject, removing those portions of the image that diminish its impact. To address these issues, *crop* your image — that is, delete the parts you find distracting. The image in 11-2 would benefit from cropping; 11-3 shows the result of the crop operation.

Note that cropping is different from *resizing*. When you crop an image, you cut portions of the image away. Resizing an image simply shrinks or enlarges the entire image, altering its dimensions onscreen and in print. Be aware, however, that for reasons relating to the image's resolution, shrinking an image yields far better results than enlarging one.

If your image is composed in such a way that cropping it to remove any distracting photo elements is impossible, you might be able to use other image-editing tools to obscure those elements in your image, which is explained later in this chapter.

11-2

11-3

ABOUT THESE PHOTOS
Figure 11-2 show the interior of a jet at full frame (40mm, ISO 100, f/16 at 1/30 second). In figure 11-3, you see the jet interior cropped. Later adjustments would show a lightening of the dark back interior (40mm, ISO 100, f/16 at 1/30 second).

ADJUSTING AN IMAGE'S CONTRAST AND COLOR

Many cameras shoot a fairly flat image, meaning the image lacks zip. If your camera failed to correctly capture the colors in your scene, if your image lacks contrast, or if the colors in your image just aren't vivid enough to convey your message, you can use an image-editing program such as Photoshop to fix them. By tweaking the image's colors and contrast, you can make it look more like the actual scene it depicts or more like how you wanted the scene to look.

What follows is a simplified explanation of some basic tools to get you started. As your needs increase and your confidence improves, look to any number of books and magazines that concentrate strictly on image-editing techniques for more extensive information.

- **Levels.** Some color-correction tools, such as Photoshop's Levels tool, work by mapping the lightest pixels in the image to pure white, mapping the darkest pixels in the image to pure black, and distributing the pixels in between accordingly (see 11-4 and 11-5).

This operation occurs on all three of the image's color channels. (A *color channel* stores color information for one of the three colors in a color system. Digital images, which use the RGB color system, contain a red color channel, a green color channel, and a blue color channel.) You can also adjust an image's levels by using the Eyedropper tool to select an area in the image that you want to appear as pure white, middle gray, or pure black; the Levels tool adjusts the image accordingly. The Levels tool is best suited for correcting highlights and shadows, somewhat like adjusting your exposure when using the Zone system.

- **Curves.** Like the Levels tool, the Curves tool enables you to adjust the tonality and color of an image. Unlike the Levels tool, however, the Curves tool represents the full range of tones and colors as a curve, with steeper curves representing higher levels of contrast. You can change the tonal and color range by dragging the curve to make it steeper or more gradual for all three color channels, or just one or two. Given your dynamic range as initially captured, the Curves tool allows for better manipulation of those tones.

- **Brightness and Contrast.** Photoshop's Brightness tool alters the lightness or darkness of your image. If your image is under- or overexposed, using the Brightness control is a quick fix. The Contrast tool changes the range of color, black, white, and gray tones;

RGB VALUES As mentioned in Chapter 6, the RGB color system, used in digital photography, was developed to describe how wavelengths of light act when combined. According to this color system, each of the millions of colors in the visual spectrum contains some level of red, green, and blue; a color's *RGB value*, composed of three numbers ranging from 0 to 255, indicates exactly how much red, green, and blue is present. For example, the RGB value of pure black is 0, 0, 0, meaning there is no trace of red, blue, or green in the color; in contrast, the RGB value of pure white is 255, 255, 255, meaning that each of the three colors is fully present.

11-4

ABOUT THIS PHOTO *Figure 11-4 shows an interior shot of Los Angeles International Airport, which is too dark (24mm, ISO 100, f/11 at 1/15 second).*

11-5

if your image is too flat, too gray, or not gray enough, then the Contrast slider is the easiest tool to use. Although these functions degrade your image, they are easier to use than Levels or Curves — although those more-advanced tools offer more precise adjustment.

> **tip** If color is critical, place a color chart or white/gray/black card in your scene when you photograph it. Then, during post-production, you can select the colors in the chart or card with the Eyedropper tool to establish pure white, middle gray, or pure black.

- **Auto Color.** This Photoshop tool identifies an image's shadows, highlights, and midtones and then automatically neutralizes the midtones to an RGB value of 128, 128, 128. This tool represents an easy way to adjust your color balance if your image looks too red, green, or blue, but as you gain confidence, switch to Levels or Curves for better controls.

- **Color Balance.** For more generalized color correction, Photoshop's Color Balance tool is an option. It adjusts the overall mix of colors in an image, warming and/or cooling the

look. This tool does not discard any image information but can introduce artifacts into your image.

- **Hue/Saturation.** Tools such as Photoshop's Hue/Saturation tool enable you to adjust the hue, saturation, and brightness of the colors in your image, either all at once or on a color-by-color basis (see 11-6 and 11-7). These tools offer an excellent way to globally adjust your colors or even to just pump up the saturation of, say, the reds.

- **Photo Filter.** Just about any filter you can put in front of your lens can now be added to your image later, in your image-editing program. These include filters that enable you to shift your color balance, warm or cool your

image, correct the green in fluorescent lighting, apply gradients — the limit is truly your imagination. Photoshop's Photo Filter tools enable you to simulate the use of certain filters, including Kodak Wratten filters. Simply choose one of several pre-set filter colors or select a custom hue and adjust the intensity of the filter effect as needed (see 11-8 and 11-9).

> **note** Many tools offer an auto version, which applies the tool in predetermined ways. You might try the auto version of a tool first and then compare it to working the tool yourself. If you use the manual version of the tool, you have more control and fine-tuning capabilities.

ABOUT THESE PHOTOS *My digital camera is set to record in standard mode in figure 11-6, with no saturated colors (35mm, ISO 100, f/8 at 1/15 second). In figure 11-7, I adjusted the hue, saturation, and brightness levels to give this warehouse scene the colors it actually contained.*

11-8

ABOUT THIS PHOTO
In figure 11-8, you see a late
afternoon scene in Marseille,
France, original color (105mm,
ISO 100, f/16 at 1/60 second).
A magenta filter and 40 percent
luminosity added some overall
color to the view as shown in
figure 11-9.

11-9

In addition to using various tools to correct the colors in your image, you can also use an image-editing program to convert a color image to black and white, as shown in 11-10 and 11-11.

The beauty of image-editing software is that you can play around with the image to your heart's content and simply undo your changes if you are not satisfied. Indeed, you quickly discover that one of the most useful commands in any image-editing program is the Undo command. Certain programs, such as Photoshop, even include a History palette, which enables you to track the changes you've made to your image and quickly undo them. Photoshop also enables you to preview changes before you make them by clicking a tool's Preview button. Save your files periodically while working on them.

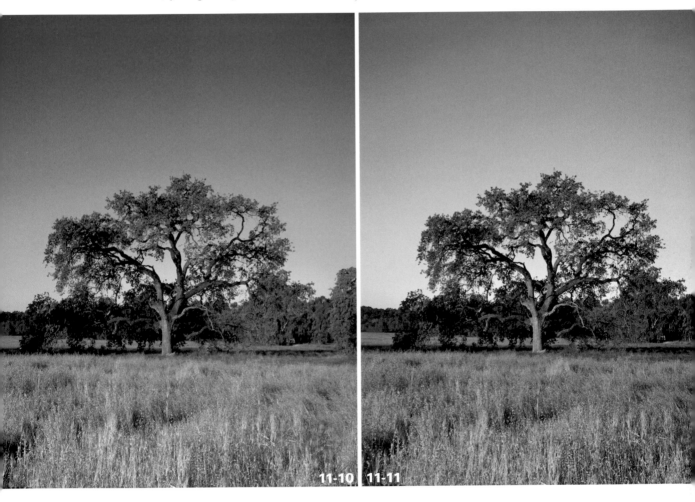

11-10 11-11

ABOUT THESE PHOTOS *Figure 11-10 is of a 400-year-old oak tree in Ojai, California, in full color (240mm, ISO 100, f/45 at 1/15 second). In figure 11-11, you see the same image, converted from RGB mode to Grayscale. A few months after I took this picture, a powerful storm toppled this majestic oak.*

CORRECTING IMPERFECTIONS

In addition to correcting the color and contrast in your photograph, you can also retouch your image to fix red eye, remove wrinkles and other skin imperfections, reduce noise, and sharpen your image.

ELIMINATING RED EYE

If, when photographing a person, you use a flash, red eye can occur. That is, the subject of your photograph might take on a decidedly demonic appearance, with glowing red pupils. This occurs in dim light when the pupil in the subject's eye is wide open and the flash is angled such that its light illuminates the many red blood vessels found in the retina in the back of the subject's eye.

You can prevent red eye during the composition phase by using a *bounce flash* (aiming the flash to bounce off a nearby surface, like a wall or the ceiling), by redirecting the flash to strike the eyes at an angle, asking your subject to direct his gaze away from the camera, increasing the ambient lighting in order to contract the subject's pupils, or using the red-eye reduction capabilities present in most cameras. Alternatively, you can eliminate red eye using one of several image-editing programs.

OBSCURING FLAWS

Even beautiful people are subject to wrinkles, blemishes, cold sores, moles, and other imperfections. Fortunately, many image-editing programs offer tools to help you eliminate these flaws. In addition, these tools can be used to remove stray objects from an otherwise uniform background. Here are a couple examples of tools that enable you to obscure imperfections (see 11-12 and 11-13):

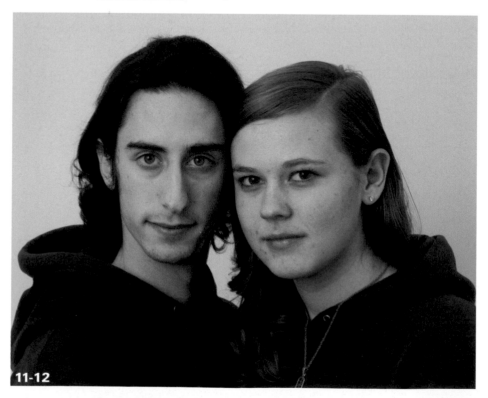

11-12

ABOUT THIS PHOTO
My teenage son, Zack, and his girlfriend, Elyse, are shown unretouched (90mm, ISO 100, f/11 at 1/250 second).

ABOUT THIS PHOTO
Here, you see Zack and Elyse retouched with Photoshop's Spot Healing brush, Clone tool, and a warming filter.

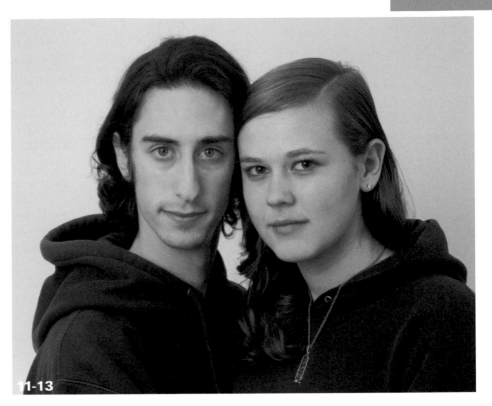

11-13

■ **Spot Healing Brush.** Some image-editing tools, such as Photoshop's Spot Healing Brush tool, sample the pixels that surround the blemish or other anomalous object in order to determine how best to heal or cover the object.

■ **Clone Stamp.** Other tools, such as Photoshop's Clone Stamp tool, enable you to select a set of pixels, clone those pixels, and apply the cloned pixels to the offending area.

note In addition to eliminating the red-eye effect found in photographs of people, many image-editing programs enable you to eradicate the green-eye effect that occurs in photographs of animals.

REDUCING NOISE

If you shot a photograph using a high ISO setting or in low light with a slow shutter speed, you might find that the image contains *noise* — that is, extraneous pixels that look grainy or patchy, or distortions or other visible features that were not present in the scene you photographed. Many image-editing programs, including Photoshop, enable you to reduce noise or eliminate it altogether (see 11-14 and 11-15).

note In addition to providing various tools to reduce noise, some image-editing programs also enable you to add it. For example, you might add noise or grain to an image to make it appear grainier, yielding an "old-fashioned" film effect.

ABOUT THESE PHOTOS *My mentor and friend, Ian Summers, shown in figure 11-14 looking a bit grainy due to the noise from the low-light environment (50mm, ISO 100, f/2 at 1/5 second). In figure 11-15, the noise has been removed. Also, using the Exposure tool, I lightened Ian up.*

11-14

11-15

 note Removing noise from an image also reduces the image's sharpness. To restore this sharpness, use your image-editing program's sharpening tools, discussed next.

SHARPENING AN IMAGE

Although no amount of work in an image-editing program can correct a photograph that is severely blurred, many image-editing programs offer sharpening tools that can be used to better define the edges in an image that are only slightly off. In general, these tools operate by locating areas in the image where significant color changes exist (that is, edges) and increasing the contrast between the pixels that define those edges in order to create the illusion of sharpness

(see 11-16 and 11-17). Be aware, however, that if you sharpen too much, you get artifacts at the edges where colors meet. Many of these sharpening tools are automatic, leaving you no room for adjusting. Sharpening should be the last adjustment you make.

For more advanced techniques, look into the Unsharp Mask tool, which includes a preview and lots of options.

tip If, in addition to sharpening your image, you also need to reduce the image's noise level, reduce the noise first. Otherwise, the sharpening operation might intensify the noise, preventing you from reducing it adequately.

11-16 11-17

ABOUT THESE PHOTOS *Figure 11-16 is just slightly out-of-focus (40mm, ISO 100, f/11 at 1/250 second). In figure 11-17, you can see that I sharpened it just enough so it's not overdone.*

FIXING THE LIGHTING

If you were unable to situate yourself or your subject in such a way as to avoid backlighting, or if you want to save an otherwise overexposed image, you might be able to use an image-editing program to correct the problem. For example, Photoshop's Shadow/Highlight tool is designed to rectify issues associated with backlighting and overexposure by lightening shadows and darkening highlights in the image, using the surrounding pixels as its gauge (see 11-18, 11-19, 11-20, and 11-21).

> *tip* You can also configure Shadow/Highlights to handle problems that might result from using a flash — namely, subjects that appear washed out.

ABOUT THIS PHOTO
The shot of Notre Dame in figure 11-18 was backlit, resulting in an underexposed subject (ISO 100, f/2.8 at 1/15 second).

11-18

ABOUT THIS PHOTO
I adjusted the lighting with Photoshop's Shadow/Highlight tool, cropped it, and got rid of some trash for the result in figure 11-19. It's not perfect, but it's much better.

11-19

11-20 11-21

APPLYING SPECIAL EFFECTS

Image-editing programs enable you to do more than simply correct mistakes in your images. They can be used to enhance your images through the application of special effects to yield an image that's far more dramatic than the scene it depicts.

USING FILTERS

Many image-editing programs enable you to apply special effects to your digital images using tools called *filters*. For example, some filters are artistic in nature, enabling you to alter an image such that it appears to have been drawn with colored pencils, composed of roughly cut pieces of paper, with pastels, painted with watercolors, sketched with chalk or charcoal, stamped on a page, and so on. Other filters can be used to blur, distort, pixilate, or otherwise stylize your image. Figures 11-22 and 11-23 demonstrate the effects of Photoshop's Grain and Ink filters.

MERGING SHOTS WITH DIFFERENT EXPOSURE SETTINGS One way to expand the contrast range of an image is by creating a composite of multiple exposures of the same scene. First, place your camera on a tripod and lock it down tight. Then bracket your exposures by shooting one using normal settings, one that is overexposed by two stops, and one that is underexposed by two stops. Do not change your aperture! Only bracket by shutter speed and make sure nothing is moving in the image. Then using an image-editing program, merge these three images into a single file. The result is an image that would be impossible to capture using a single frame, but that more closely resembles the scene as it was perceived by your eyes.

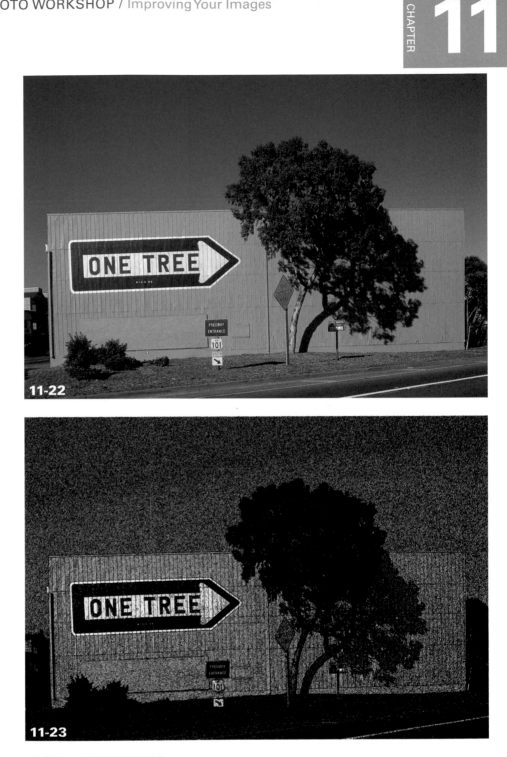

11-22

11-23

ABOUT THESE PHOTOS *I love this sign in figure 11-22. Normal exposure is 85mm, ISO 50, f/16 at 1/60 second. In figure 11-23, I applied the Grain and Ink filters to the file.*

CREATING COMPOSITE IMAGES

In addition to providing filters for creating special effects, many image-editing programs also enable you to create special effects by compositing photos. For example, the image shown in 11-24 is a composite of four separate photographs (see 11-25, 11-26, 11-27, and 11-28). The images were color-corrected, sized,

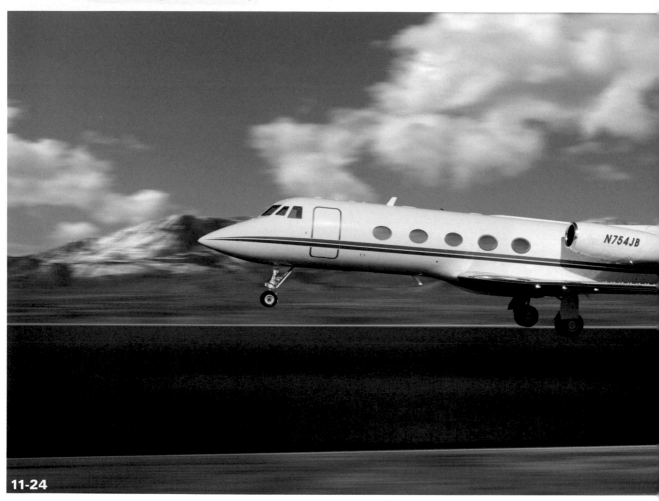

11-24

ABOUT THIS PHOTO *Composite of four images, used to promote my photography and Michael Standlee's retouching and compositing skills (105mm, ISO 50, f/22.5 at 1/8 second; compilation and retouching by photoshopdude.com).*

and cleaned up, and selected areas were moved onto the master file using layers. Motion and jet exhaust were added to create a realistic look to the finished picture.

11-25

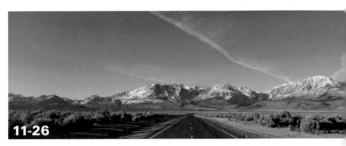

11-26

11-27

11-28

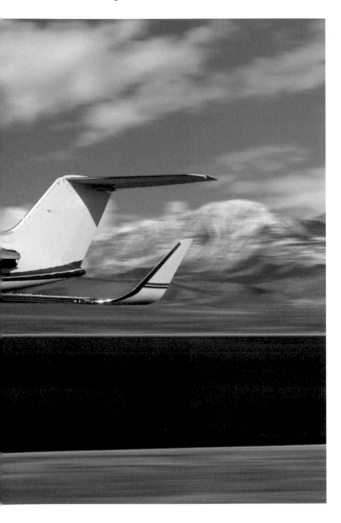

ABOUT THESE PHOTOS *Figure 11-25: A Gulfstream jet, on the ground in Van Nuys, California, used for the composite image (30mm, ISO 100, f/16.5 at 1/125 second). Figure 11-26: The Eastern Sierra mountains, looking west from Mono Lake, used for the composite (105mm, ISO 50, center-weighted neutral-density filter, f/22.5 at 1/8 second). Figure 11-27: The beautiful clouds shot from 1200 feet up in the hills above Los Angeles, used for the composite (105mm, ISO 50, center-weighted neutral-density filter, f/22.5 at 1/8 second). Figure 11-28: Horizontal road shot in Utah, used for the composite (105mm, ISO 50, center-weighted neutral-density filter, f/22.5 at 1/8 second).*

BACKING UP AND ARCHIVING YOUR IMAGE FILES

Any number of catastrophes can befall a computer — theft, loss, breakage, not to mention the ravages of time and weather. If your computer is lost or stolen, or if it crashes, you want to mitigate your losses by ensuring that copies of your digital images have been saved in a separate location. That is, you need to back up your image files. That way, you have backup copies of all your images in the event disaster strikes. One approach is to simply copy image files to CDs and DVDs; another is to copy the images to an external hard drive. (Some people swap external hard drives, with one at home and one at work. Others keep a hard drive in a safety deposit box.) Whatever method you choose, be sure to archive your image files often and to store the discs or drive onto which these files are copied in a safe place with minimal weather fluctuations. Regardless of which approach you use, back up, back up, back up! Back up daily or weekly, perhaps even using special software to do it automatically so you don't even have to think about it.

In addition to backing up your image files, you should also archive them — that is, organize and store them for easy retrieval. This is especially crucial as your images grow in number. Before the advent of digital photography, many people archived their images in shoeboxes; these days, they can be stored as electronic data. To better keep track of your images, you should develop a consistent naming system for your files; for example, you might name all original, untouched files by date or subject matter, along with a term to indicate that the image is the original, such as "master," keeping all these files in one place. Then, as you work, file new copies separately using, say, "v1" or "v2" to indicate which version of the image it is.

In addition to enabling you to organize and store your image files, many image-editing programs include archiving capabilities, which enable you to embed metadata (keywords that enable you to easily find your files when you search for them) into your files. For example, you might embed the phrase "family vacation" in your vacation photos; then, when you want to locate those photos, you can simply search for that phrase and by adding dates as a way of refining your search.

TAKING THE NEXT STEP

Understanding the technical aspects of composition is only half the equation; inspiration is the other half. Until now, this book has focused on the first half, discussing the myriad ways to compose an image. In this section, you discover ways to develop your own unique style and lift your compositions to the next level.

- **Practice.** Each and every day, athletes work out to stay in top form; musicians rehearse to master their material; artists draw to maintain their skills. Likewise, you must practice your photography in order to excel. Carry your camera with you everywhere you go. Taking pictures each and every day is the only way to grow as a photographer.

- **Learn from your mistakes.** Not every shot you take is worth framing and hanging on your wall. In fact, most of what I shoot never makes it past my initial editing process.

 tip Although I mentioned this earlier, it bears repeating: Bring a small notebook and pen with you on your photographic excursions and use it to record the lighting conditions during the shoot, your exposure settings (ISO, f-stop, and shutter speed), and which camera and lens you used. Writing this information down not only helps you after the fact, when you want to determine what settings yielded a particular result, but also during the shoot; it forces you to think about what you are doing as you work, to shoot more mindfully. If you can't bring yourself to tote a notebook around, don't fret; most digital cameras store the camera settings in the metadata.

Nonetheless, I learn from my mistakes. In fact, my failures are my best teachers. By carefully studying my photographs that don't make the grade, I learn how to improve; I discover what not to do next time.

■ **Focus yourself before you focus your camera.** Work from your heart and shoot what you love. For example, I love texture, and the way it is revealed by light. When I realized this, I began seeking out scenes rich in texture. Because of this clarity in purpose, my photographs improved tremendously. If you are confused, then your pictures probably reflect that.

■ **Stretch.** To keep your photography fresh and energized, practice stretching, which just means working on projects whose primary purpose is to go against your normal way of working. You might stretch by using a new lens, to take enough photos for a gallery show, or to shoot at night. For example, I recently stretched myself by taking a photograph at midnight every night for a month. The idea is to choose a stretch that is challenging, that enables you to flex your creative muscles, moving yourself out of your comfort zone to an area you've never been before. The resulting images might not always be earth-shaking, but you inevitably learn something, loosen up your style, or even develop a whole new way of working. Sure, it's scary, but it's also liberating. Stretching keeps you sharp and open to new ways of seeing and doing.

■ **Work on a series.** I work on several personal projects at all times, each a series of related images. For example, I am currently working on a series depicting identical twins. First, I shoot them in a very straightforward and symmetrical manner; then I loosen it up, photographing the subjects in an environment that has special meaning to them. I also have an ongoing love affair with close-ups of seed pods. These series enable me to concentrate my energies on specific types of images. Some of my projects include only a dozen images; others have been ongoing for years.

■ **Study the work of others.** Studying other people's photographs is not only a great way to learn about composition, lighting, and the like, it's also an excellent means of stimulating your creativity. Excellent places for looking at photographs include galleries, museums, books, magazines, Web sites, and artists' studio tours. I make it a habit to visit galleries in my area once a month and have discovered the work of many amazing photographers in the process. Even if you don't like what you see, you can learn from the way the artist composed the image. Alternatively, you might walk away inspired.

note If you find some aspect of photography difficult, or don't enjoy it, then that is probably the area you should be working on.

225

HEIGHTENED VIEWING To really learn from other people's photos, engage in *heightened viewing* or enlightened viewing. That is, look at a single photograph for an hour or more. Heightened viewing slows you down, helping you to eliminate the chatter in your mind and focus intently on a single object. First look at the image's composition and elements of design. Study it until you can close your eyes and see the entire image, in full detail, in your mind. Next, interpret the image. Try to figure out what the photographer had in mind when he composed the picture. Your interpretation might vary widely from the photographer's or from that of other people who view the photograph, but as long as your interpretation is based on what actually appears in the photograph, there is no right or wrong answer. Finally, decide what you like about the photograph and why it excites you, and think about ways to generate that same excitement with your own work.

■ **Take a class.** Peruse the Internet or photography magazines for listings of workshops. If you like the instructor's work, sign up! A true master can teach you a lot, saving you years of blind experimentation. Life is very short. Learn from the best!

■ **Join a photography organization.** Because most artists are independent thinkers, they often work alone. Joining a photography organization, be it local or national with local chapters, can help you connect with fellow photographers. Many of the larger photography groups support online forums, where you can learn and share techniques not just about photography, but about running a photography-based business. Many of these organizations also sponsor workshops, speakers, and other events. For more information, enquire at your favorite camera store or search online.

■ **Assist a pro.** Working as a photographer's assistant provides invaluable hands-on experience — plus, you get paid to learn. Alternatively, shadow a photographer for a day or two so you can see how he or she works.

Assignment

Working with Shadows

As you know, no photographic images can exist without light. Shadows, on the other hand, are typically ignored. For this assignment, I want you to include shadows in your image as part of your composition. I want you to explore their potential. For best results, shoot this assignment on a clear, bright, sunny day. Once you gather several images you are happy with, post your favorite to the Web site.

In this shot, I was eating with a friend of mine in the late afternoon when he got up to answer a phone call. While waiting for him to return, I noticed the projection of the glass on his empty seat. It got me to think about shadows; after taking this photograph, I began really looking for interesting shadows as well as for subjects with interesting shadow projections (of which there are several in this book). Always having a camera close by enabled me to take this picture (50mm, ISO 100, f/8 at 1/60 second).

Don't forget to go to www.pwsbooks.com when you complete this assignment so you can share your best photo and see what other readers have come up with for this assignment. You can also post and read comments, encouraging suggestions, and feedback.

ambient light All the light occurring in an environment, including sunlight and artificial-light sources such as tungsten or fluorescent lights. Also known as available light.

ambient metering A handheld meter that measures the light falling on your subject.

angle of view The area that a lens sees and that is included in the viewfinder or LCD screen.

aperture A variable opening in a lens that allows light into the camera. Also called f-stop.

archival Describes prints and materials that, when stored properly, will last for many years without degrading.

artifact Unnatural coloration of pixels caused by lens aberrations or interpolation of image data.

asymmetry Unequal balance in a composition.

available light See *ambient light.*

bellows attachment An adjustable accordion-like device that goes between your camera body and lens for taking macro photographs.

bracket To take several exposures of the same scene using different settings, typically overexposing and underexposing the image by one f-stop. In post-production, you can blend overexposed and underexposed versions of an image to achieve more detail in the highlight and shadow areas.

cable release A cable that you can attach to your camera, with a push-button on one end. Pressing the push button trips the shutter. Using a cable release is handy when photographing scenes that require long exposure times because it minimizes camera movement.

camera obscura From the Latin word for *dark room*. Originally a darkened room with a small opening or aperture for letting light inside resulting in the projection of an upside-down image on the wall opposite the opening.

catch light Any light or light source reflected in a subject's eyes.

center of interest The area of a composition that attracts the viewer's attention.

center-weighted neutral-density filter A piece of optically clear glass with a darker center, gradating outward to clear edges. Used with wide-angle lenses, particularly panoramic lenses, where the image circle projected to the film or image plane is so wide that the light rays travel farther to the edges than to the center. Without the filter, the image would get progressively darker toward the edges; with the filter, the light is held back in the center to make the exposure even from edge to edge. Many filters of this type are made specifically to match a particular lens's optics.

chip Short for *microchip*, a sensor used for storing image data.

circles of confusion The projection of circles of light onto the image plane, controlled by the size of the aperture.

close-up Any image that is taken from a distance that's closer than the minimum focusing distance of a normal lens, used to emphasize detail. Usually done with a special close-up filter or macro lens.

close-up filter A special filter that screws onto the front of your lens, enabling you to focus closer than the lens normally allows.

CMY color system A color system in which cyan, magenta, and yellow are the primary colors.

CMYK color system A color system in which cyan, magenta, yellow, and black make up the primary colors, used in the printing process.

color balance The color temperature of the dominant light source illuminating a scene that is adjustable.

color channel Stores color and tonal information for one of the colors in a color system. For

example, the RGB color system has three color channels: one for red, which stores red color information; one for green, which stores green color information; and one for blue, which stores blue color information. The three channels blend together to create a full color image.

color-conversion filter Used for major shifts in color; usually from tungsten to daylight and daylight to tungsten.

color meter A device used to measure the color temperature of the dominant light source illuminating a particular environment and to suggest filter corrections.

color temperature The measurement, in Kelvin, of the color of a given light source.

color theory A system for organizing colors based on the additive or subtractive methods.

complementary color The color opposite a given color on a color wheel.

composition The way individual design elements are combined to express a particular idea.

compression A way of reducing an image file size to save storage space or for quicker transmission of data.

cones Receptors in the eye that perceive sharp detail and color.

contrast The difference between the dark and light tones in an image.

contrast filter A colored filter used on a camera's lens to lighten or darken selected colors in a black-and-white image. For example, a red filter lightens reds while darkening their opposites, blues.

cornea The transparent portion of the outer layer of the eye wall that helps to focus light rays.

correct exposure The exposure necessary to allow sufficient detail in the highlight and shadow areas, as evidenced by a smooth histogram.

crop To eliminate portions of an image.

cross-lighting Light that skims across an object, used to reveal texture.

decisive moment As defined by Henri Cartier-Bresson, when all the elements in a scene come together in balance.

demosaic To interpolate a complete image from the raw data recorded by the sensor.

depth of field The amount of space in front of and behind the subject of your photograph that appears in focus. An image's depth of field can be shallow, meaning that only a small amount of space in front of and behind the subject is in focus, or deep, meaning that a large amount of space in front of and behind the subject appears sharp.

depth of field scale Measurements in feet or meters on your lens that indicate what portions of the depth of field zone will be acceptably sharp at a given aperture.

electromagnetic radiation Radiation consisting of electromagnetic waves, including radio waves, infrared, visible light, ultraviolet, X-rays, and gamma rays.

elements of design Those individual parts (point, line, plane, and so on) that are used to make a composition.

environmental portrait A portrait in which the environment is the dominant compositional element, while the person is the lesser element although the main focal point.

equivalent exposure An exposure that provides the same look, contrast, and density as another exposure, but with a different f-stop and shutter-speed.

establishing shot Typically a wide-angle shot, meant to provide an overall sense of a location.

extended time exposure An unusually long exposure.

extension tube A non-adjustable attachment that goes between the camera body and lens to allow for a closer working distance.

external flash A portable or larger flash unit that generates light through stored-up energy (a battery) or operates through a direct plug-in to an electrical current.

f-stop The variable opening in a lens that allows light into the camera. See also *aperture*.

fill card Usually white (although it can be silver or gold) cardboard or foam core used to reflect light from another source back onto your subject.

film speed Light sensitivity of film (or of a digital sensor) as rated by the ISO. Faster (higher numbered) film speeds mean increased light sensitivity.

filter Optically clear medium (for example, glass, cast resin, or gelatin) with a set color used to influence the color of an image. Also, preset effects that can be applied to parts or all of an image in an image-editing software.

focal length The length of a lens, measured in millimeters, from the center point to the image sensor when focused at infinity.

focal plane The surface or sensor where the points of focused light fall at their sharpest.

focal point The area of the scene at which the photographer focuses the camera. Also, the center of interest in a composition.

foreshorten To reduce or distort a three-dimensional object to represent it on a two-dimensional surface.

fovea centralis The area in the eye of sharpest vision, where only cones are present in the macula lutea.

frame The visible area that makes up an image. It typically comprises the view in your viewfinder or camera's monitor. Also, the shape of your picture as determined by your digital sensor, typically rectangular. Also called format.

golden hour The hours at which rich yellow or golden light naturally occurs, generally an hour or so just after sunrise and just before sunset.

golden ratio The ratio 1:1618. The long sides of the golden rectangle are 1.618 times larger than the short sides.

golden rectangle A two-dimensional geometric figure with four 90 degree angles where the relationship between the long and short sides is dictated by the *golden ratio*. One distinctive feature of the golden rectangle is that if you create a square within the rectangle, the remaining portion of the rectangle will itself be a golden rectangle.

graduated neutral-density filter Typically, a clear filter that gradually progresses to a deeper gray density at the top. The deeper density absorbs light and does not alter the final color of the image. Available in different densities and soft and hard gradations.

gray scale A scale that uses eleven tones of gray, black, and white, relating to the zone system for black-and-white photography.

hard light Light from a small source (relative to the subject's size) whose rays are nearly parallel, resulting in shadows that are crisp with hard edges.

head shot A photograph of a person's head and shoulders.

heightened viewing The act of slowly looking at a work of art to fully appreciate and understand it.

highlight The brightest area of an image that is illuminated by a light source.

histogram A graph that shows the distribution and quantity of pixels, representing the tones in an image.

horizon line The area where the earth and sky meet.

hot shoe Located on your camera, usually above the viewfinder, for attaching an external flash unit for added light.

hue Pure color with no white or black added.

hyperfocal distance When focused at infinity at any f-stop, the closest plane to the camera in focus will be the *hyperfocal distance*. When you refocus at this hyperfocal distance, infinity is still in focus and the closest plane of focus now moves to half of the hyperfocal distance.

image data The information collected from a digital sensor that becomes a photograph.

image file A file in which image data is stored in a special format.

image format The way in which image data is stored.

incident meter See *light meter*.

ISO International Organization for Standardization. This organization gives numerical ratings (100, 200, 400, and so on) for accepted standards of light-sensitive materials — first for film, now for digital sensors.

key light source The dominant light source in a scene. When outside, the key light source is the sun; when inside, the key light source is generally a flash or a tungsten light.

lens The area behind the bulge in the eye. It can adjust its shape using surrounding ligaments to focus light rays on the retina. Also, a combination of glass elements that gathers and focuses light on your camera.

light-balancing filter Usually 81 (amber) or 82 (blue) series of filters, which warm up or cool down an image by incrementally lowering or increasing an image's color temperature.

light meter A device for measuring the light that falls on a subject (incident meter) or that is reflected or emitted from the subject (reflected meter) so as to determine the correct f-stop and shutter speed combination. Most cameras have a light meter built in, but hand-held units can also be used.

line An infinite succession of points, or the section where two planes intersect.

linear perspective A method of rendering three-dimensional objects in space on a two-dimensional surface.

lossless compression Describes a compression algorithm that reduces the size of an image file without eliminating any image data. A TIFF file is a lossless file type.

lossy compression Describes a compression algorithm that permanently eliminates image data in order to make smaller files for increased storage capabilities or speedier data transmissions. JPEGS are a lossy file type.

macro An extreme close-up image.

macro lens Lens used for extreme close-up pictures.

macula lutea The central region of the retina that is yellow in color. It features a depression called the *fovea centralis*, where the sharpest vision occurs.

magic light See *golden hour*.

midrange portrait A portrait shot from a medium distance that typically includes the subject from mid-thigh, upward.

model release A signed contract that gives the photographer the right to use pictures he/she has taken of an individual.

monocular vision Sight accomplished by the visual impulses from one eye.

motor drive A camera feature that enables you to take sequential images in pre-determined sets, (three, five, eight, and so on), limited only by your camera's buffer and your memory card's writing speed.

nanometer One billionth of a meter.

neutral-density filter A neutral color filter for absorbing light in different densities. This type of filter does not alter the final color of the image, but does enable you to use a lower ISO.

noise Random pixels that might appear in your image, particularly in shadowy areas, when the ISO is high or if light levels are low.

normal lens The lens that just covers the diagonal distance of the image sensor with its circle of projected light. It most closely approximates our vision.

orientation Describes how the camera is held: horizontally, vertically, or somewhere in between.

orthogonal line Guidelines in a perspective grid that help you position objects and determine their shapes relative to the horizon line and vanishing points.

panning To move your camera while following a moving object. Panning typically results in a blurred background behind an acceptably sharp subject.

panoramic rectangle A ratio of width to height in which the width is at least twice the height.

pigment Colored material used in paints or inks.

pixel Short for *picture element*, the smallest unit that makes up a digital image, be it on your monitor or digital sensor.

plane An infinite set of lines in two dimensions.

plane of critical focus The plane parallel to the camera's digital sensor at which focus is sharpest.

point The smallest element of a line.

polarizing filter A filter that reduces reflections from nonmetallic surfaces by preventing stray light rays from striking your sensor.

portrait An image of a person.

pose To arrange your subject.

primary color On a color wheel, one of three colors that cannot be created by mixing other colors in the wheel.

pupil The opening in the eye that allows light to pass through to the retina.

rear curtain sync To adjust your flash's outburst of light to happen just after the shutter opens. When the flash is delayed using rear curtain sync, the ambient light on your subject creates a blur behind the subject, which is frozen the moment the flash goes off. The end result is a stationary object frozen with a trailing motion blur behind it.

red eye The result of a flash exposing the blood vessels on the back of the retina, due to low light levels and dilated pupils.

reflective meter See *light meter*.

resize To change the dimensions of your image.

resolution The amount of data available in any given area, usually referred to in terms of detail revealed. In digital imaging, resolution is measured in *pixels per inch* (ppi).

retina The area on the inner wall of the eye that contains the eye's visual receptors.

RGB color system A color system that uses red, green, and blue as its primary colors, which are created from light.

RGB value The amount of red, green, and blue information at any given pixel, ranging from 0 to 255.

rods Visual receptors that are hundreds of times more sensitive to light than cones. They produce colorless vision, enabling you to see general outlines of objects and in dim light.

rule of thirds This rule dictates that you place the center of interest in your image on one of the cross-points of a grid.

RYB color system A color system that uses red, yellow, and blue as its primary colors.

saturation The degree of purity of a hue.

secondary color A color made by mixing the primary colors of a given color system.

selective focus Narrow depth of field achieved through aperture choice.

selective vision A physical function of the eye in which only the center of the eye records sharply. Also the act of the brain only responding to certain stimuli so as to avoid sensory overload.

shade Any hue mixed with black.

shadow The dark area adjacent to the illuminated highlight side of an object.

shutter speed Measured length of time that the camera's shutter opens and closes to allow light to fall on the light-sensitive sensor.

soft light Light from a broad, diffuse light source, which scatters when falling on a subject.

solid An object with three dimensions: length, width, and height.

spot metering Typically, a 1- to 5-degree angle of view for a light meter, used for pinpoint metering of light reflected off or emanating from a subject.

stereoscopic vision Sight accomplished by the visual impulses from two eyes, resulting in three-dimensional images of depth, distance, height, and width.

still life Any arrangement of small objects, usually on a table top.

strobe Stored light emitted through an on-camera or off-camera flash unit.

Sunny 16 rule This rule states that on a clear day, with the sun at your back, in the period two hours after sunrise to two hours before sunset, while shooting a subject fully illuminated by the sun, your exposure should be f/16 and your ISO setting should match your shutter speed.

symmetry Describes an identical arrangement of elements on either side of an imaginary line.

telephoto extender A device that magnifies your telephoto range by 1.6xs or 2x, reduces light levels, and slightly softens your image.

telephoto lens A lens with an angle of view smaller than the normal lens for a given sensor size.

terminal point The point at which your eye comes to a rest.

tint Any hue mixed with white.

tone Any color.

tripod A device used to steady the camera.

vanishing point A point on the horizontal or vertical axis of a scene that locates objects in space on a two-dimensional surface.

visual spectrum Forms of electromagnetic radiation wavelengths that are visible to the human eye.

wavelength The distance between one peak or crest of a wave of light, heat, or other energy and the next corresponding peak or crest.

white balance Color balance of the light falling on an environment that is adjusted so the whites read white with no other color added.

white card A pure white piece of cardboard, used for zone-system metering or for white-balancing your camera.

wide-angle lens A lens with an angle of view that is greater than the normal lens for a given sensor size.

working distance The distance from your camera to the object you are photographing.

Wratten filter One of a standard system of colored filters, used to change the color of the light striking the image sensor.

Wratten numbers A numbering system used to standardize the color of filters.

zone One of eleven tones used in the zone system for matching light-meter measurements to black-and-white tones.

zone of focus The area in an image that appears the sharpest.

zoom lens A lens with multiple focal lengths.

continued

continued